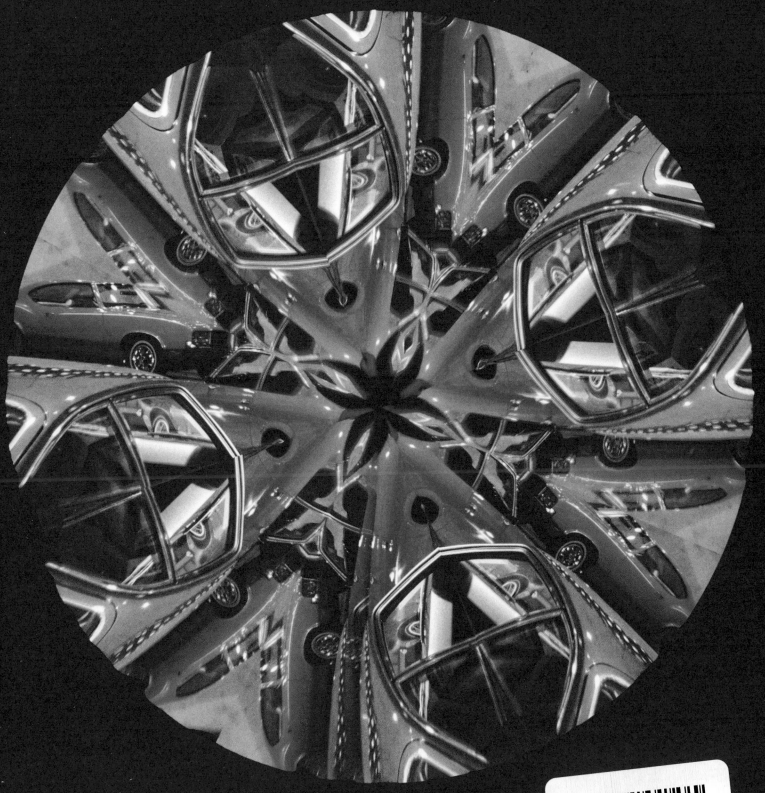

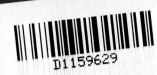

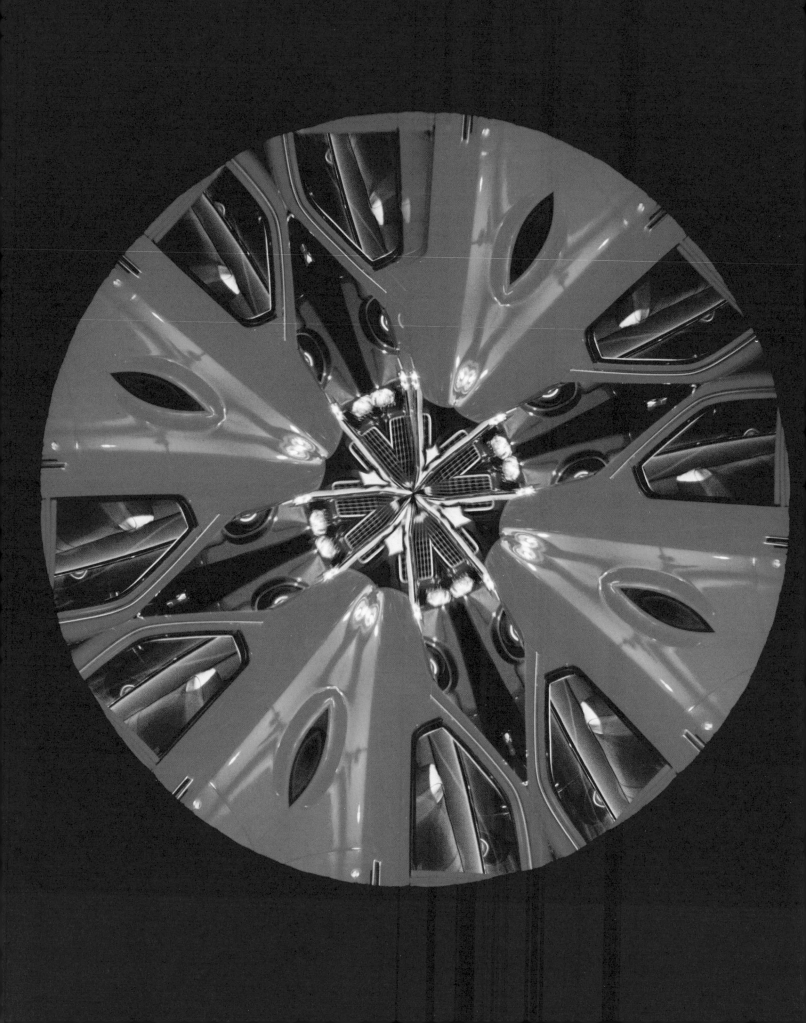

AUTO
AMERICA
CAR CULTURE
1950s–1970s

AUTO AMERICA
CAR CULTURE
1950s–1970s

PHOTOGRAPHS BY
JOHN G. ZIMMERMAN

RIZZOLI
NEW YORK

New York Paris London Milan

CONTENTS

INTRODUCTION: CAR CULTURE
by TERRY McDONELL/7

DREAMS/13

DESIGN/55

CULTURE/129

RACING/185

ACKNOWLEDGMENTS/224

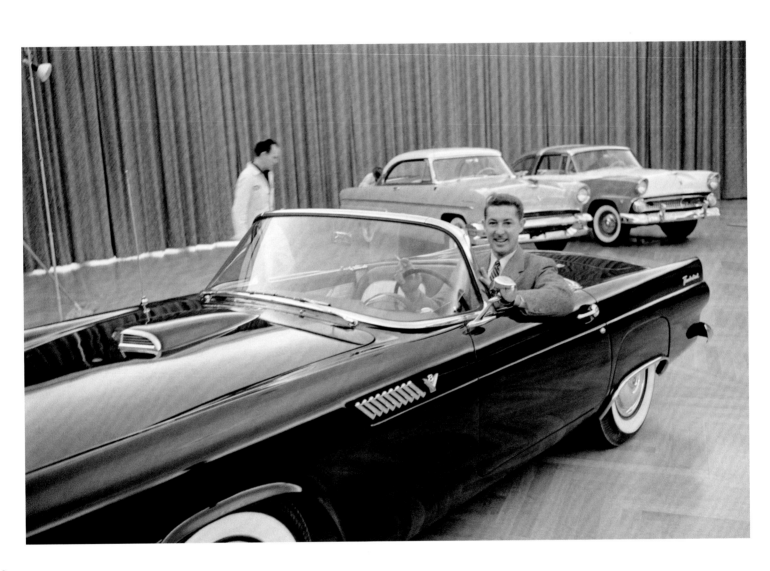

AUTO AMERICA
CAR CULTURE
1950S–1970S

TERRY McDONELL

As a physical extension of the human body, a sublimated manifestation of our inner emotions, or an expression of social identities inflected by race, class, and gender, the motorcar presents rich territories for artists to explore.

—ALINE LOUCHHEIM, "The Automobile in Modern Art," *The New York Times*, September 20, 1953

Fun, fun, fun 'til your daddy takes the T-bird away...

—BRIAN WILSON AND MIKE LOVE, "Fun, Fun, Fun," *Shut Down Volume 2* (1964) by the Beach Boys

I T WAS 1954. The rising photojournalist John G. Zimmerman was twenty-seven years old and freelancing out of the *Time Life* bureau in Detroit when he began photographing feature stories about the "Big 3" Detroit automakers: Chrysler, General Motors, and Ford. It was a perfect match with profound implications for what was to come.

One of his first assignments for *Life* magazine came out of Henry Ford II's hiring of a new chairman, Ernie Breech. Zimmerman shot the two men looking back into his camera from the twin seats of a newly introduced Thunderbird, as if they were saying "Follow us." From then on, Zimmerman's evolving eye and innovative techniques captured and translated the most significant sociological shift in twentieth-century American life: the rise of American car culture.

Automobile business was exploding. More affordable prices, the growth of suburbs, and a sprawling interstate highway system were putting more and more Americans on the road. Owning a car, once thought of as a luxury, became a given. More significant, what you drove became a symbol of independence and individuality. The introduction of new models

like Ford's Lincoln Premiere in Detroit in 1956 carried all of the glamour of Hollywood premieres, and Zimmerman's images framed them in that exciting light. He understood that nothing grabbed the imagination of America at mid-century as completely as fantastic-looking automobiles and attendant dreams of the open road. Americans everywhere wanted to hit the highway in clean machines with evermore high-revving horsepower, elaborate taillights (often the brightest red), wraparound windshields, chrome hood ornaments (and more and more chrome!), and—above all—tailfins reflecting an imagined Space Age of innovation and adventure.

It was a heady time, and Zimmerman's flawless images made new cars into dazzling stars and reflected every nuance of their attraction. He didn't just show you; it was as if he made you look. Many of his images, like his night shot of a 1960 Chrysler 300F in Times Square, were as rich and lavish in light and color as any Broadway musical extravaganza of the period. Numerous so-called modernizations were being introduced or refined. Automatic transmissions were becoming dominant in passenger cars. Words like "powerglide," "super hydramatic," and "dynaflow" were entering the lexicon. Power windows, air conditioning, and all-transistor radios would soon be popular options. Seat belts were patented. The horsepower race was on, laying the foundation

OPPOSITE: Zimmerman sits behind the wheel of a '55 Ford Thunderbird before a photo shoot in 1955.

7

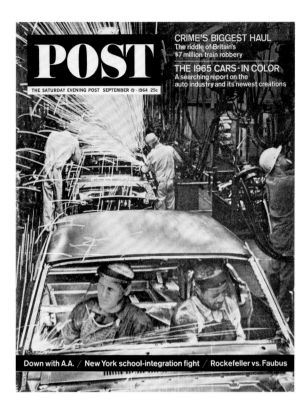

for the muscle car era. Perhaps most surprising, automobile design was emerging as an accessible cultural preoccupation. Everyone who owned a car, wanted a car, or just rode around in cars—in other words, everyone—had strong opinions about how cars preformed and what they should look like. What Zimmerman understood instinctively was that new cars were never simply ubiquitous industrial products, but rather flashy combinations of modernism, consumerism, and popular culture. Now his images opened new ways of looking at them, sparking imagination and a consciousness of the emergence of automobile design as art. His eye reflected the sharpest design aesthetic of a range of new cars that looked like they belonged in the Museum of Modern Art—where the best of them would ultimately be collected.

Zimmerman had loved photography growing up in Torrance, a quiet Los Angeles suburb that would become a hot spot of car culture in the 1960s. His father, a gaffer at a major film studio, built him a darkroom in the garage, and he studied photography with the Hollywood cinematographer Clarence A. Bach, who was famous for launching the careers of no fewer than six *Life* photographers. Boosted by Bach's informal network, Zimmerman landed his first job as a photographer at the *Time* bureau in Washington, DC, shooting both news and features, followed by

a series of assignments for *Ebony* that depicted the lives of African Americans in the Jim Crow south. He was audacious and gifted, and defined himself as a photojournalist, somehow able to bring pathos and compassion to breaking news, as evidenced by his tragic images of the General Motors plant fire in 1953.

Those pictures along with his perfectly styled early automotive work brought him to the attention of *Sports Illustrated*, which was just launching. His first major photo-essay for *Sports Illustrated* was "Dream Cars" in the March 5, 1956, issue. The bright, silhouetted images showed off seven futuristic concept cars including the Mercury XM-Turnpike Cruiser with flip-up roof hatch, the Packard Predictor with disappearing headlights and push-button transmission, and the Ford Mystere with a bubble-canopy top and protruding air scoop. The popular "Dream Cars" feature was followed by a succession of Zimmerman pieces on auto execs, factories, and various rallies and shows, all radiating the optimism of the moment.

In 1956, Zimmerman joined the staff of *Sports Illustrated*, where his innovations began to revolutionize sports photography. He placed cameras inside hockey nets and above basketball hoops. Fans had never seen their beloved games from Zimmerman's new angles and wanted more. A wizard with specialty cameras, camera angles, and shutter design, he lit entire arenas with strobe

ABOVE LEFT:
This 1964 *Saturday Evening Post* cover reflects the electrifying power of the postwar automotive industry.

ABOVE RIGHT:
Stunt pilot Frank Tallman takes an antique biplane for a spin—a technical feat, both aeronautically and photographically. The image was captured in 1963 with a remote-controlled camera using a slow shutter speed.

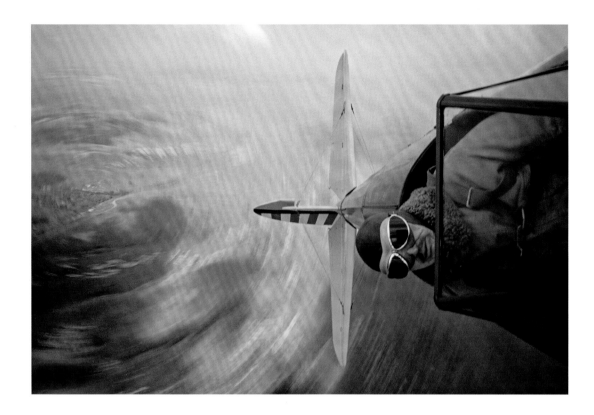

lights, creating many iconic images. Sports photography would never be the same, and his images of race cars and racing were part of that rolling revolution.

From the Indianapolis 500 to dirt tracks and early NASCAR, Zimmerman's images were moments in time, with his creativity allowing him to catch images on film that the naked eye could not see—sometimes stretching and blurring his background images to show motion. More eccentric images like a crew in white lab coats and pith helmets vacuuming the track at Indy earned good-natured attention, and his humanizing images of new kinds of fans socializing on car fenders and partying on infields with hot dogs and beer foreshadowed the popularity of twenty-first-century NASCAR. It was photojournalism at its best.

The professional racing insiders liked both Zimmerman and his pictures. His access to the up-to-then unrevealed sides of racing allowed him to contribute to revolutionary stories. His photo-essay on the first woman drag racing champion, Shirley Muldowney, showed her not just burning rubber and being a grease monkey, but also napping before a race and applying her lip gloss in a rearview mirror. His in-the-field portraits of American Racing Royalty were as glamorous and charismatic as the drivers themselves. His March 1959 *Sports Illustrated* cover of Phil Hill and his Formula One Ferrari stands as *the* classic.

Zimmerman knew that cars were not just cars but emblems of speed and motion across American culture (not only on American racetracks), and he applied his innovative techniques everywhere. He was among the first to use remote-controlled cameras for unique placements, and he mastered motor-driven camera sequences, slit cameras, and double-shutter designs to show motion. At the same time, his traditional black-and-white images of used car lots—particularly, one of a salesman on the phone puffing on a cigar—reflected a less friendly but no less real side of the culture. He had it all covered.

He found ever more angles and experimented with techniques that had seldom if ever been used. The impression of freeway speed was created with his innovative lighting. His first-person point-of-view shots from behind the wheel, like the cover of *Sports Illustrated*'s "Safe Driving" issue in 1961, seem eerily familiar and anticipated GoPro cameras by decades. He even welcomed what might be considered boring assignments as opportunities that called for radical new techniques. For GM's corporate report on its new line of cars for 1971, he shot through a specially adapted telescopic filter for a kaleidoscopic snowflake effect.

Colleagues across all the top magazines raved that Zimmerman could shoot anything and, although many of his most innovative techniques are widely used and may seem

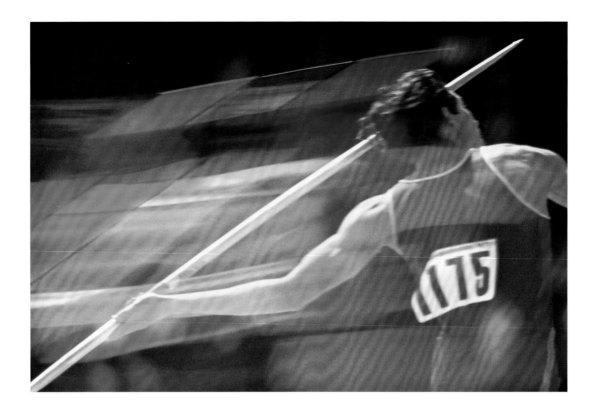

familiar today, they were unheard of and exciting when Zimmerman perfected them in the 1960s, 1970s, and on. For decades, he worked on better ways to capture a car in motion, going as far as to build a special camera and dolly system—again, pushing the limits of existing camera technology. Zimmerman's Motion Machine—which he designed in order to control the blur of the background while keeping a speeding car in sharp focus—was first used in a Ford ad in the 1980s.

Starting in the Mad Men era, Zimmerman worked increasingly in advertising, photographing campaigns for all major Madison Avenue agencies and their biggest clients: Ford, Chrysler, AT&T, Exxon, G.E., Pepsi, Coca-Cola, and Marlboro, among others. In fact, his advertising work went far beyond his immediately famous Marlboro Country images, and every time a car was involved his images hummed.

Zimmerman's advertising images were as immaculate and creative as his editorial work, in some cases solving complicated puzzles influenced by market research and media analysis. For so-called "lifestyle marketing," every client wanted attractive, spirited young people having a wonderful time or happy children piling out of a station wagon. Zimmerman enlisted his family for test shots; his wife Delores would sometimes serve as a model, as in the image for the *Saturday Evening Post* cover story on "New Cars" of 1965.

Advertising work allowed him more control and thus more perfect images than he could create on hard-charging editorial assignments. The lighting was especially important, and he was a master—highlighting with strobes that he said expanded his creativity. There were no limits on what he could try as long as he made sure he delivered the basic concept. Sometimes, he would present as many as four different solutions, and the client could choose from among them. When auto design in the 1950s was said to reflect the new Space Age, Zimmerman took this a step further with his image of a Flying A gas pump and station attendant floating in space.

Zimmerman was a man of ideas, and he followed the latest in modern art, architecture, and design, all of which influenced his work. In the late 1960s, after photographing a series for *Life* on great architectural homes, he built an ultra-modern vacation house in Vermont, underlining his interest in hard-edged abstraction, which also carried over into some of his photographs. His compositions could be powerfully abstract, as in his aerial shots of freeway interchanges and expansive lots of new cars of different colors to traffic on the George Washington Bridge.

John Zimmerman was a handsome, athletic man with beautiful manners. "Call me John," he would say when introduced to green assistants on the 28th floor of the Time & Life Building.

ABOVE: Zimmerman created a custom shutter and filter for his 35mm Hulcher camera to capture the athleticism of javelin with light and color.

OPPOSITE: A 1965 Flying A Gasoline print advertisement.

This could be extremely disconcerting because Zimmerman was himself as glamorous as the Marlboro Man images that he shot for the cigarette brand, although he smoked a pipe and dressed on a different level of sophistication than cowboy boots. When it came to his own cars, Zimmerman drove to assignments in a Dodge Ram panel van that he customized to carry his many cases of equipment. He also drove a yellow Mercedes diesel station wagon for a while, as well as a couple Buick LeSabres and a favorite 1966 Ford Mustang. He had photographed the New York World's Fair for the *Saturday Evening Post* in 1964, when the original Mustang was introduced. Two years later, after an ambitious photo-essay documenting the production of the Mustang from initial design stage to new cars being shipped from the factory, he bought one for himself—a Nightmist Blue hardtop, running a peppy Ford V-8 with a factory rating of 271 horsepower.

Zimmerman continued to shoot for *Sports Illustrated* and other major publications through to his retirement in 1991 to Pebble Beach. He lived in a house on the fourteenth fairway at Spanish Bay. He played golf almost daily and continued to work on perfecting his Motion Machine even in his retirement, making tests of neighbors in Pebble Beach with their luxury cars. His legacy of working at the highest level through the Golden Age of photojournalism was ensured.

On a personal note, I never met John Zimmerman, although I followed his work for many years and knew it well before I became the editor of *Sports Illustrated* in 2002, the year John died. To honor him and his work for the magazine, I ran three spreads of his images in the August 12, 2002, issue. A team of photo editors argued down to final deadline about which images to include. There were so many.

John G. Zimmerman, as his byline read, is credited with 107 *Sports Illustrated* covers alone, including five for the Swimsuit Issue. My favorite swimsuit cover has always been his shot of Christie Brinkley in 1981. His photograph of the famous Bednarik–Gifford hit during the NFL season of 1960 hung mural-size outside my office until I left the magazine in 2012. Now, writing this, I see that as exact and polished as all of his automotive images were, they also showed off what was almost a rowdy visual ingenuity, and the versatility of a genius to match the energy and style of our ever-changing car culture.

In the end, this is a book about great photography of wonderful cars and the rich and vivid culture that surrounded them. It is rare and ultimately transcending when an artist appears at exactly the right time to so perfectly document and translate such a significant cultural shift. That is what happened over the three decades after John G. Zimmerman began photographing automobile culture in Detroit in 1954.

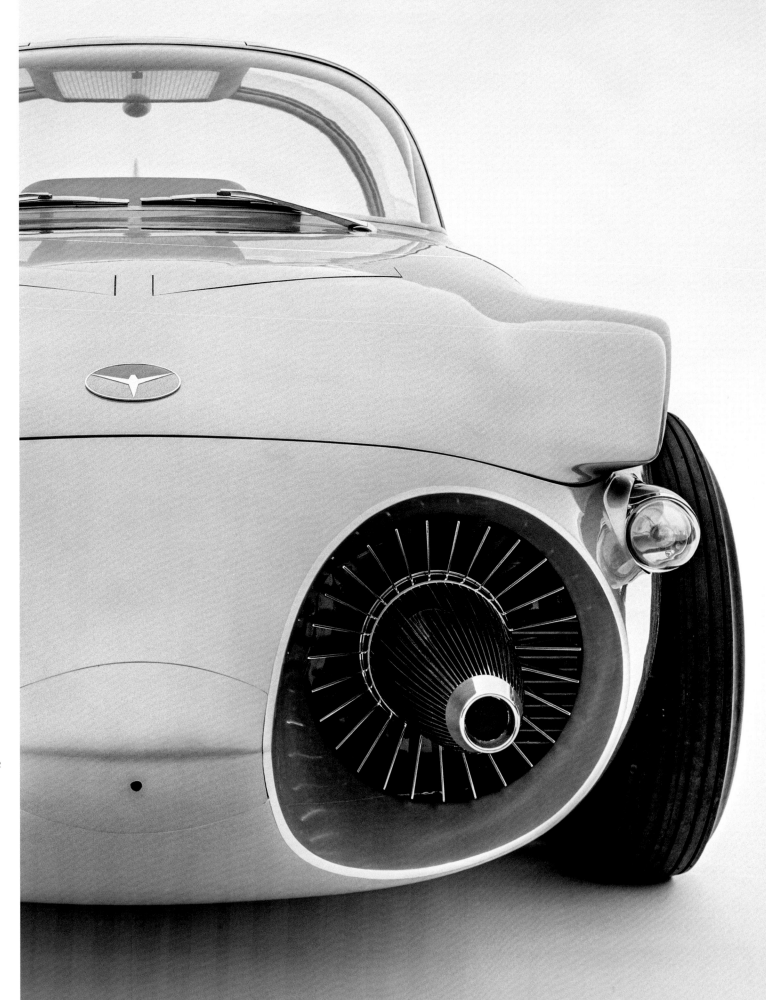

DREAMS

DREAMS

NOTHING CAPTURED THE imagination of America at mid-century as completely as the evolving idea of fantastic-looking automobiles symbolizing personal freedom and dreams of the open road. You got there in clean machines with evermore high-revving horsepower, elaborate taillights (often the brightest red), wrap-around windshields, chrome hood ornaments (and more and more chrome!), and—above all—tailfins reflecting an imagined Space Age of innovation and adventure. Cars were dazzling stars, and Zimmerman's flawless images reflected every nuance of their attraction and made them look like they belonged in the Museum of Modern Art—where the best of them would ultimately be collected.

—T.M.

PREVIOUS:
GM Firebird II.

OPPOSITE:
Automobiles were Zimmerman's first foray into shooting photo essays for *Sports Illustrated*.

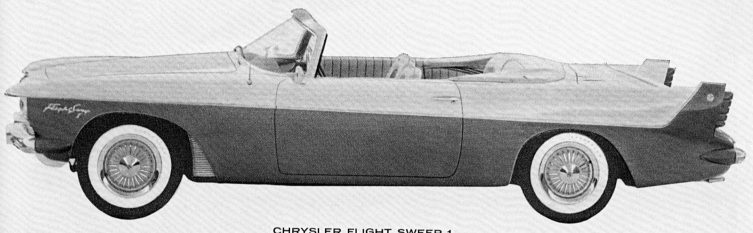

CHRYSLER FLIGHT SWEEP 1

Tapered nose and upswept rear-fender line of this convertible reflect Chrysler's admiration for the dart-shaped look of jet fighters and racing boats. The controls for transmission, heater, radio and lights lie between bucket-type front seats. Height 53½ inches, length 207 inches.

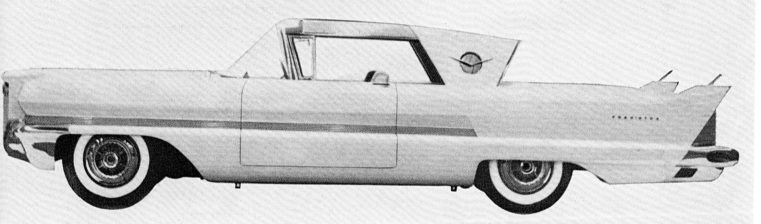

PACKARD PREDICTOR

Roll-back roof doors, disappearing headlights and electric push-button transmission are features of this pearl-white hardtop coupe which is powered by mammoth 374-cubic-inch V-8 engine. Front seats swivel outward when passengers alight. Height 54 inches, length 225 inches.

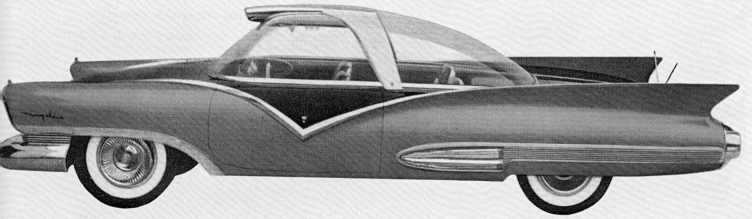

FORD MYSTERE

Bubble-type canopy of Ford's idea entry, with a protruding air scoop, is most extreme example of the tendency to observation-car styling. Rear compartment is designed to accommodate either gas turbine or the conventional piston engine. Height 52 inches, length 220 inches.

15

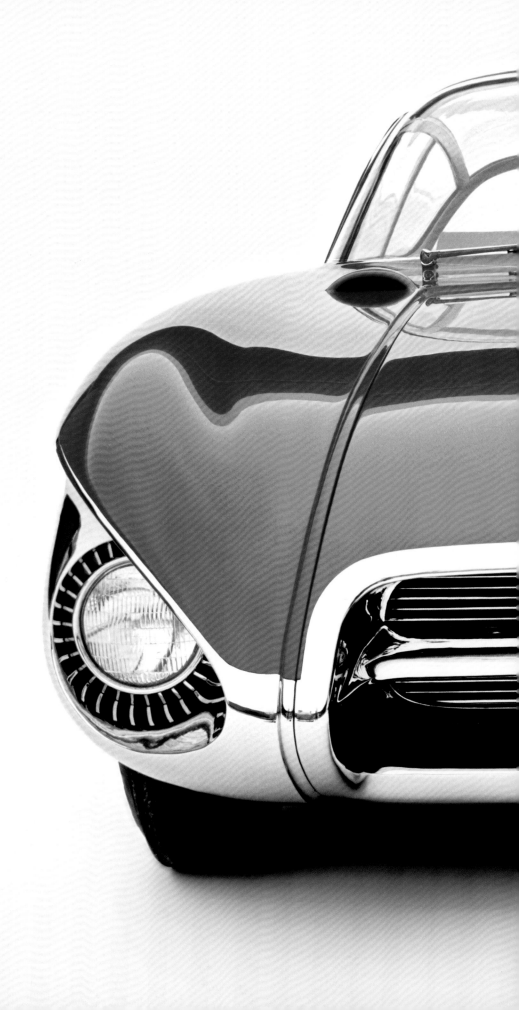

16 RIGHT, FOLLOWING:
The aerodynamic
'56 Buick Cen-
turion featured a
fiberglass body, a
bubble-top roof,
and a cantilevered
steering wheel.

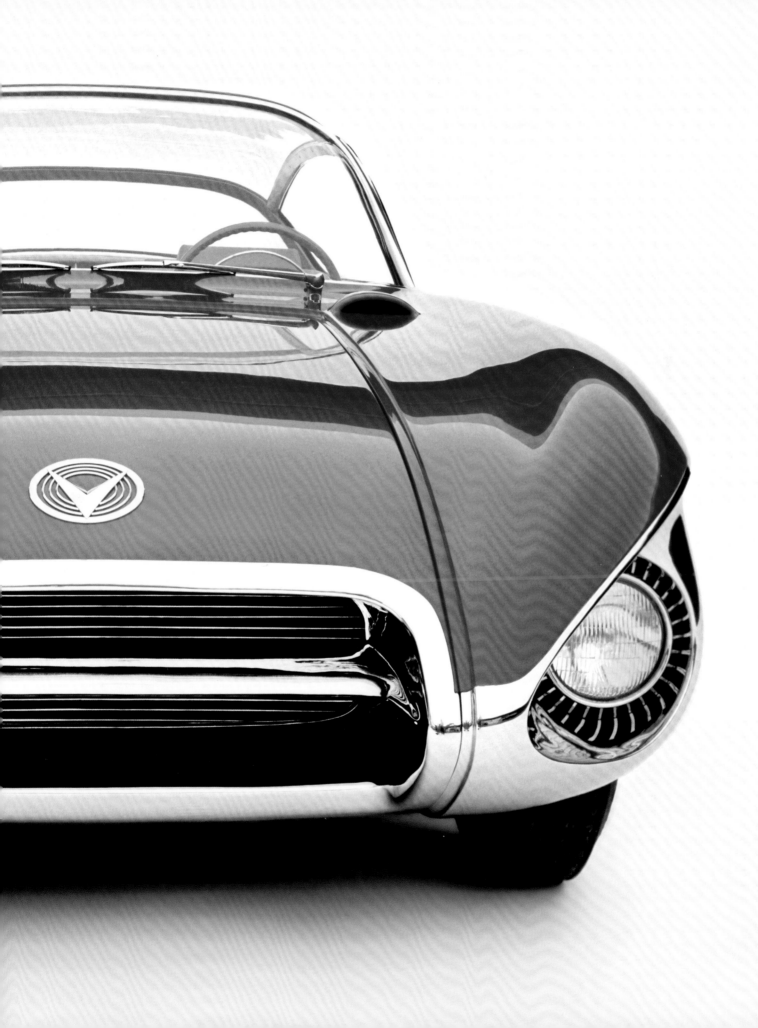

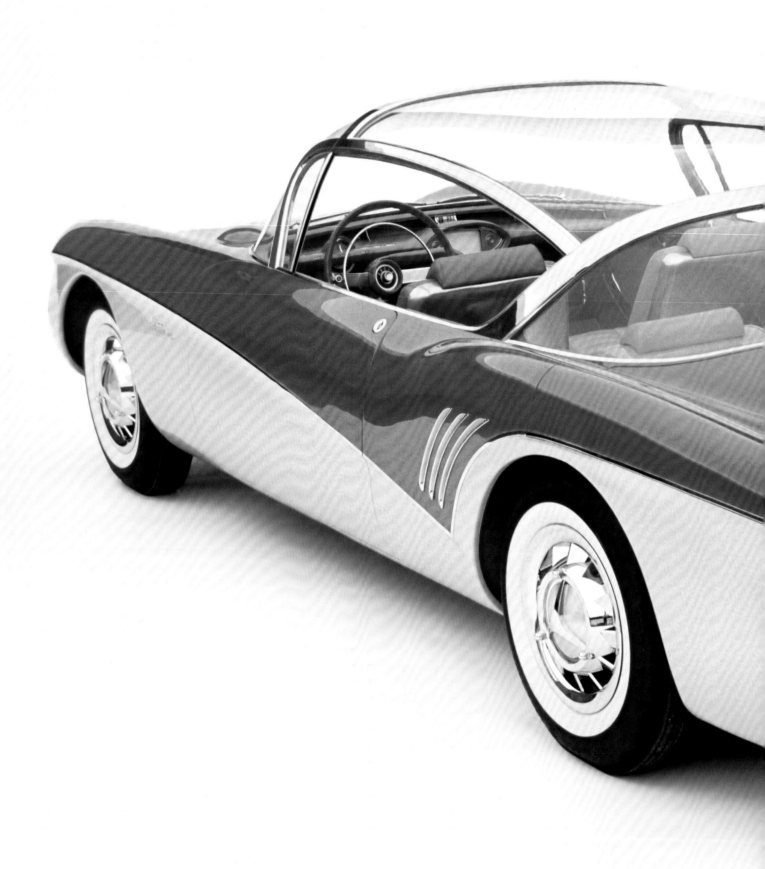

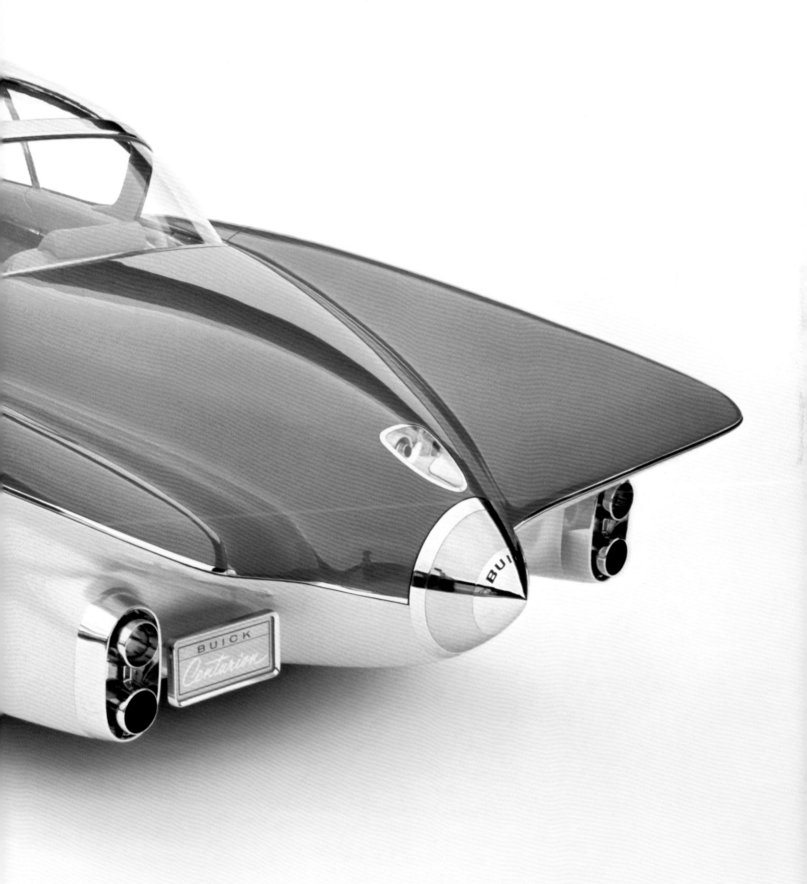

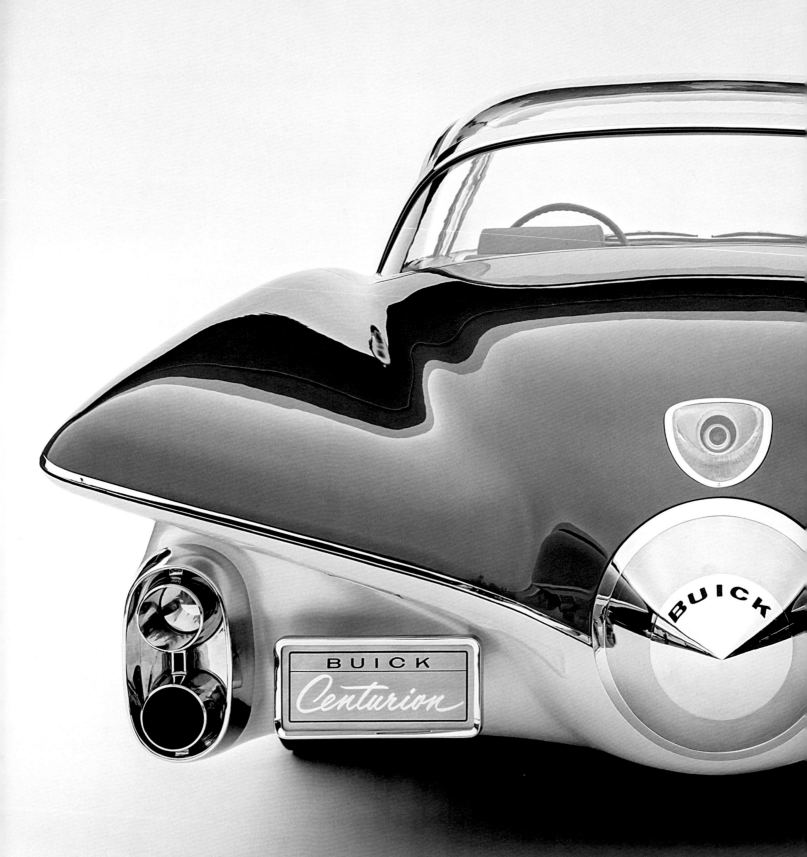

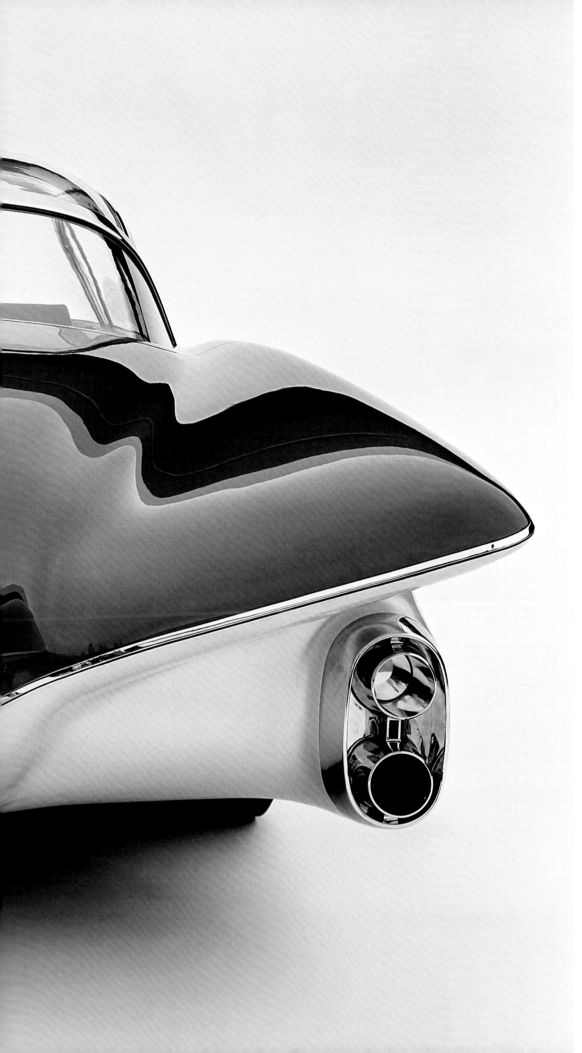

The Centurion's
futuristic design
included the first
prototype of a
backup camera.

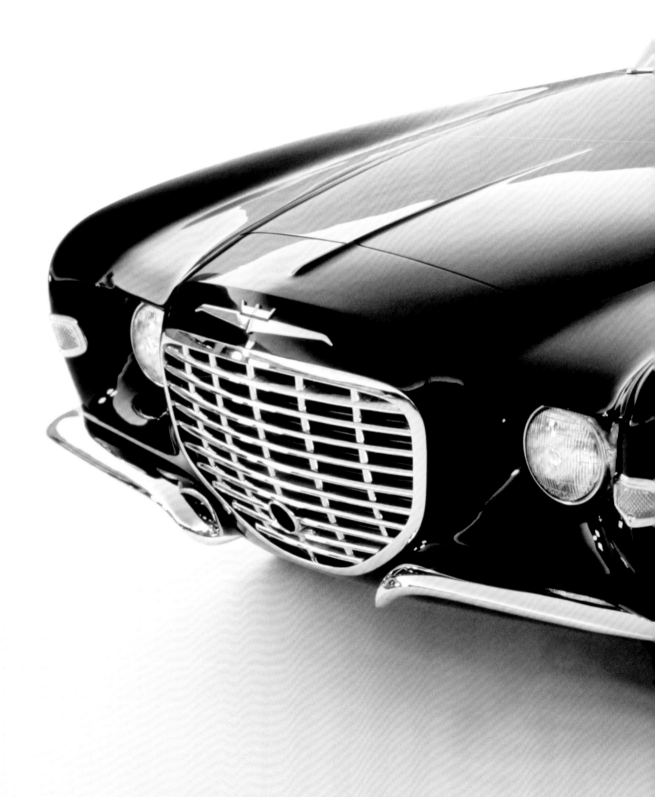

The '55 Chrysler
Falcon concept
car tempted
consumers with
race-track
elements such as
side exhausts.

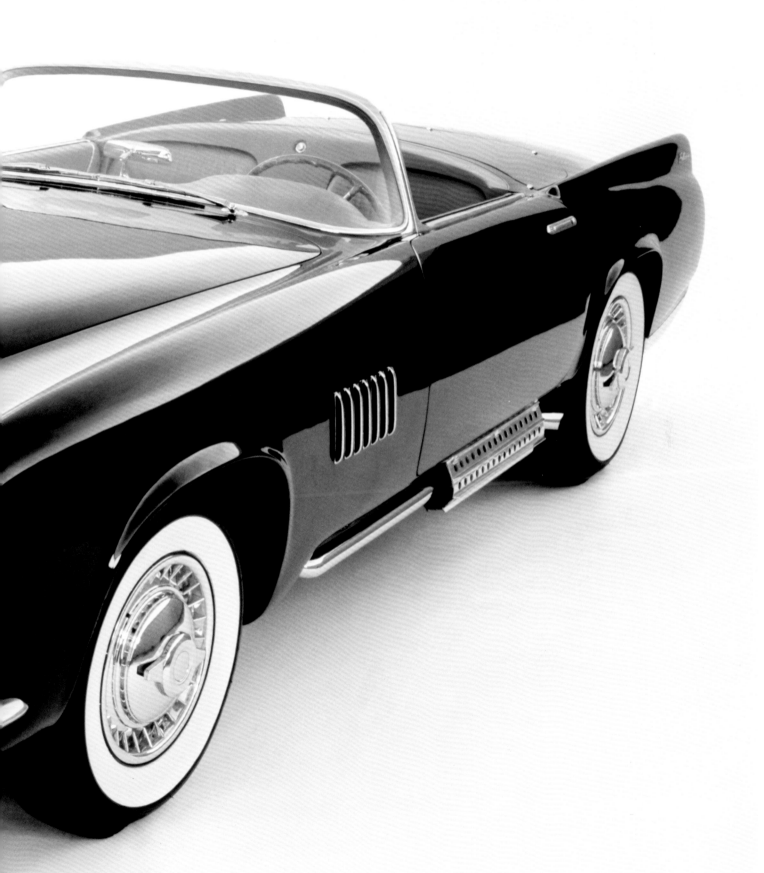

23

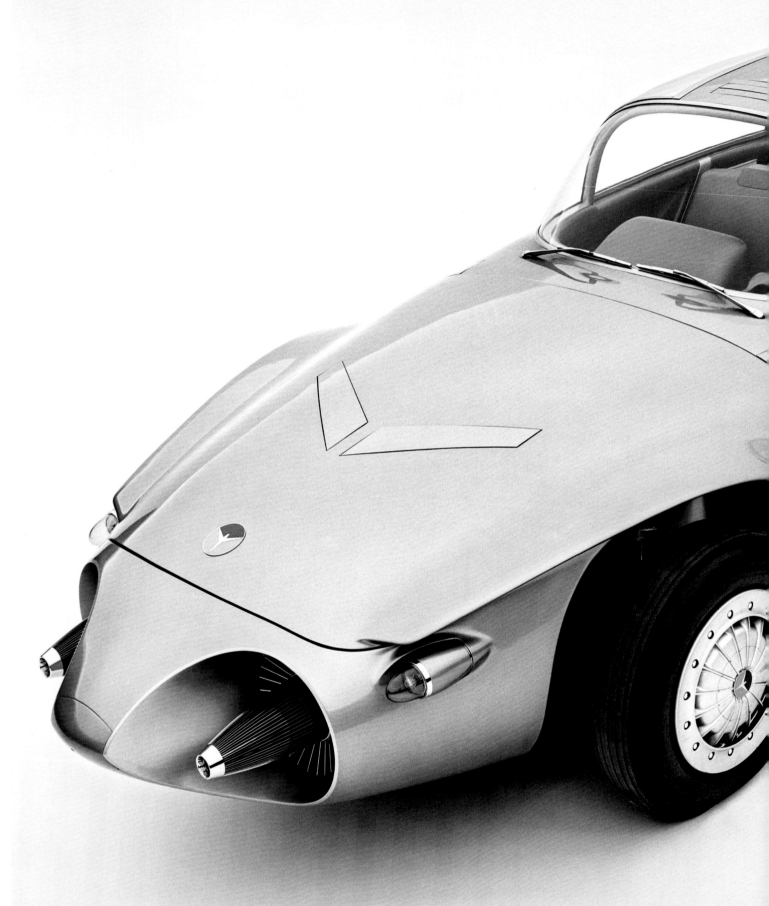

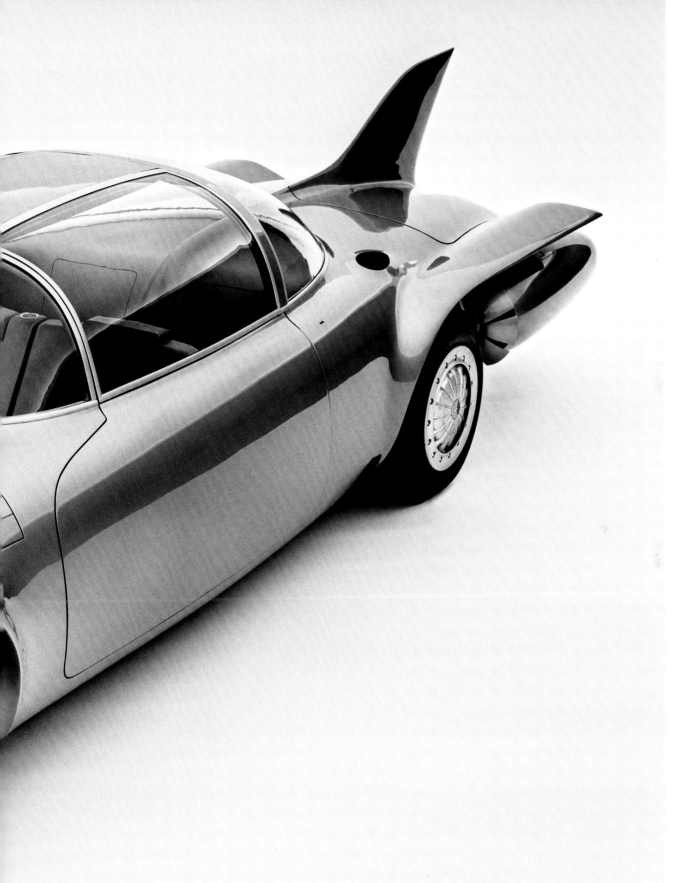

LEFT:
The GM Firebird II, conceived in 1956 as a family car with a gas turbine engine, also anticipated a future with autonomous driving.

FOLLOWING:
The Firebird II included kerosene fuel pods for an extra boost.

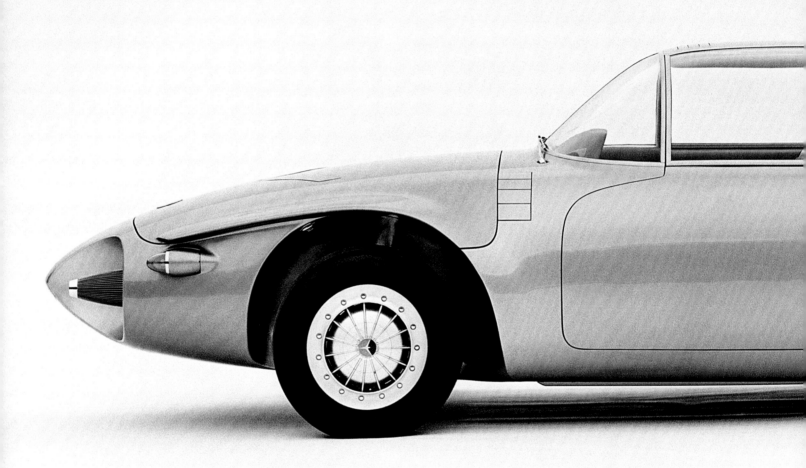

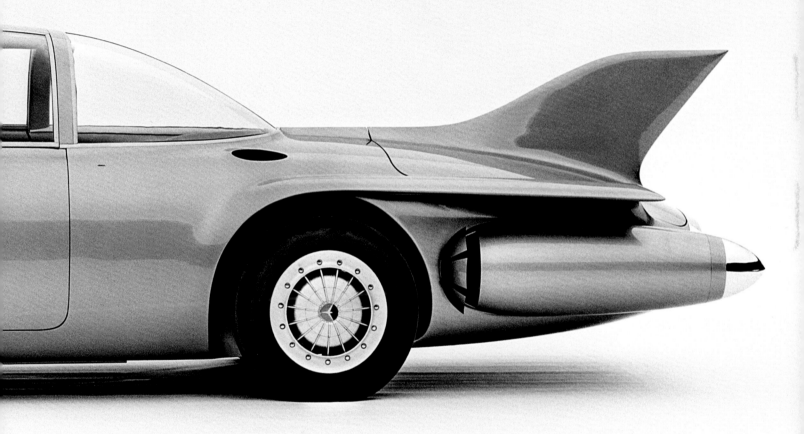

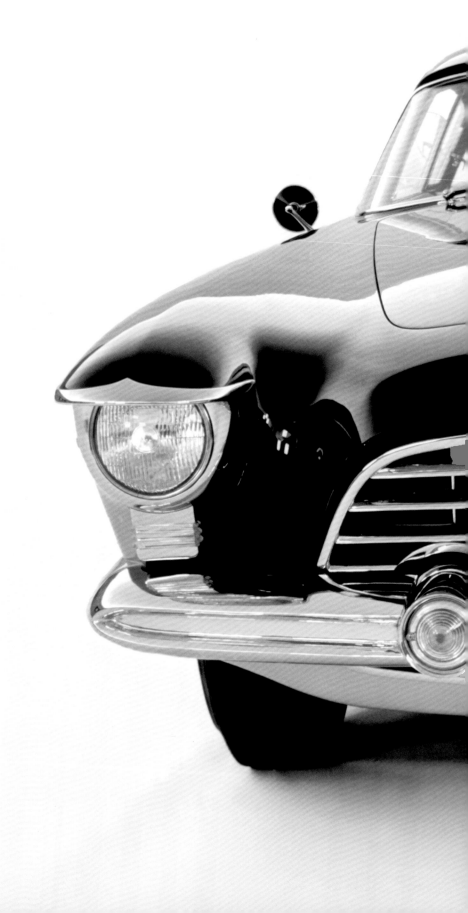

28 Intended to reduce drag, the swept-body curvature of the '55 Chrysler Flight Sweep ll inspired the concept car's name.

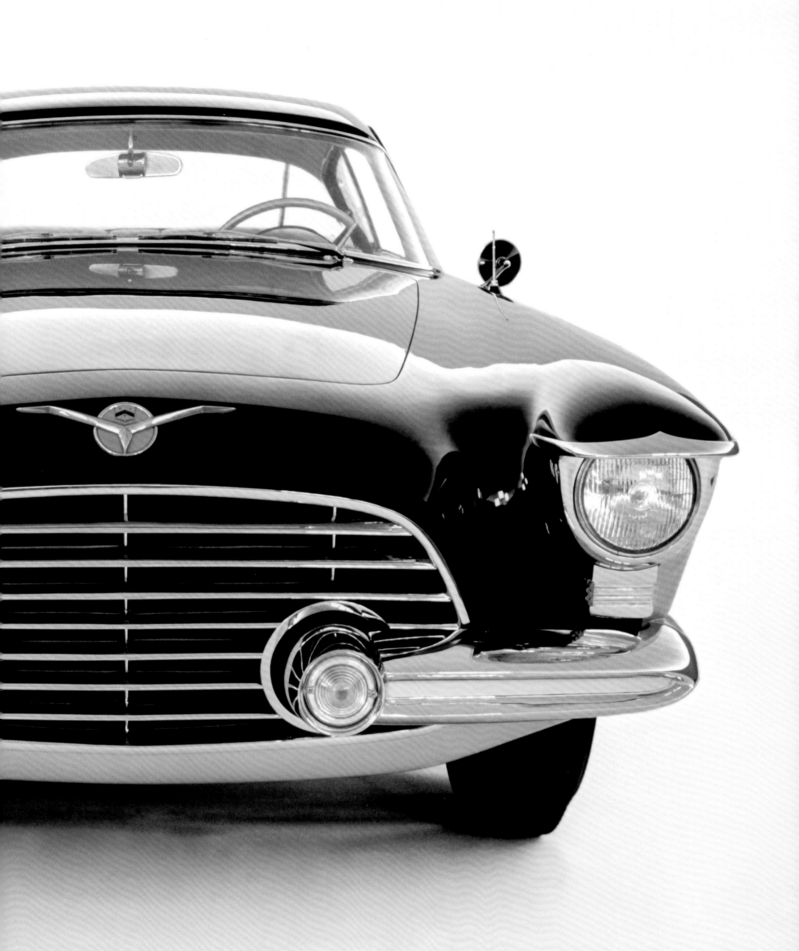

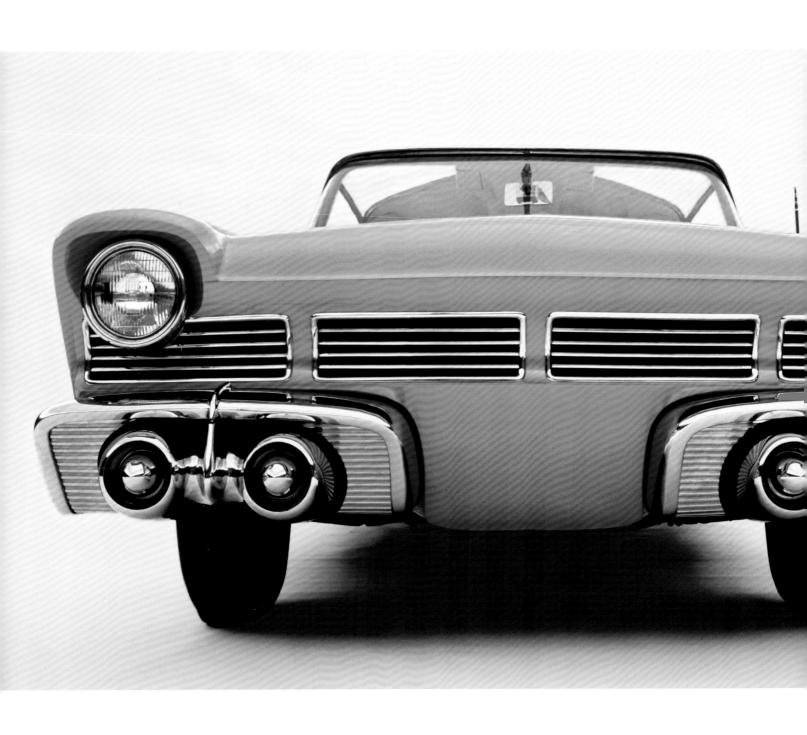

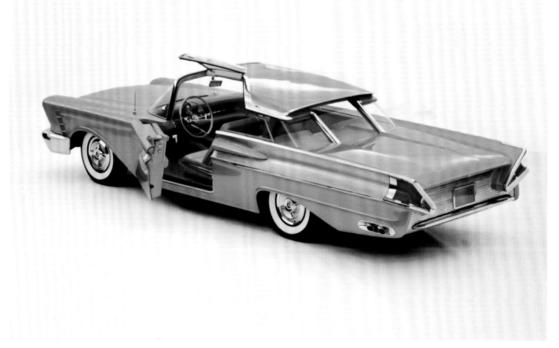

LEFT, ABOVE:
A '56 Mercury concept car, the XM-Turnpike Cruiser featured a "butterfly" top and wraparound windshield through which to take in the scenes from the highway.

FOLLOWING:
The cars shine on the Henry Ford Museum floor during the "Sports Cars in Review" show in Dearborn, Michigan, in 1956.

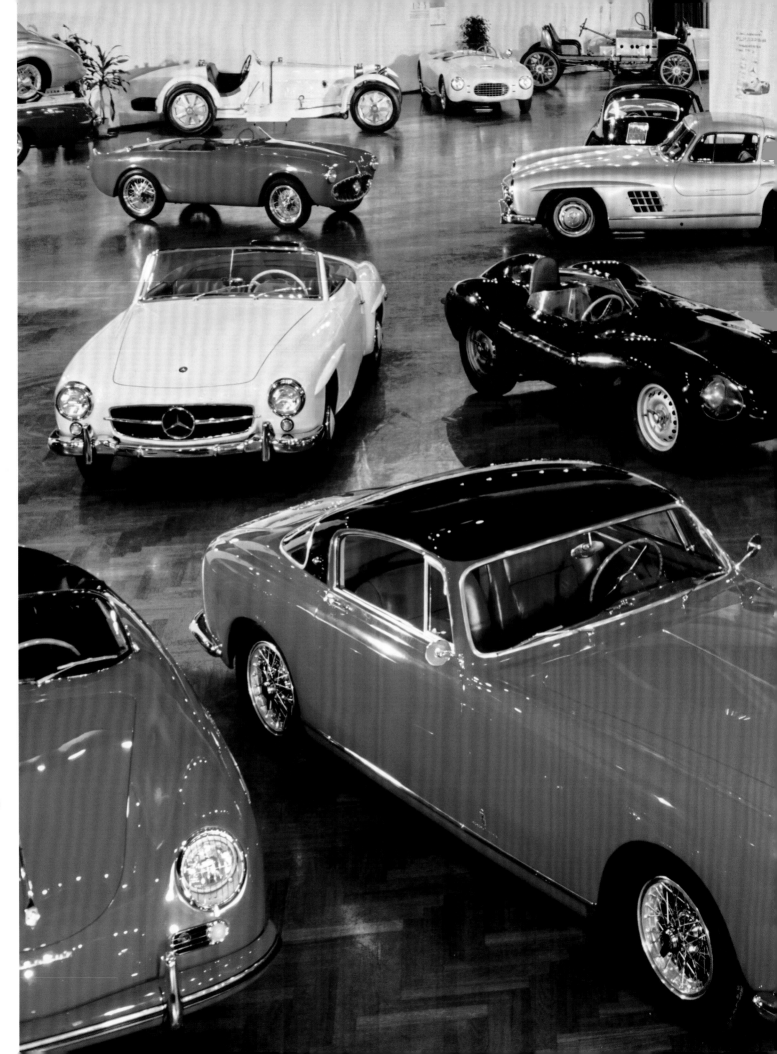

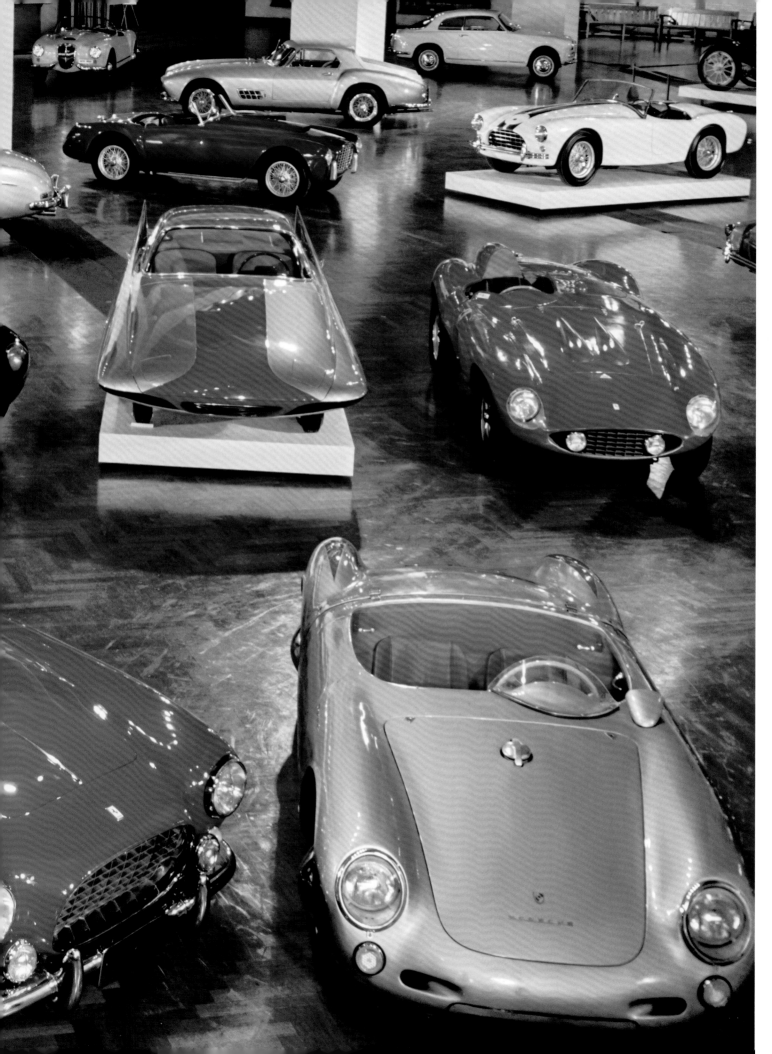

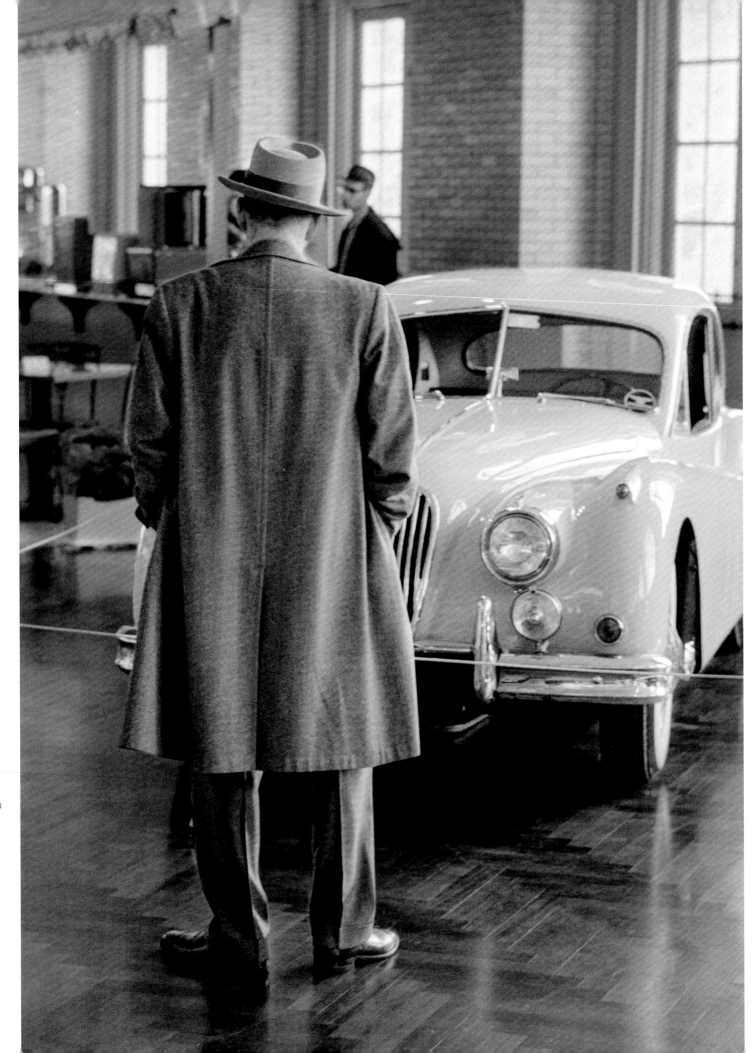

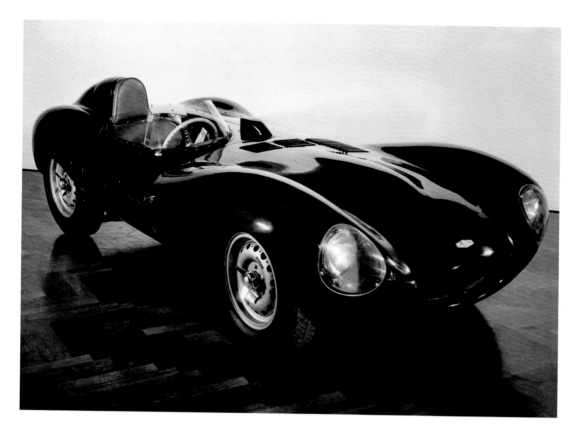

OPPOSITE:
One of the largest exhibitions of its time, the show brought together domestic and foreign cars (such as the Jaguar XK 140) on a scale previously unseen.

ABOVE:
'56 Jaguar D-Type.

RIGHT:
Mercedes-Benz 300 SL "Gullwing Coupe."

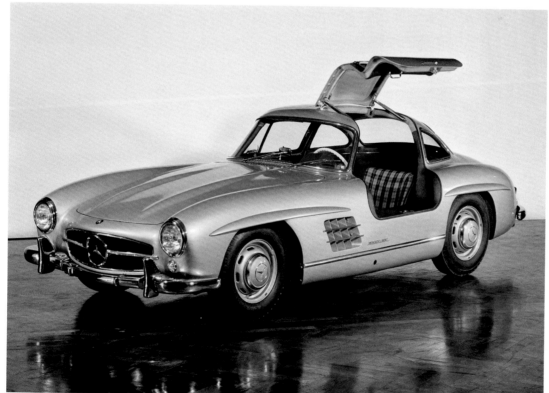

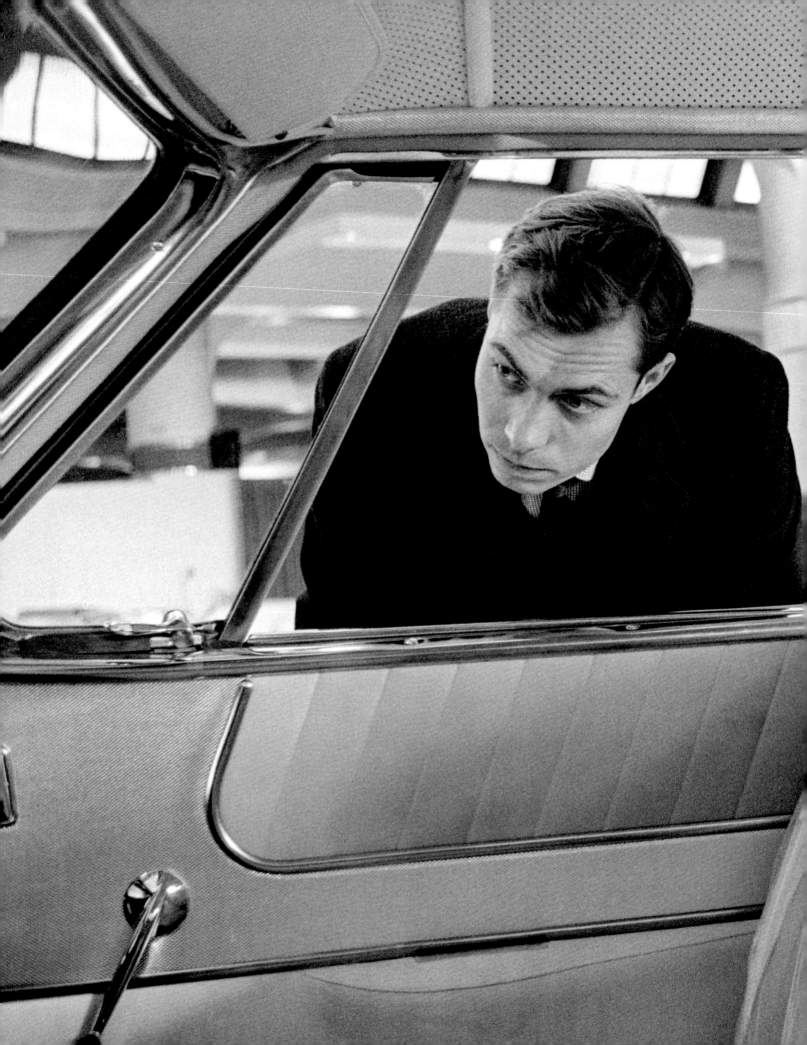

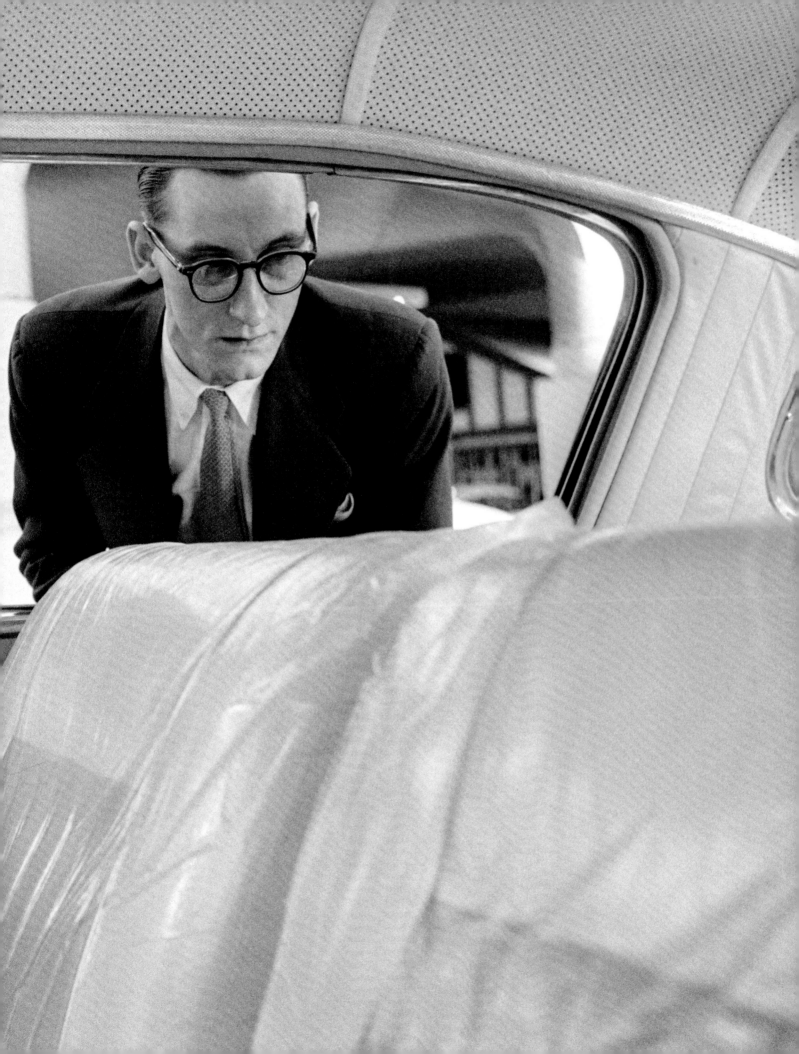

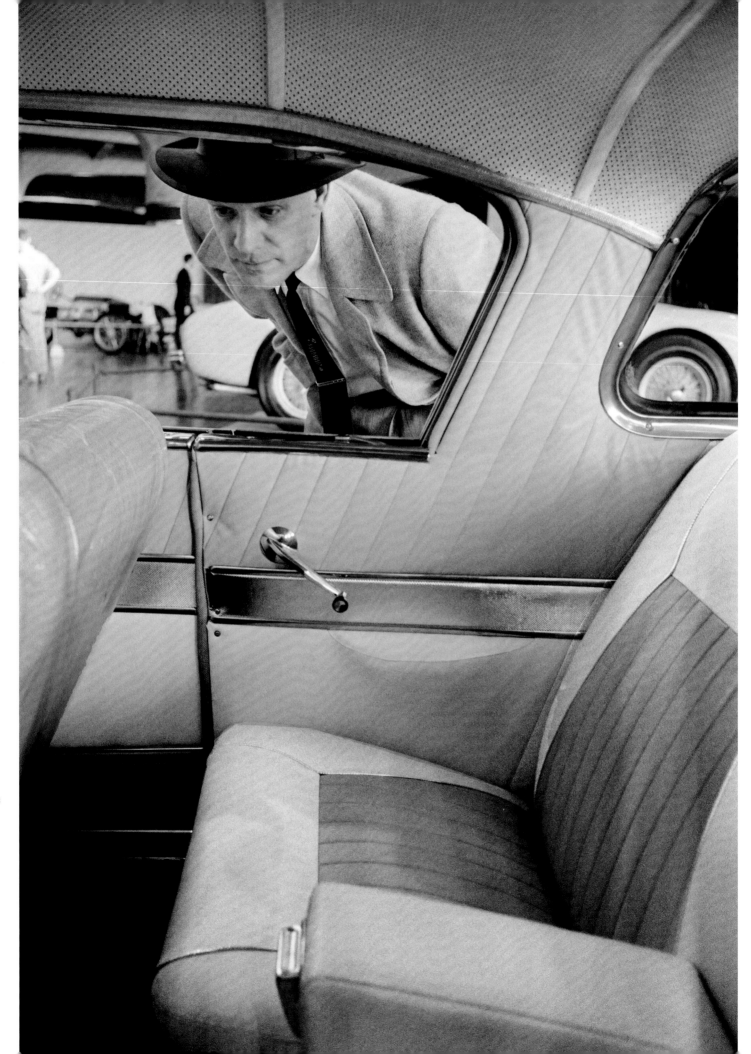

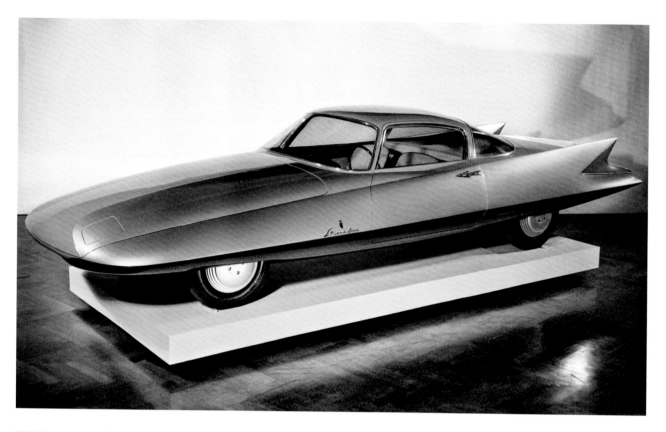

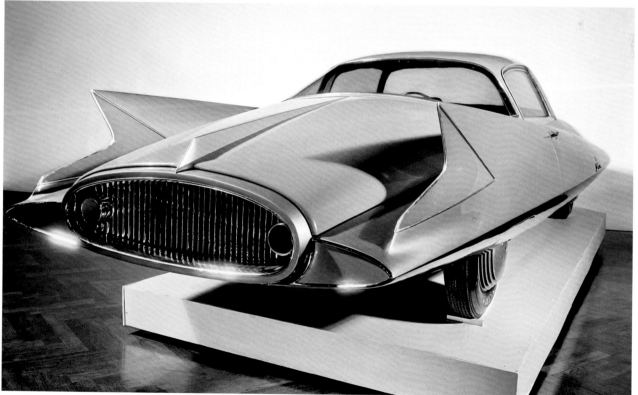

PREVIOUS, OPPOSITE:
The Golden Hawk
by Studebaker
captivated visitors
with its beautiful
interior.

ABOVE:
Built by the
Italian design firm
Ghia, the Gilda
enthralled with its
daring curves and
sleek tailfins.

Like this '55
Corvette, the
cars from the
1956 show both
intrigued and
delighted. Some
visitors even
took a hands-on
approach to
their admiration.

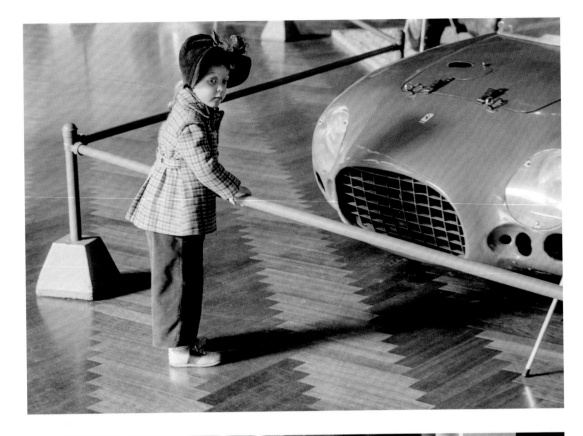

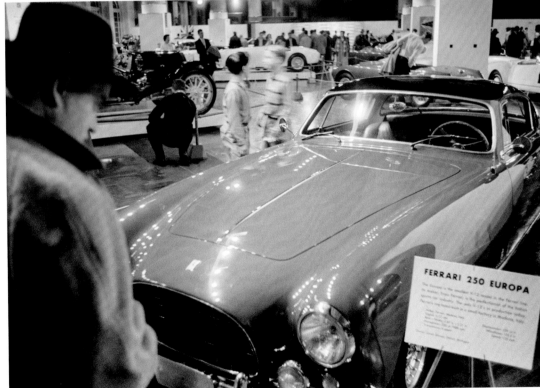

ABOVE:
Something
flashier than the
Ferrari Mexico
caught the atten-
tion of this young
spectator.

LEFT:
Ferrari 250 Europa.

OPPOSITE:
The 1913 Mercer
Raceabout is
a cause for
conversation.

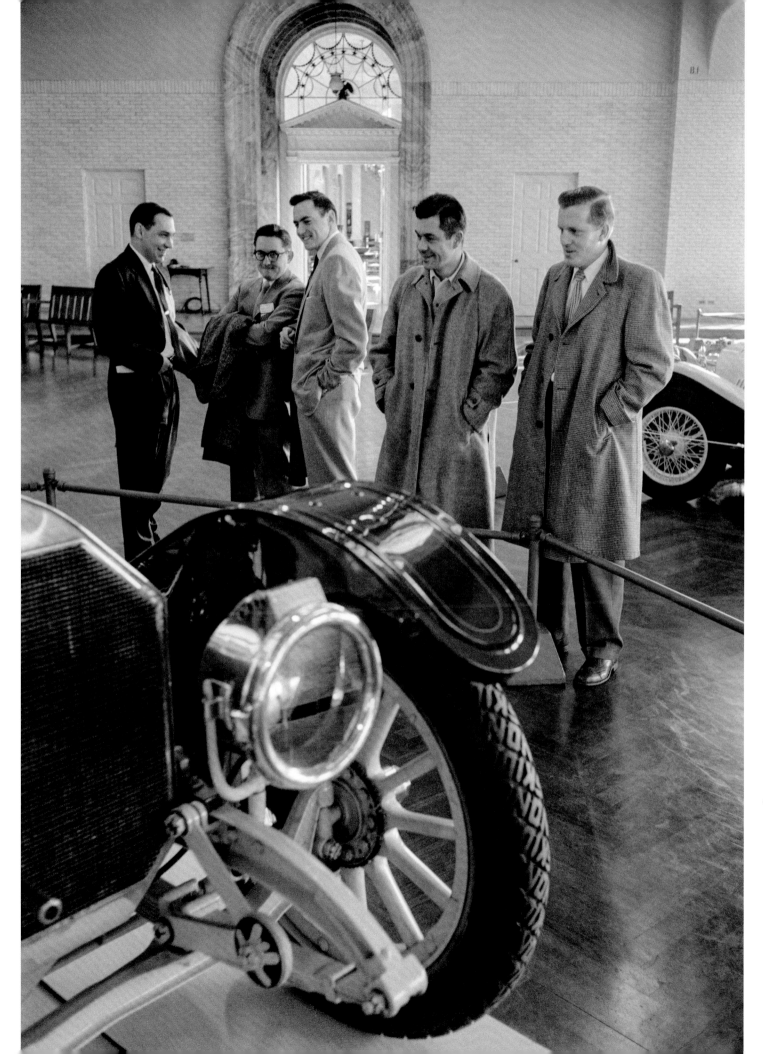

44 Simca Coupe
 de Ville.

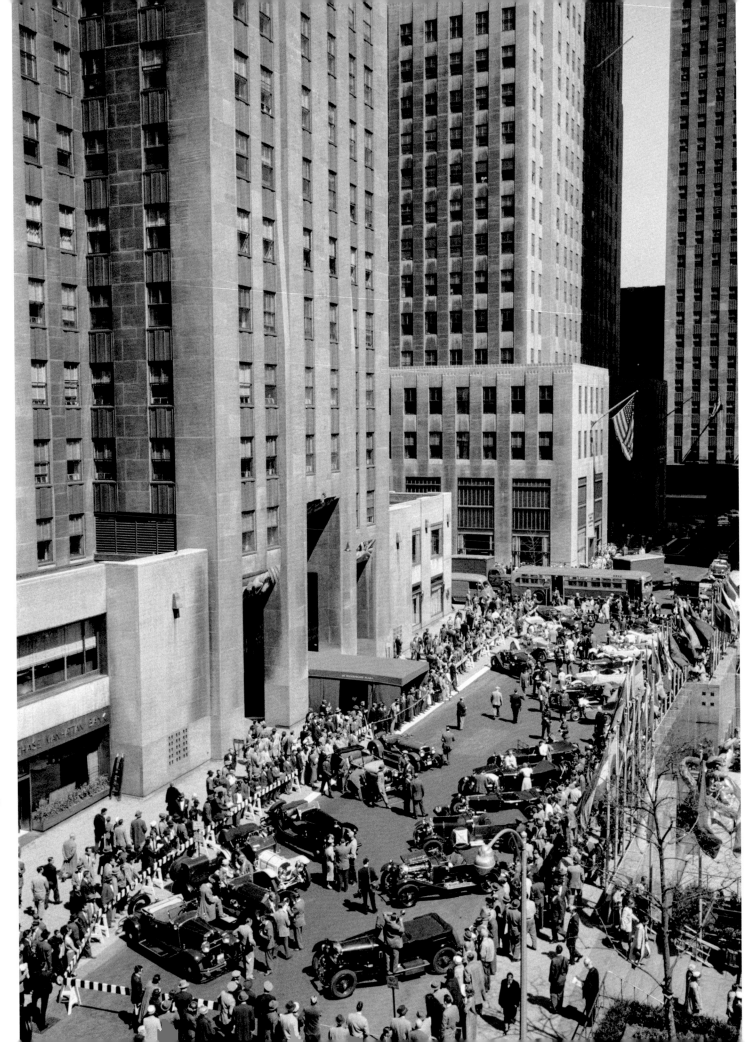

OPPOSITE:
The Second Anglo-American Vintage Car Rally would wind its way through the American Northeast in 1957. Crowds flock to see cars before their departure from Rockefeller Center.

RIGHT, TOP:
A young driver attempts to divert attention from a '13 Lanchester Thirty-Eight.

RIGHT, BOTTOM:
The '26 Bentley Red Label Three-Litre is prepped for the rally.

FOLLOWING:
A judge ensures that an engine meets the exacting standards of the 1957 rally.

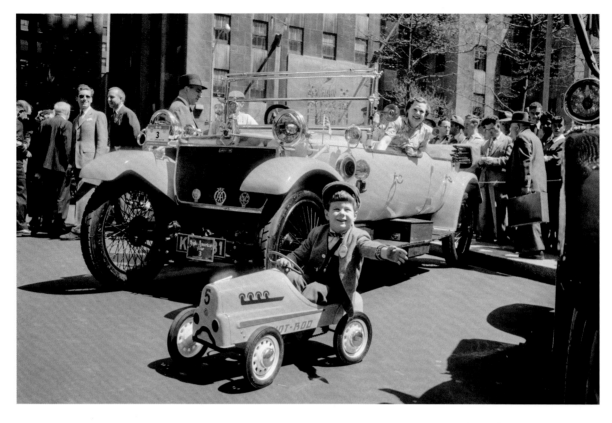

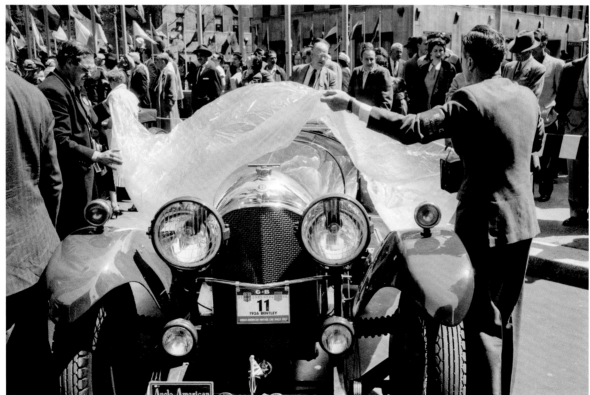

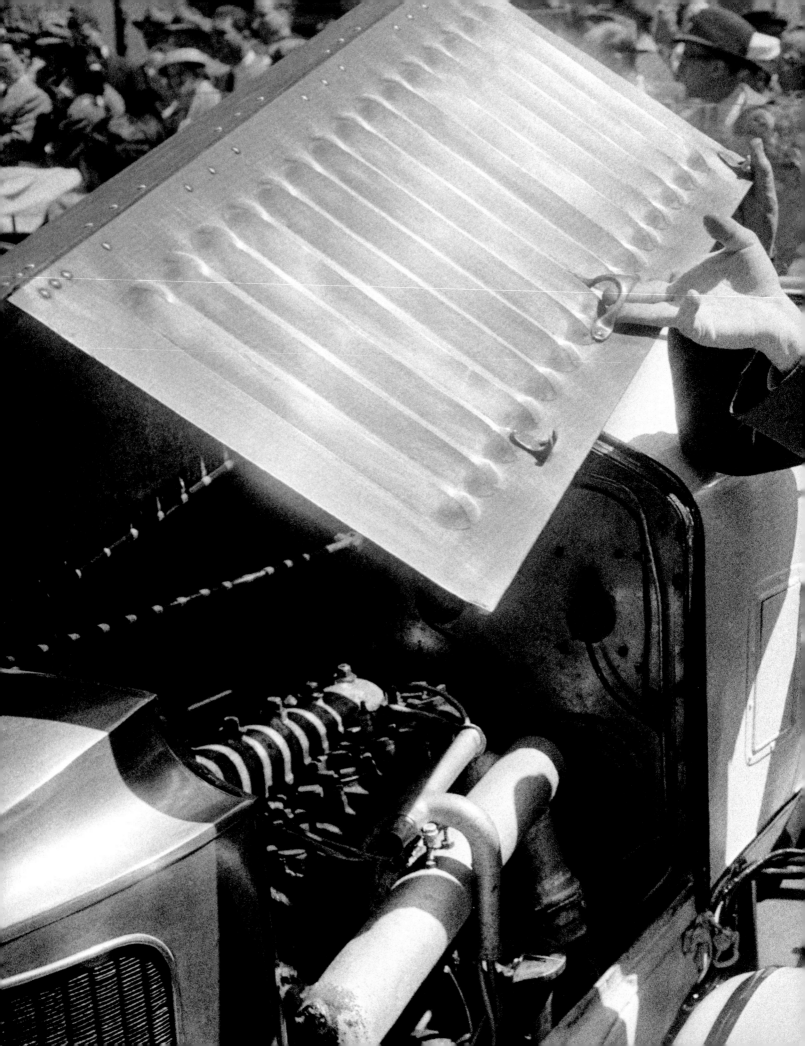

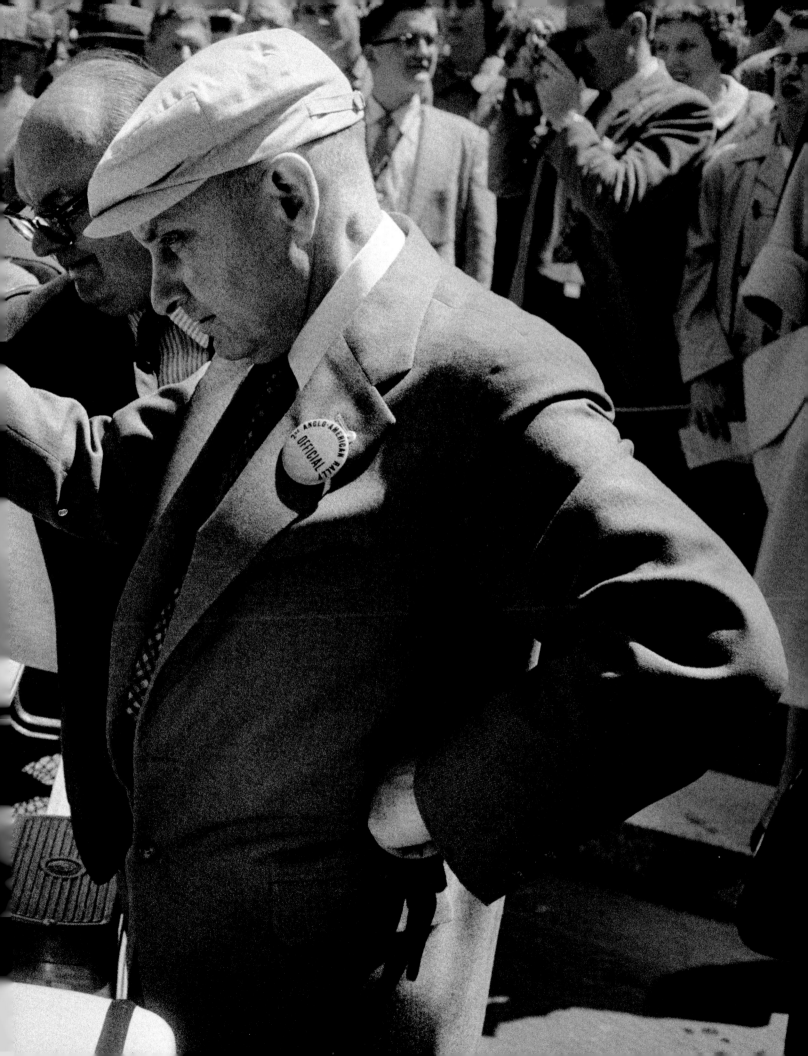

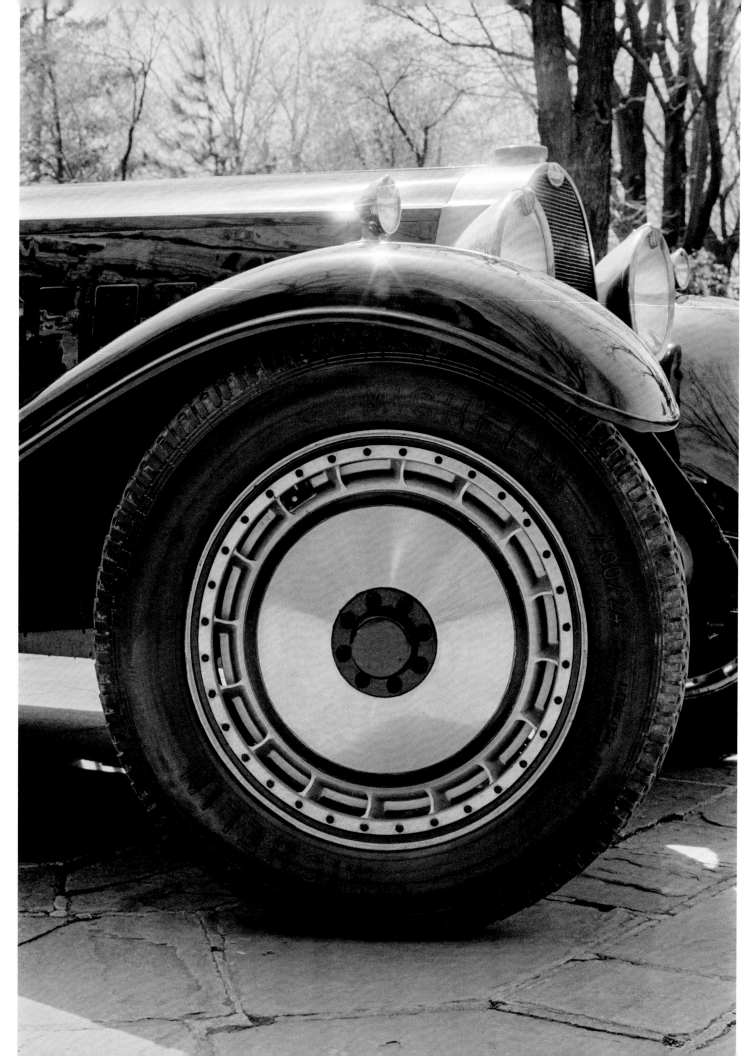

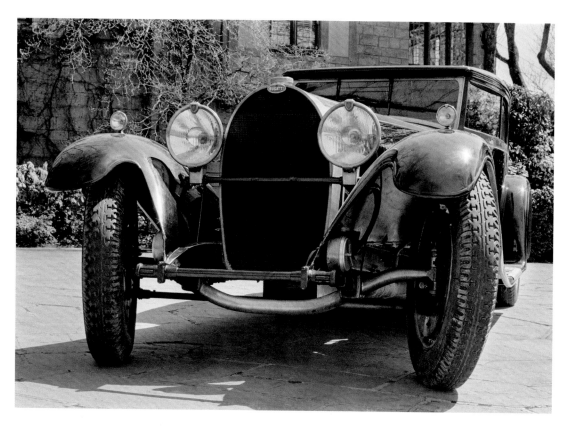

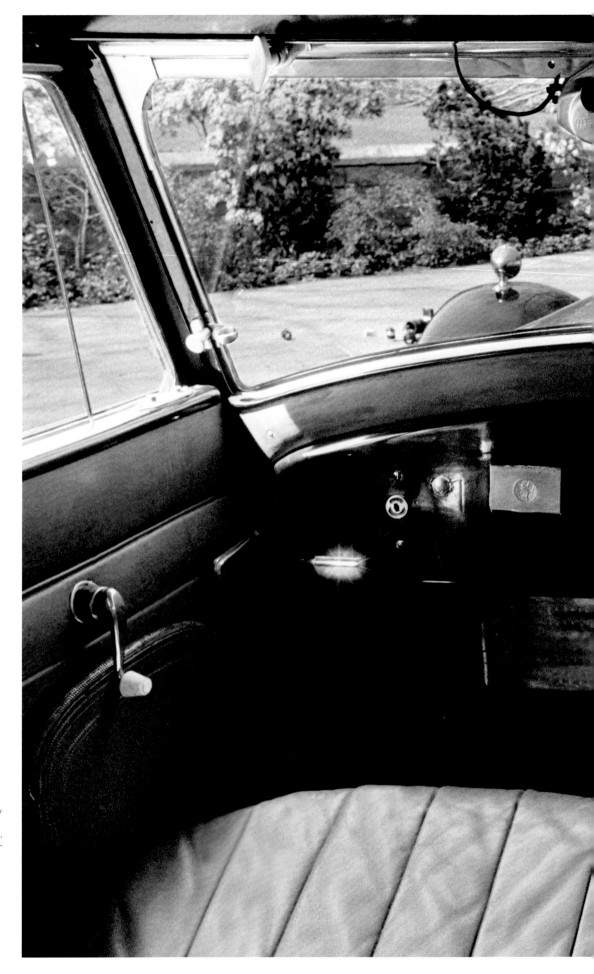

52 **PREVIOUS, RIGHT:** The Bugatti Royale is one of the rarest automobiles in the world. Only seven were built—just six remain—and each has a story. Pictured here is the Type 41 (as it is officially called) of Connecticut sportsman Briggs Cunningham at his Greens Farms estate in 1962. The Bugatti family sold the fifth one (chassis no. 41141, known as the Kellner car) directly to Cunningham for cash and two refrigerators.

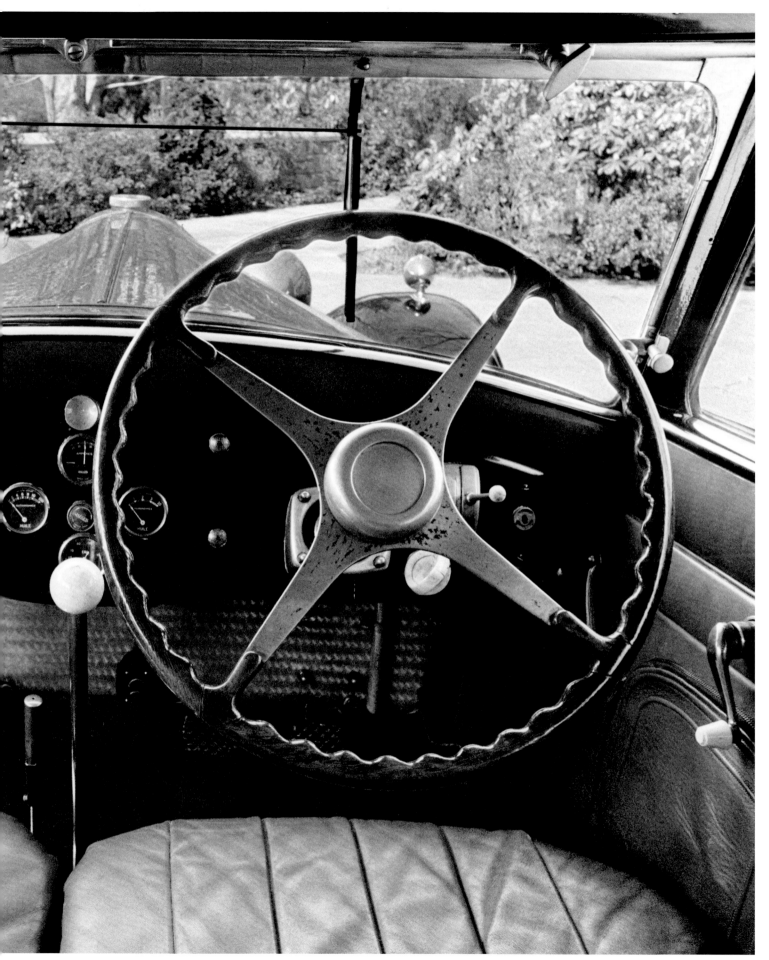

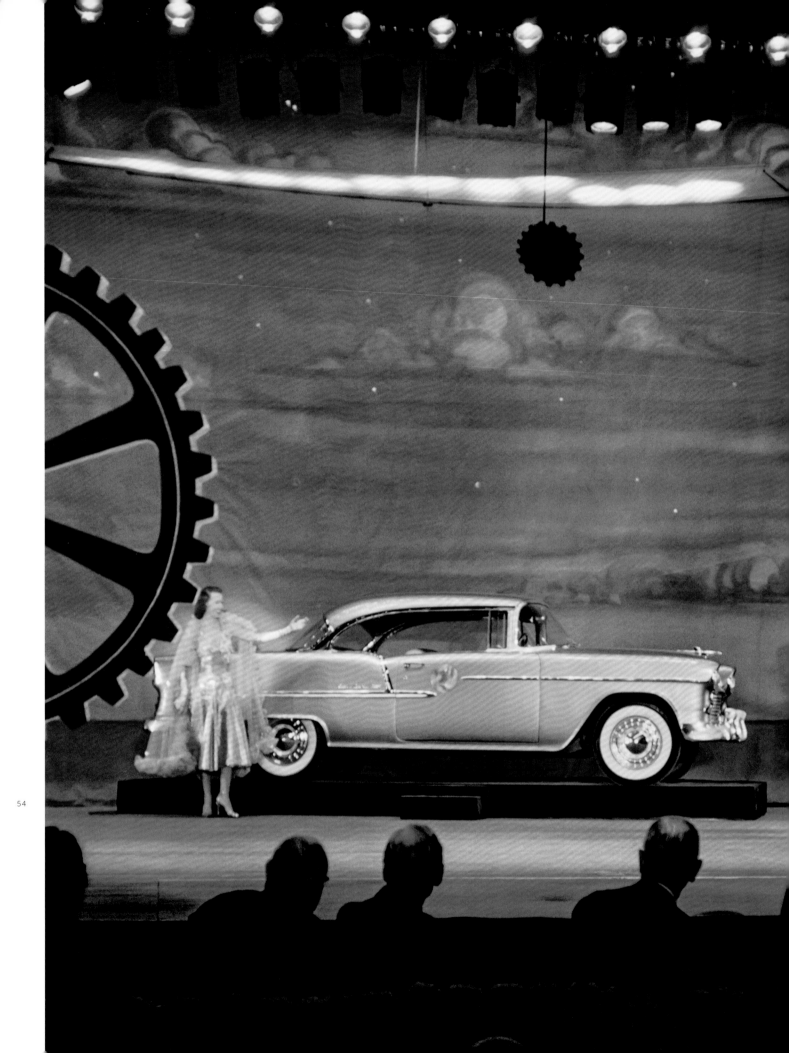

DESIGN

DESIGN

AUTOMOBILE DESIGNERS WERE
artists, and automobile
manufacturing was becoming
the largest industry segment
in the country and the largest
ever created. By 1960, one
in six working Americans
would be employed directly
or indirectly by the industry.
Assembly line innovation
brought prices down, and
ambitious design teams
from Ford to General Motors
competed for success
with an anything-goes spirit
that lit up with more than
just an innovative use of
strobe lighting.

—T.M.

PREVIOUS:
A gold-plated
'55 Chevrolet Bel
Air Sport Coupe
represents the
50 millionth car
produced by GM
on November 23,
1954.

OPPOSITE:
In 1966, a Ford
engineer calcu-
lates a change in
procedure for the
following year's
Mustang model.

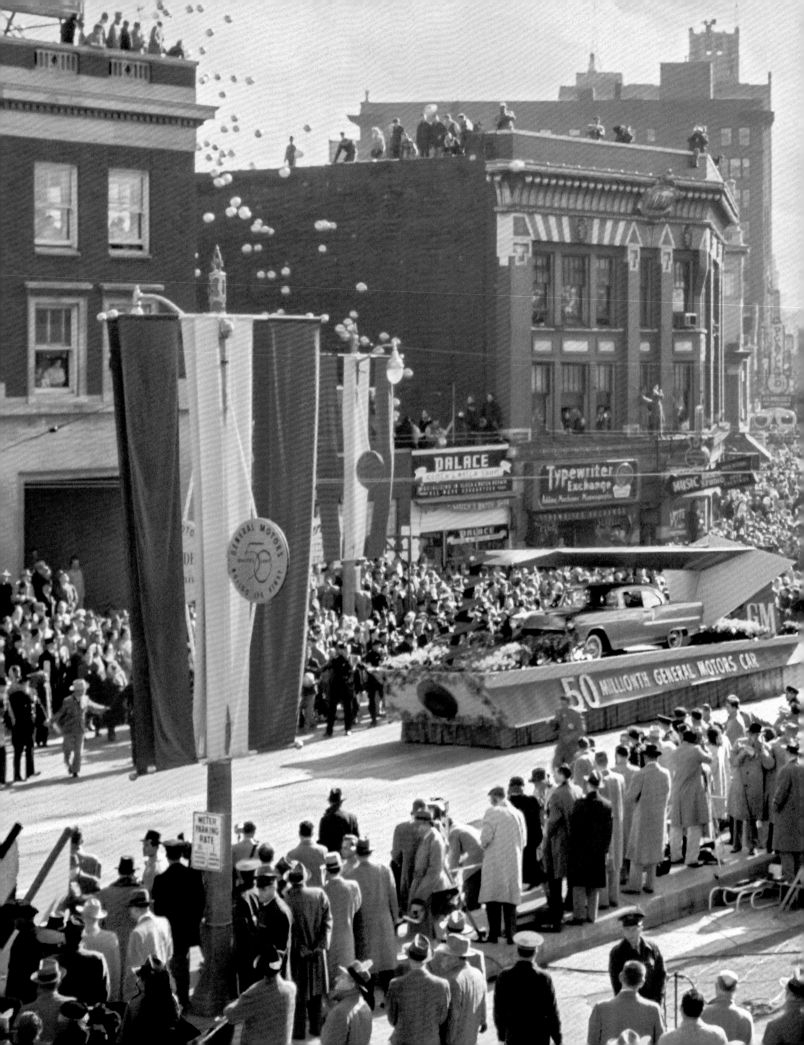

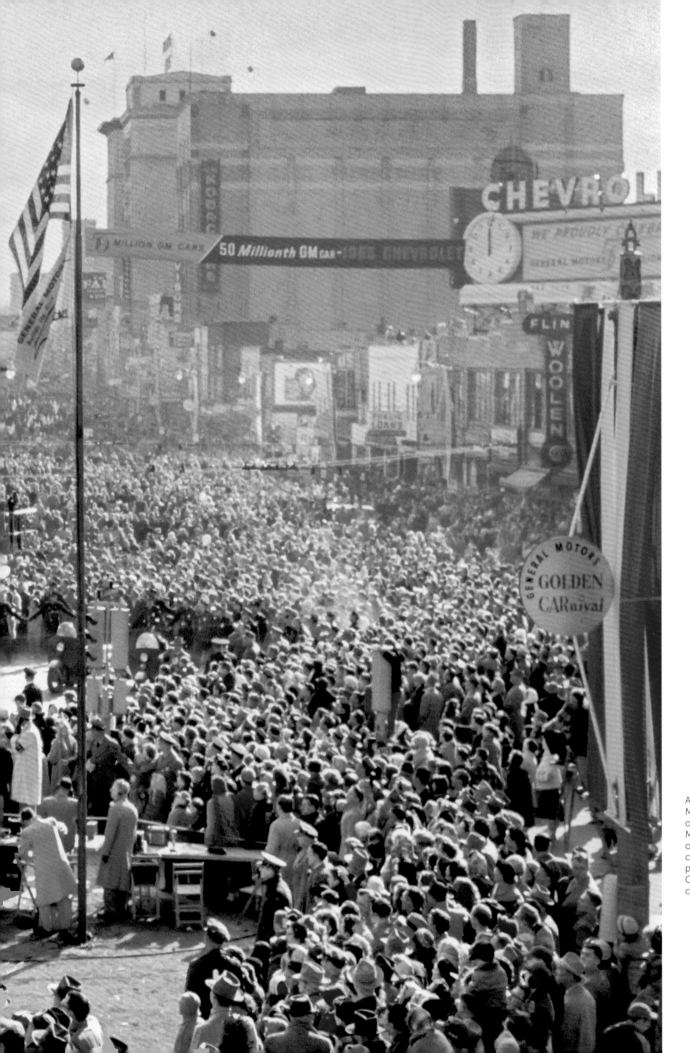

All of Flint, Michigan—home of General Motors—turns out for the parade celebrating the production of GM's 50 millionth car in 1954.

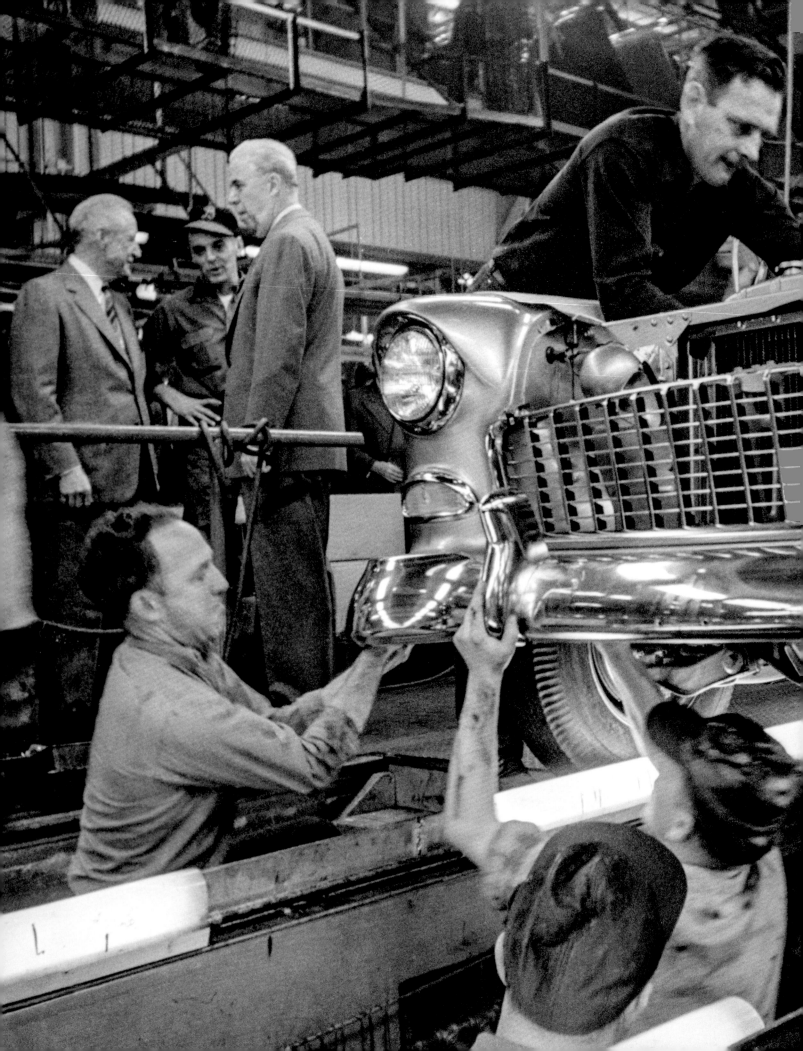

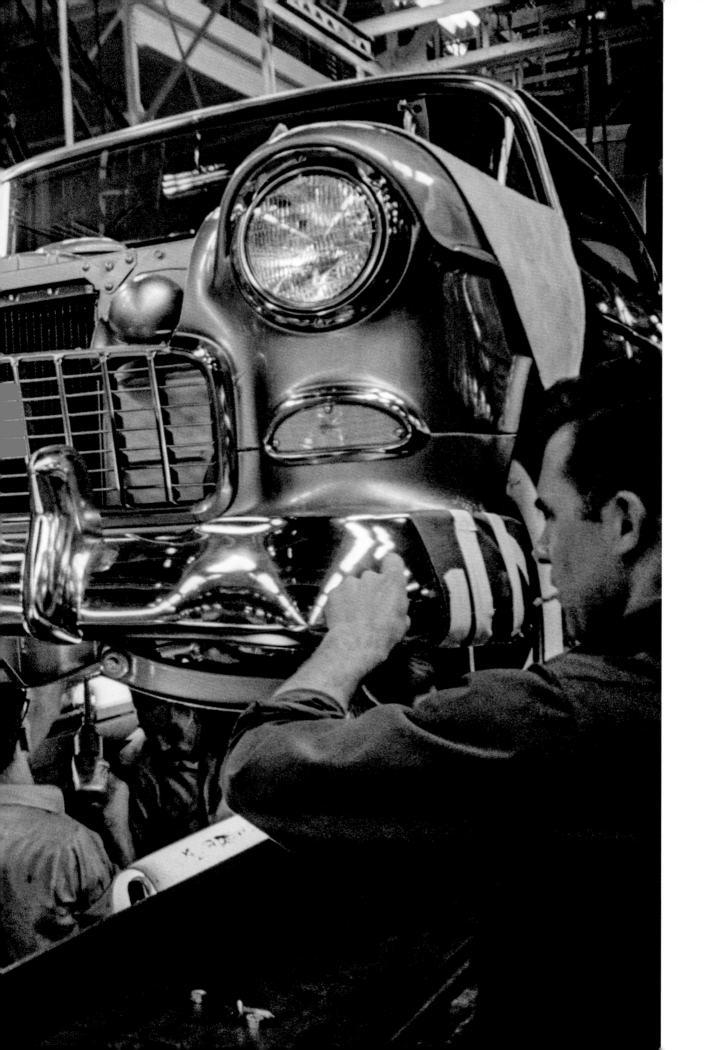

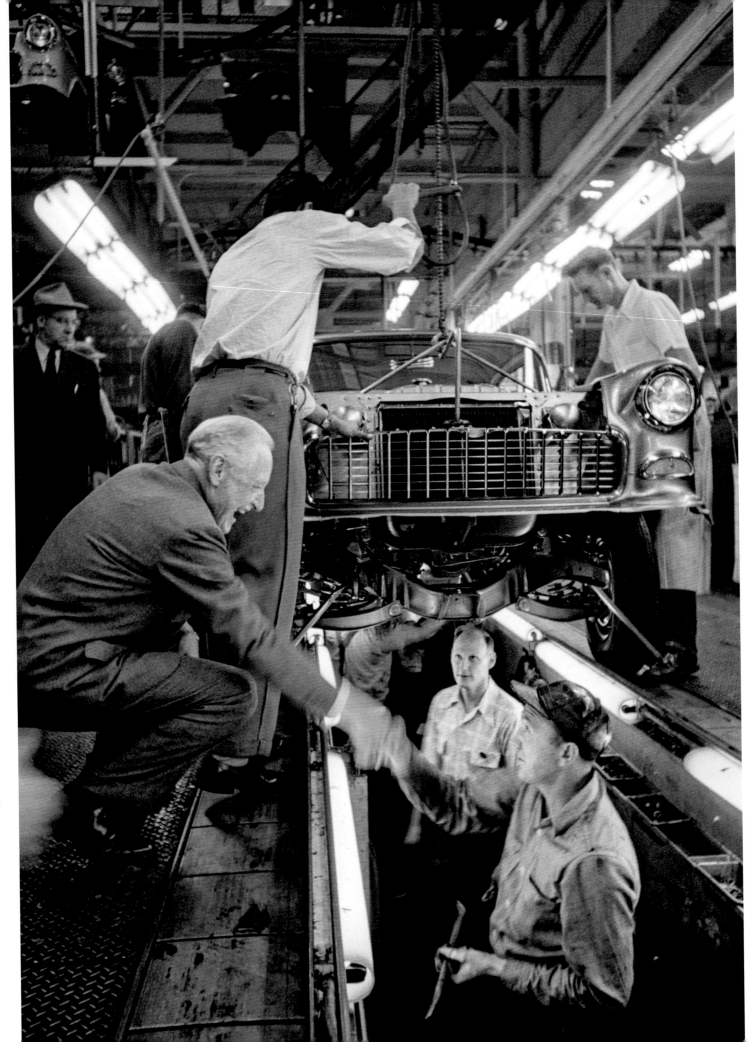

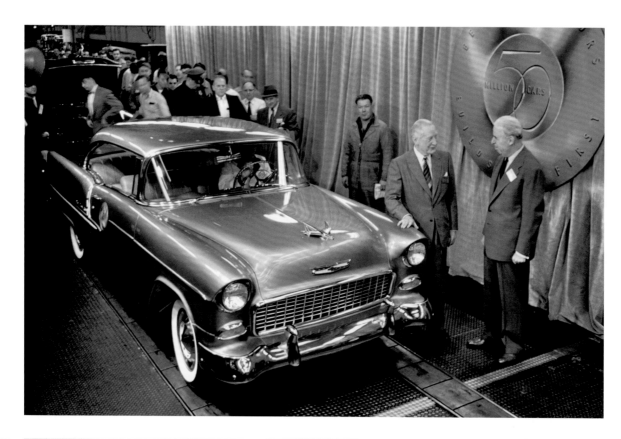

PREVIOUS, OPPOSITE:
As factory workers apply the finishing touches to the golden car, GM president Harlow Curtice gladhands.

RIGHT:
Chevrolet general manager Thomas Keating chats with Curtice as the 50 millionth GM rolls off the line. Parade-goers swoon at the spectacle.

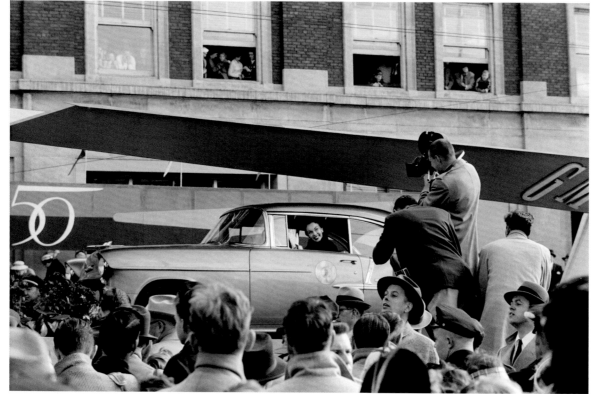

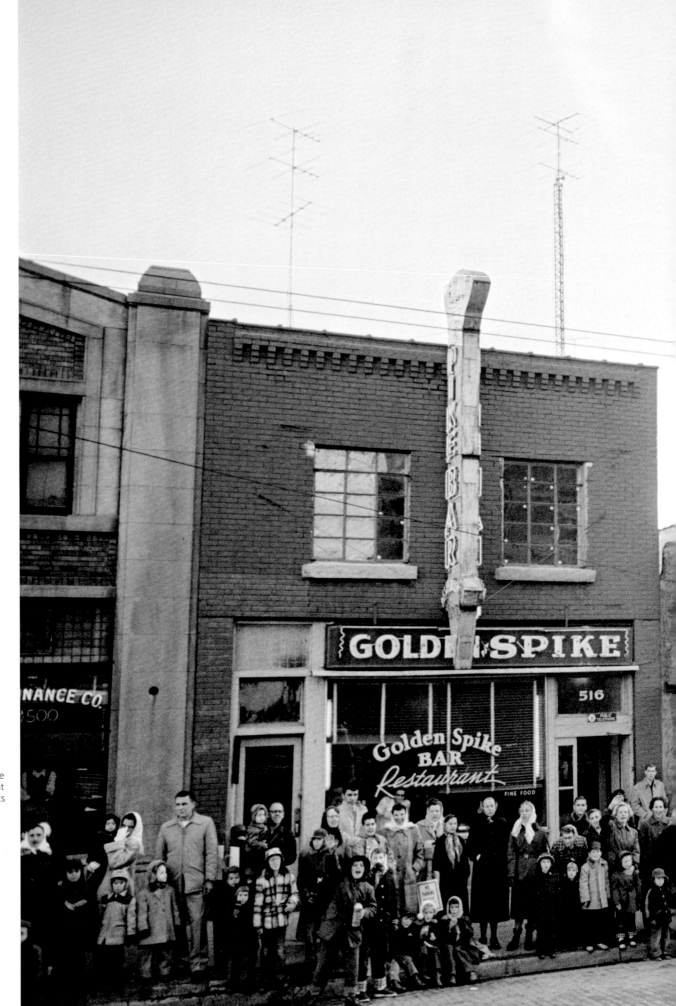

64 Parade-goers line the streets of Flint (and spill out of its bars).

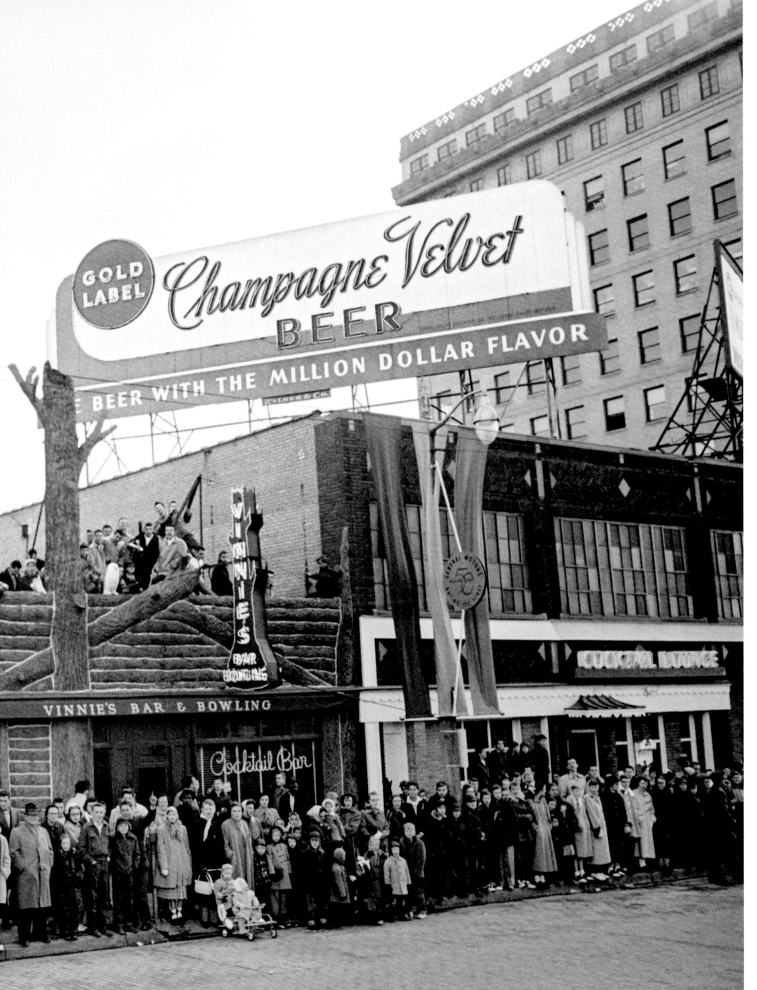

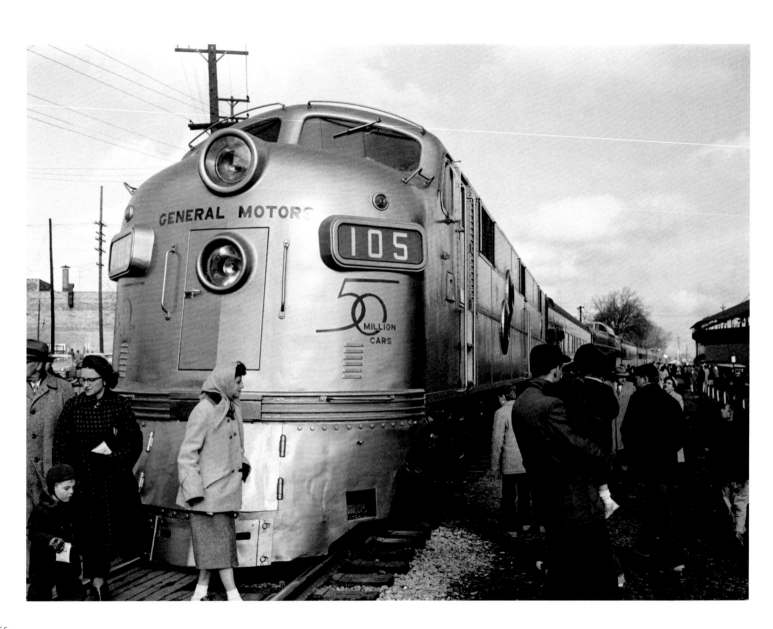

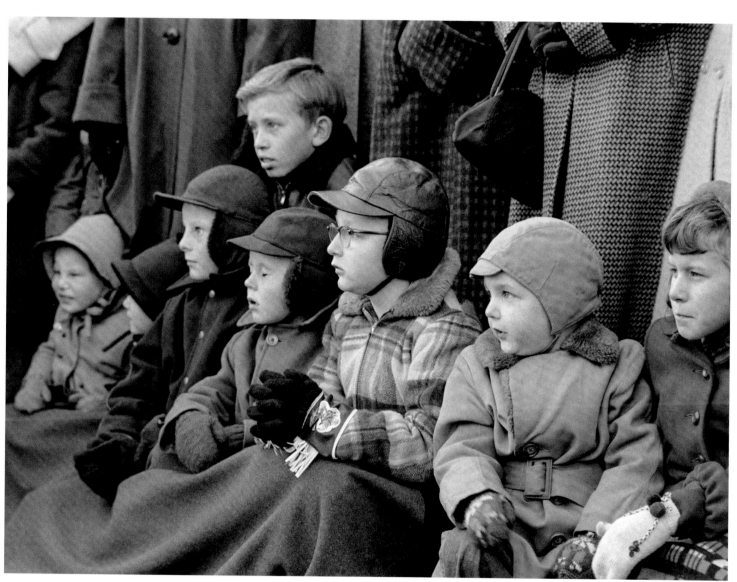

OPPOSITE, ABOVE: The golden car was not only a cause for celebration for GM and Flint, but also a symbol of the industrial might of postwar America.

Here, a gold-painted train engine transports parade attendees, while children enjoy a chilly day off from school.

FOLLOWING: Harlow Curtice and the promotional power of GM were larger than life in 1954.

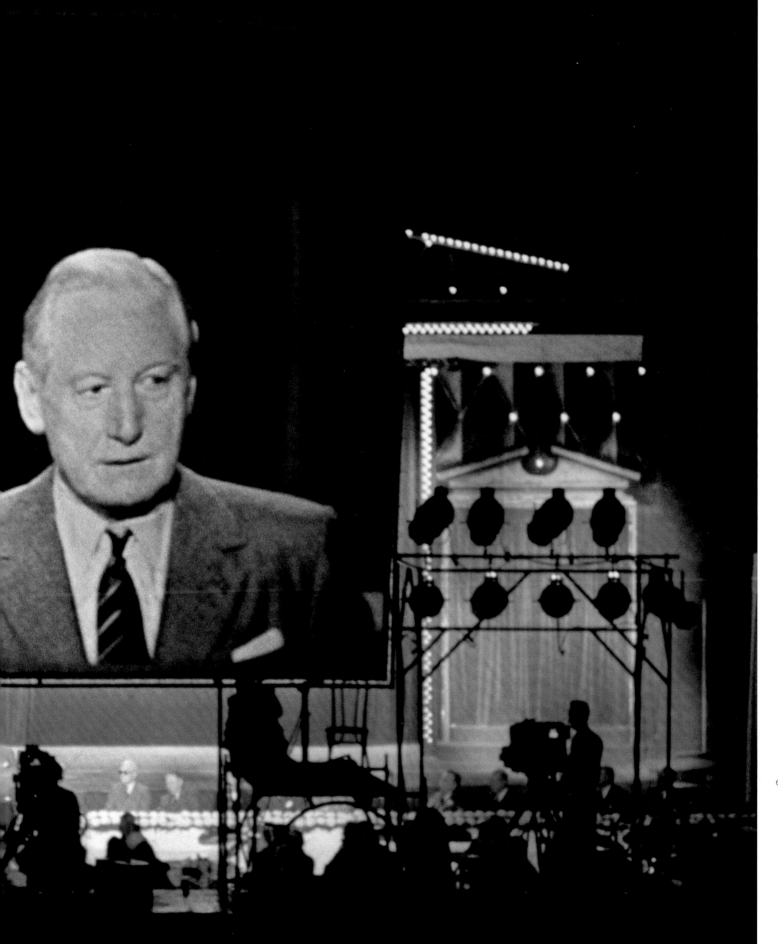

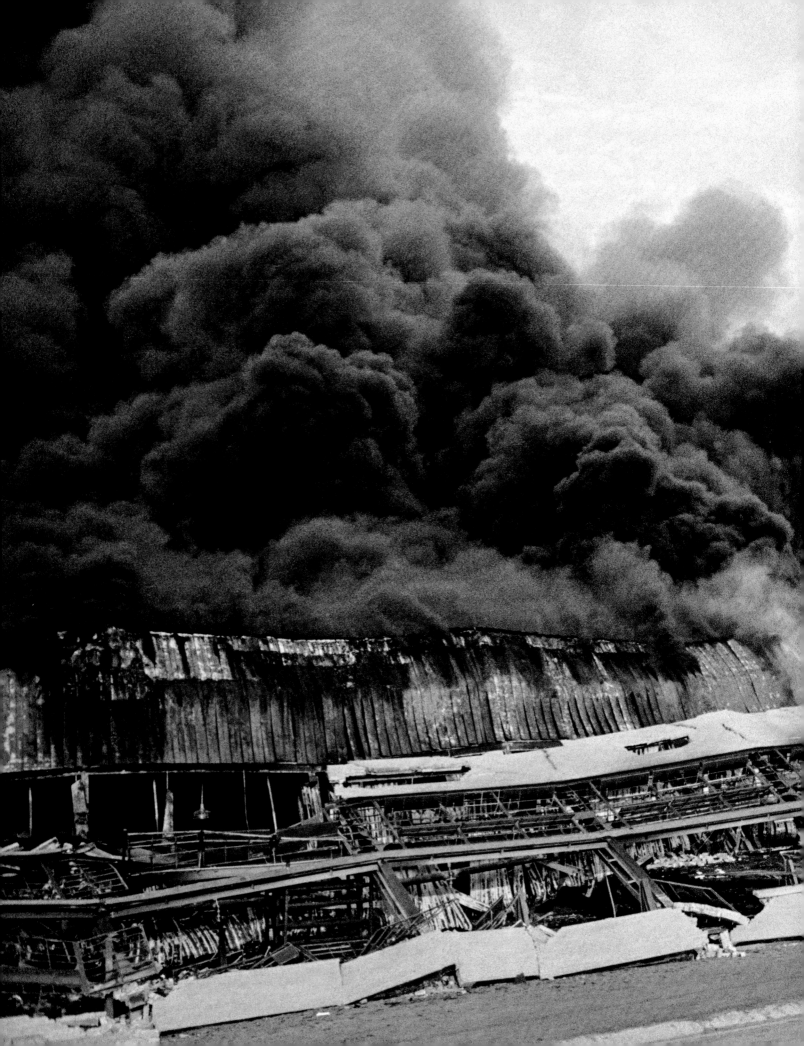

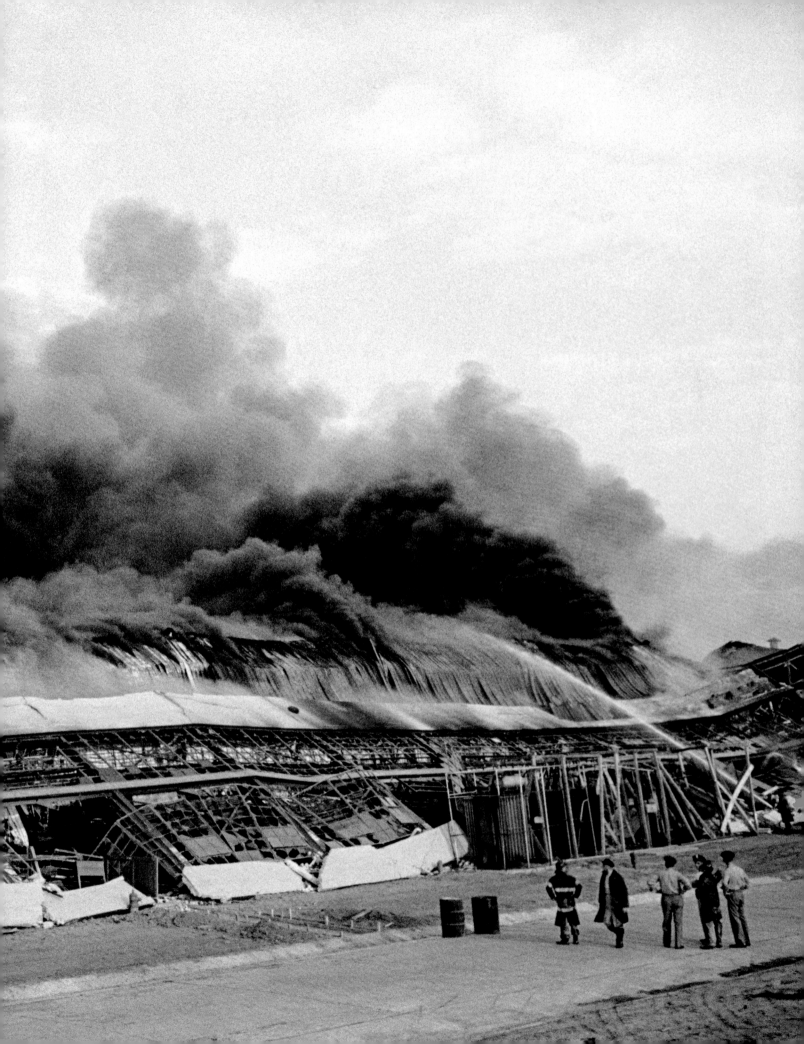

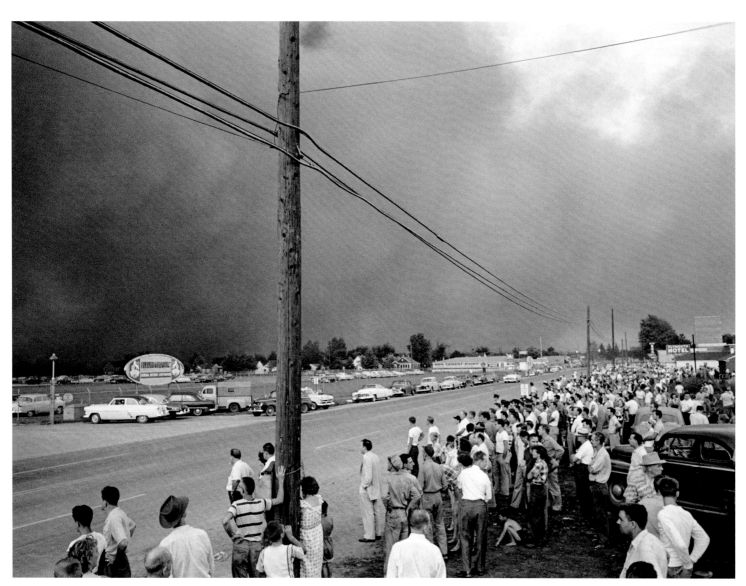

PREVIOUS:
The 1953 Hydra-
Matic plant
inferno, which
was sparked by
a construction
worker's torch,
was the largest
industrial fire in
the United States
at that time.

OPPOSITE, ABOVE:
People gather
to witness GM's
state-of-the-art
transmission
plant smolder, as
smoke darkens
the sky over
Livonia, Michigan.

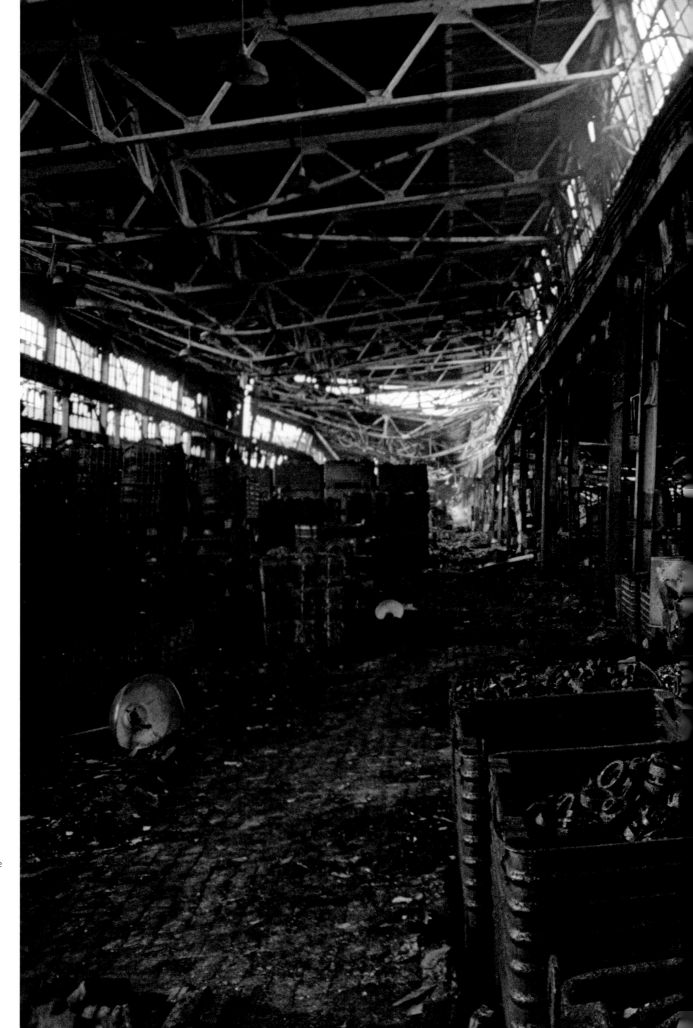

74 Fire officials inspect the ruins that resulted in six deaths and stymied GM's production of automatic transmissions. Despite the tragedy, the company rallied to produce its 50 millionth car a year later.

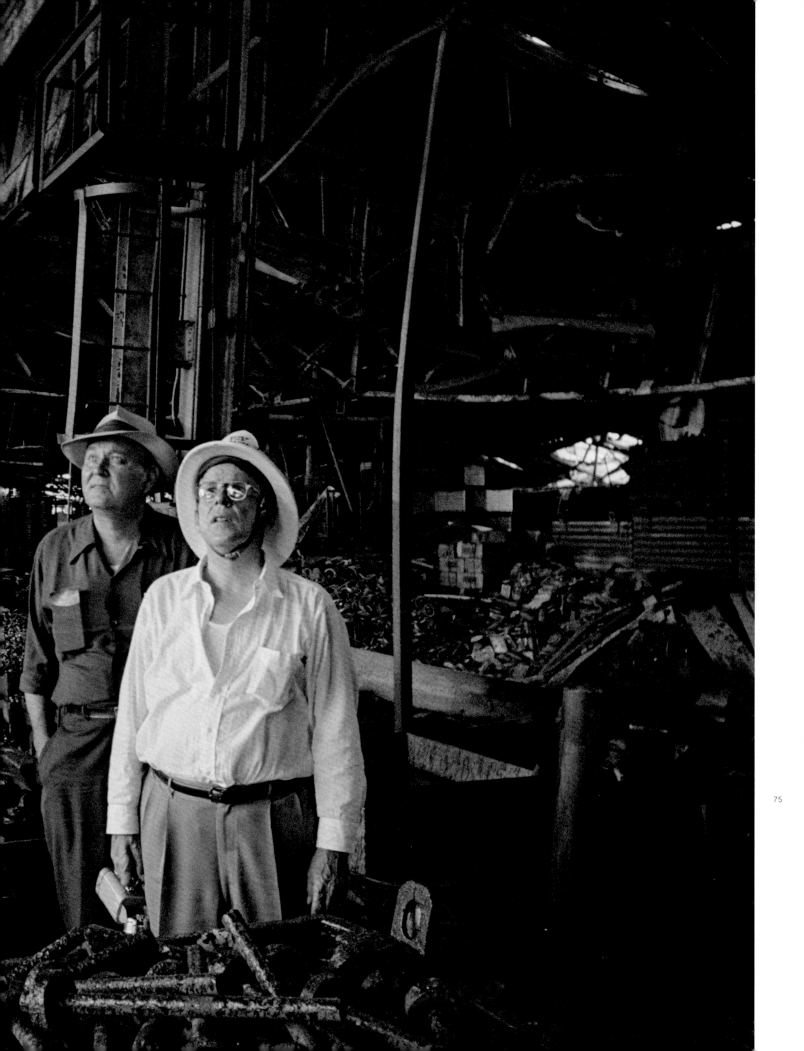

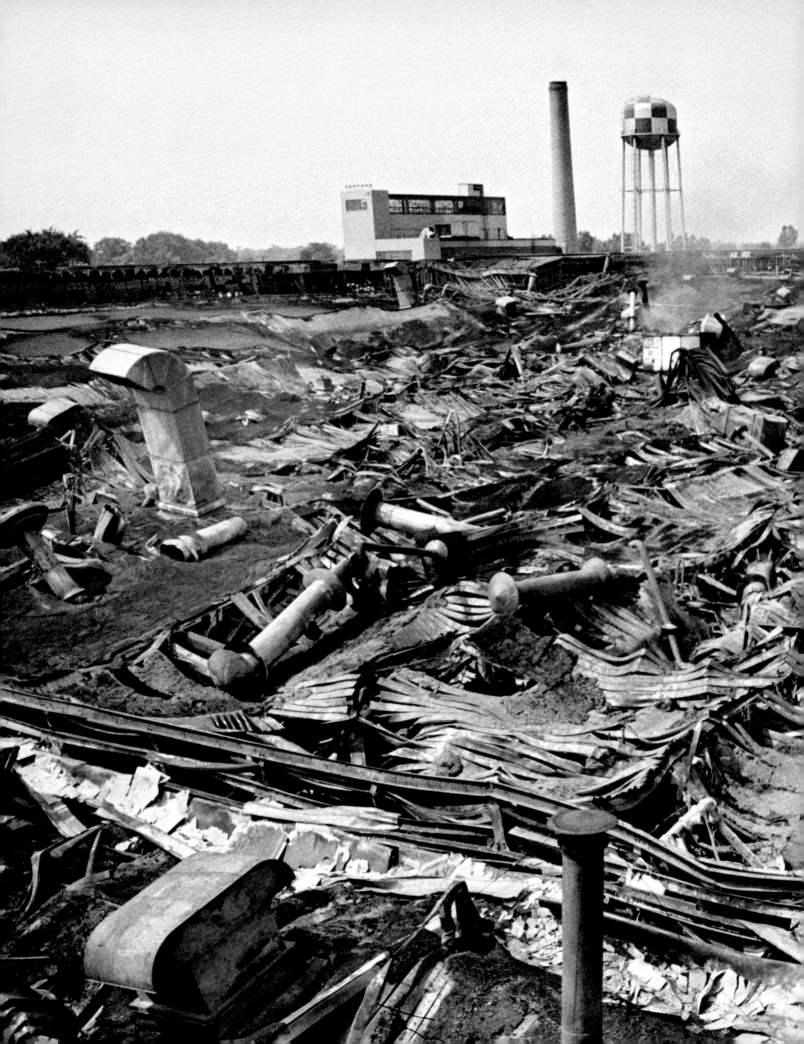

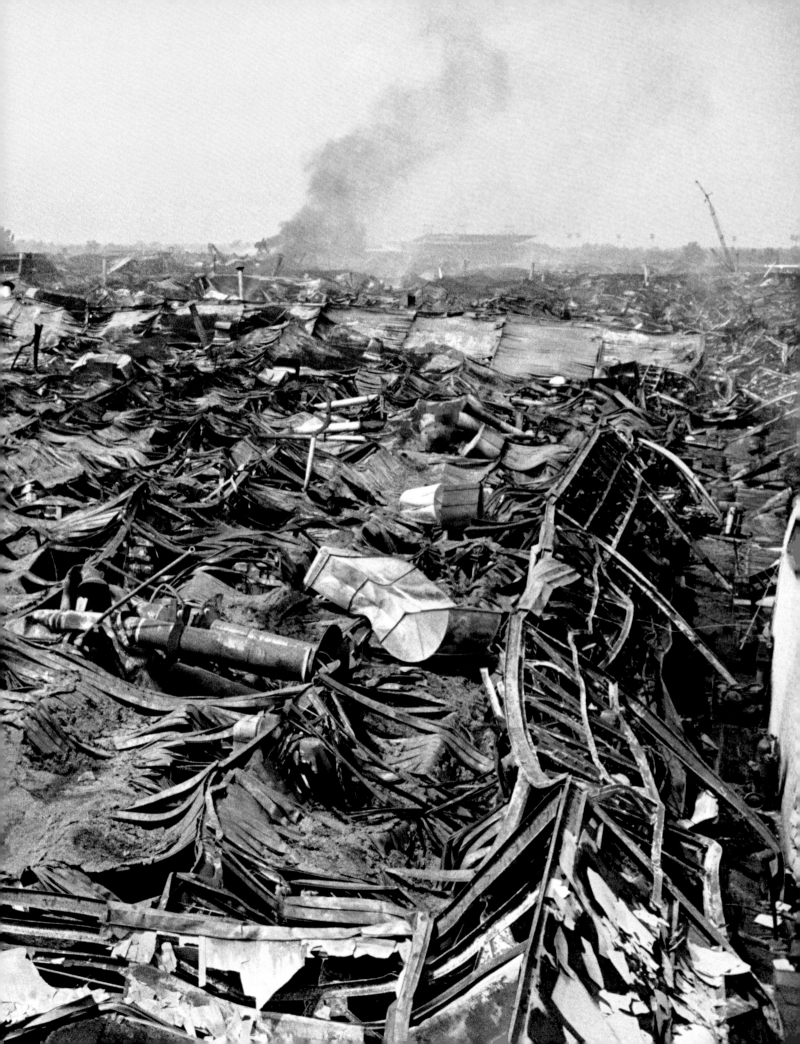

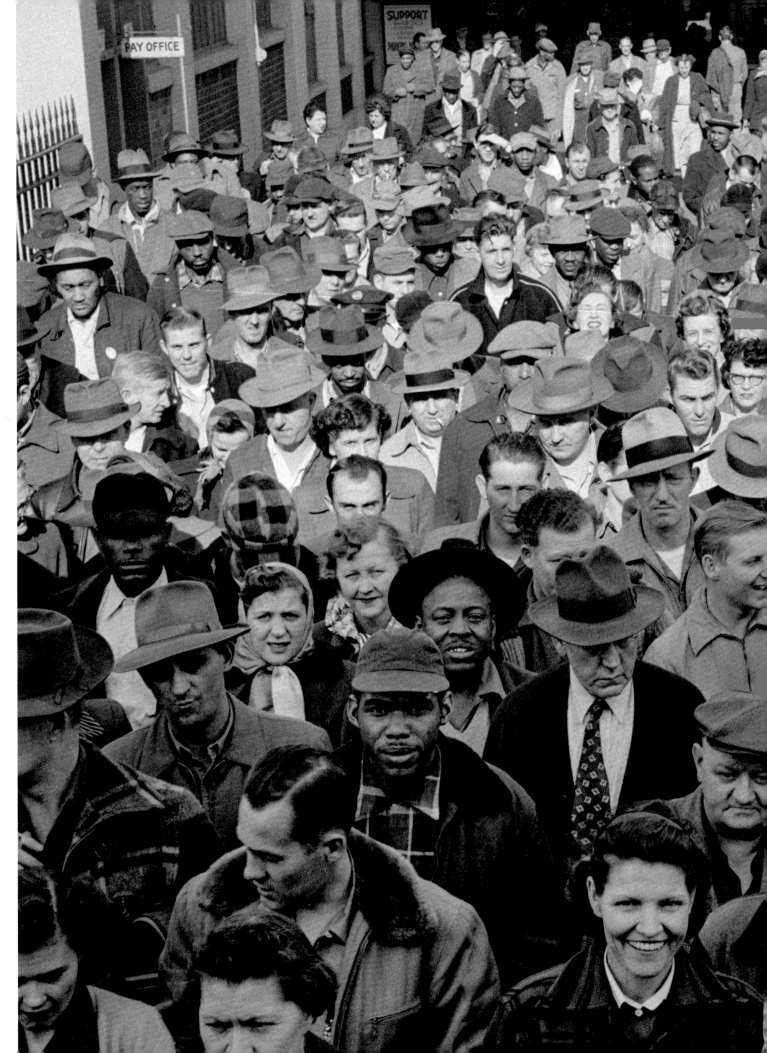

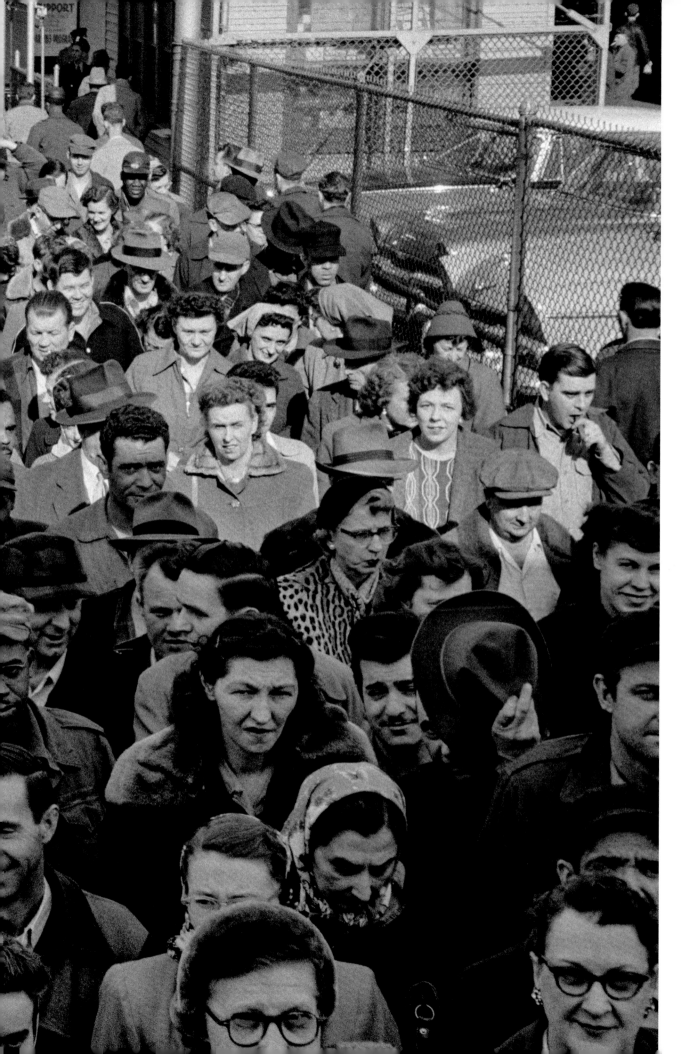

Detroit auto-workers in 1955.

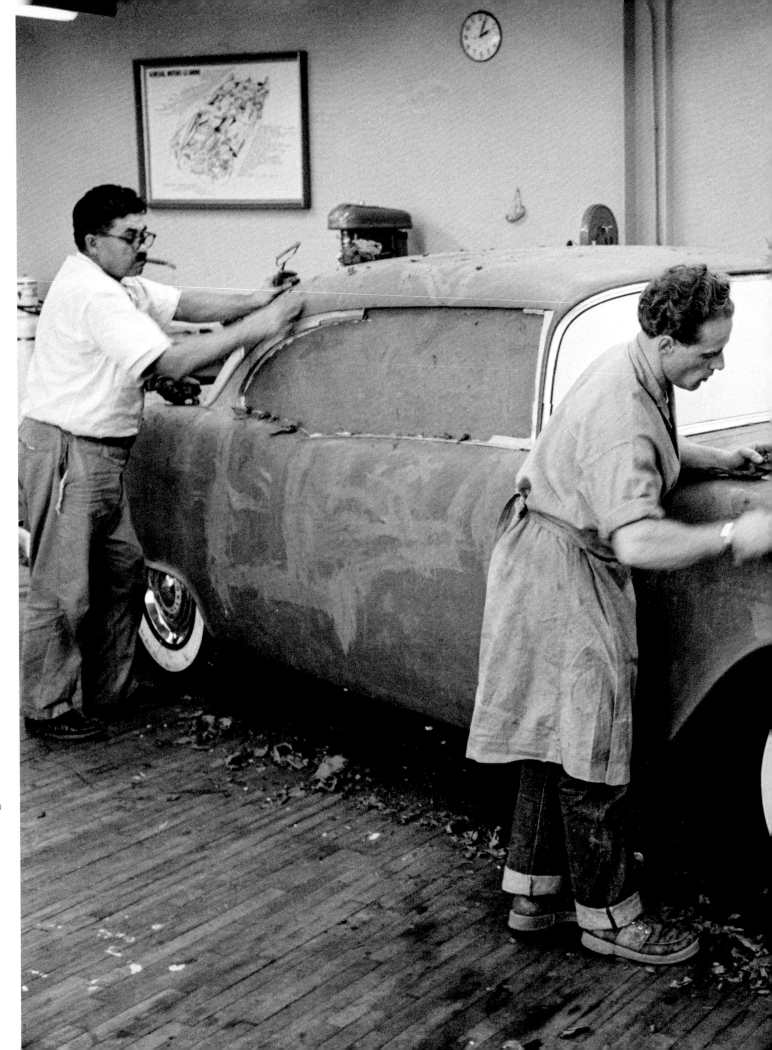

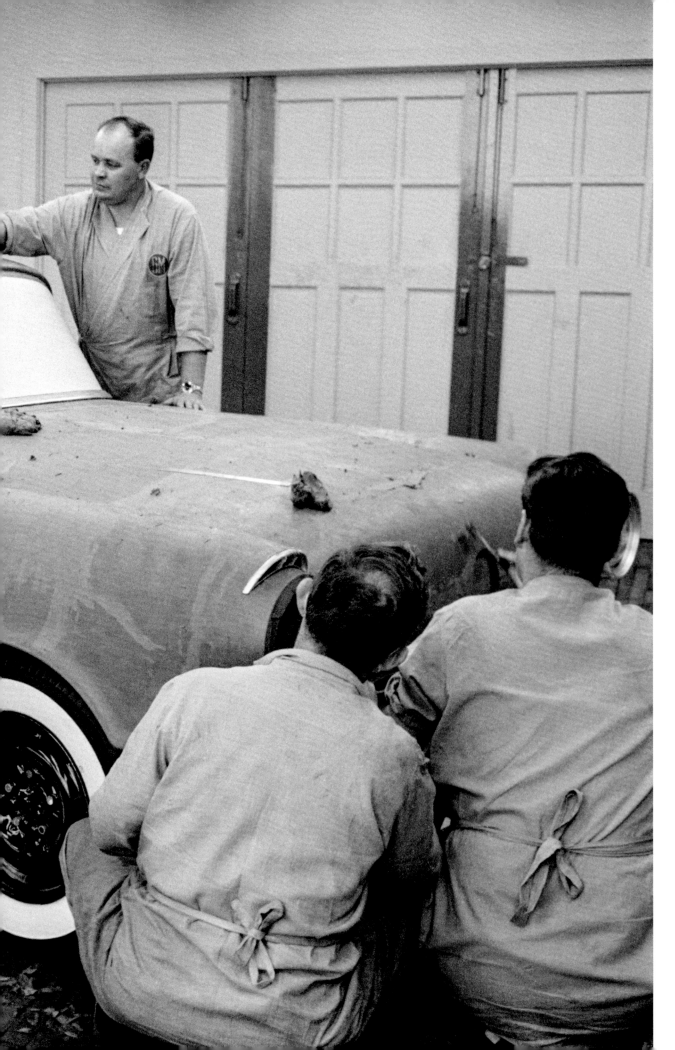

Clay modelers
sculpt a GM body
in 1955.

LEFT:
Packard produc-
tion staff work
at the factory in
Utica, Michigan, in
1955—a year after
the merger with
Studebaker.

OPPOSITE:
A Packard Clipper
gets the spray
treatment, while
workers provide
the shine.

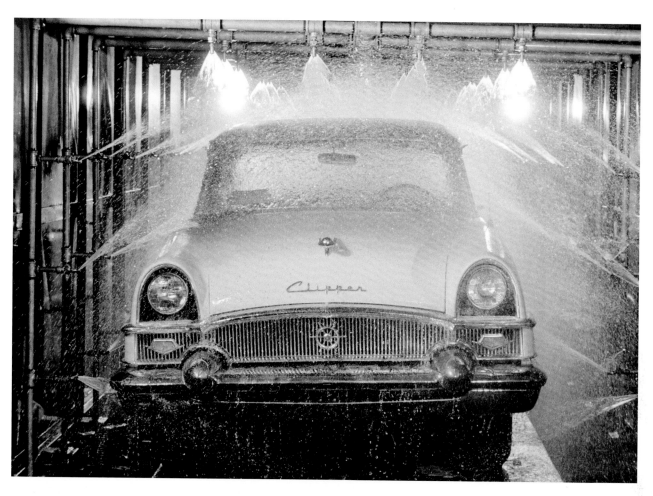

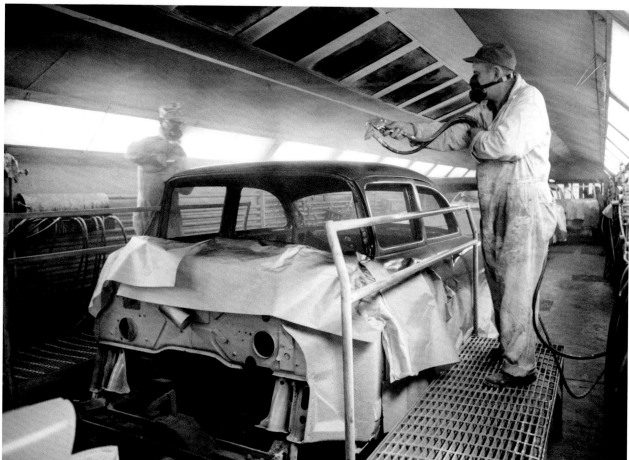

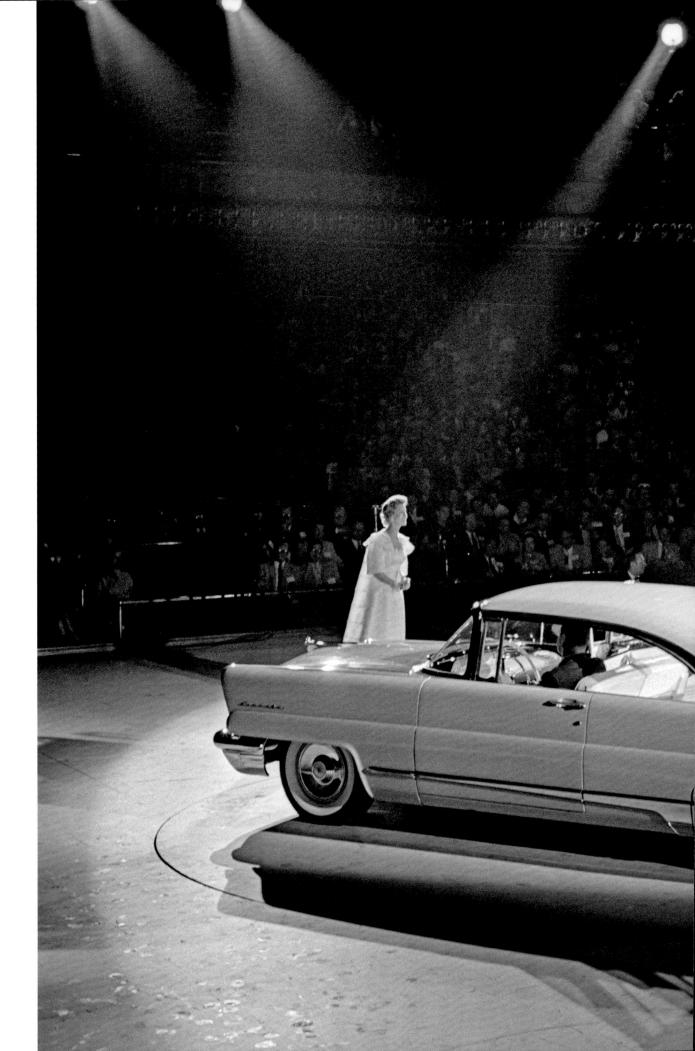

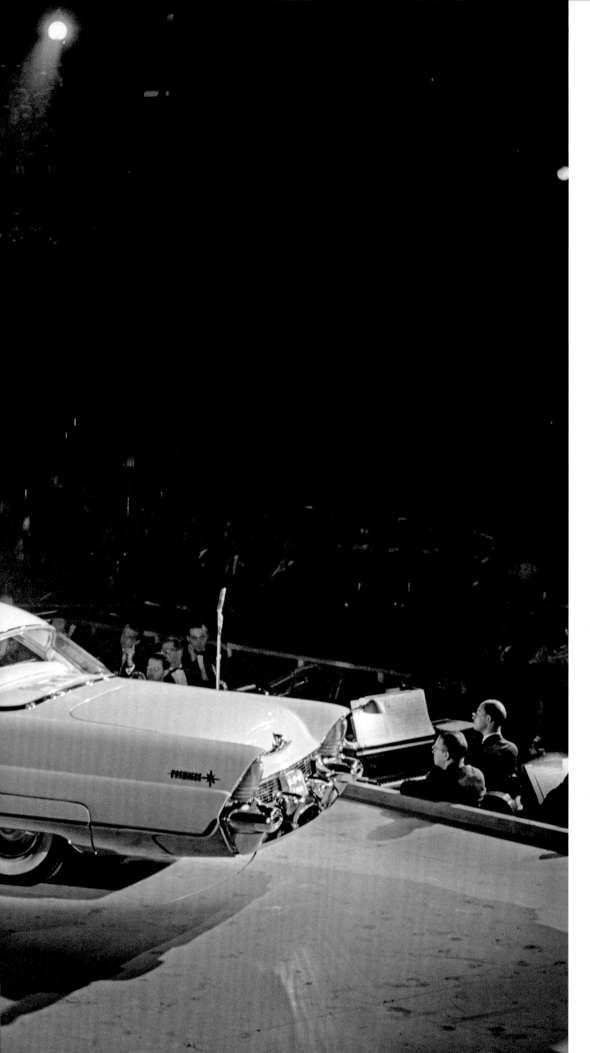

The '56 Lincoln
Premiere makes
its grand entrance
(from stage right)
in Detroit.

85

The full Broad-
way treatment
announced the
launch of the '56
Lincoln Premiere
to the world.

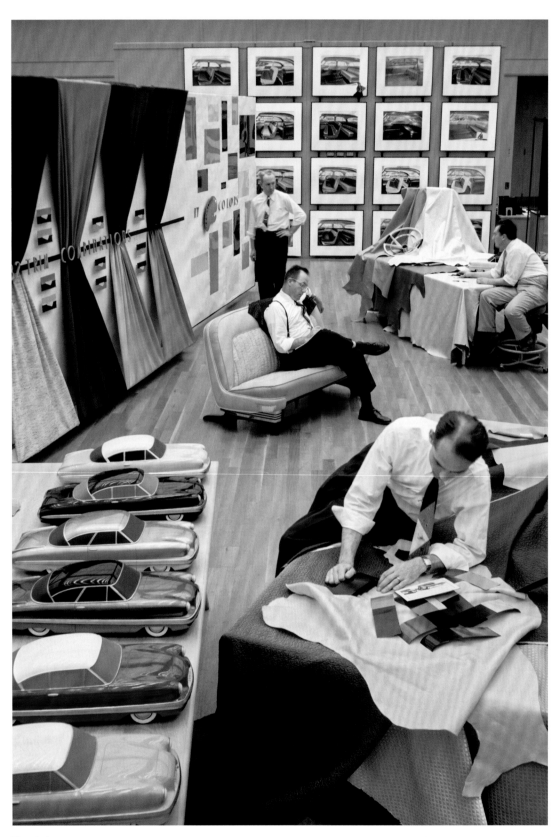

The designers
responsible
for the upscale
Lincoln aesthetic
offer a behind-
the-scenes look at
their work in 1955.

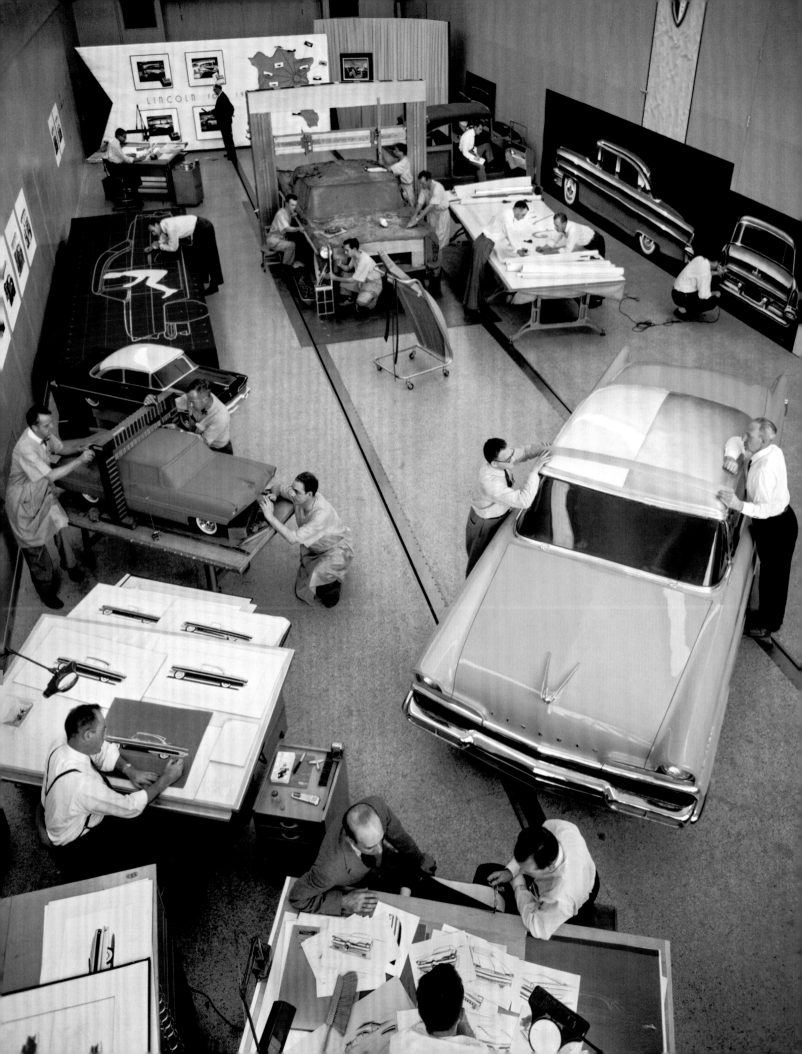

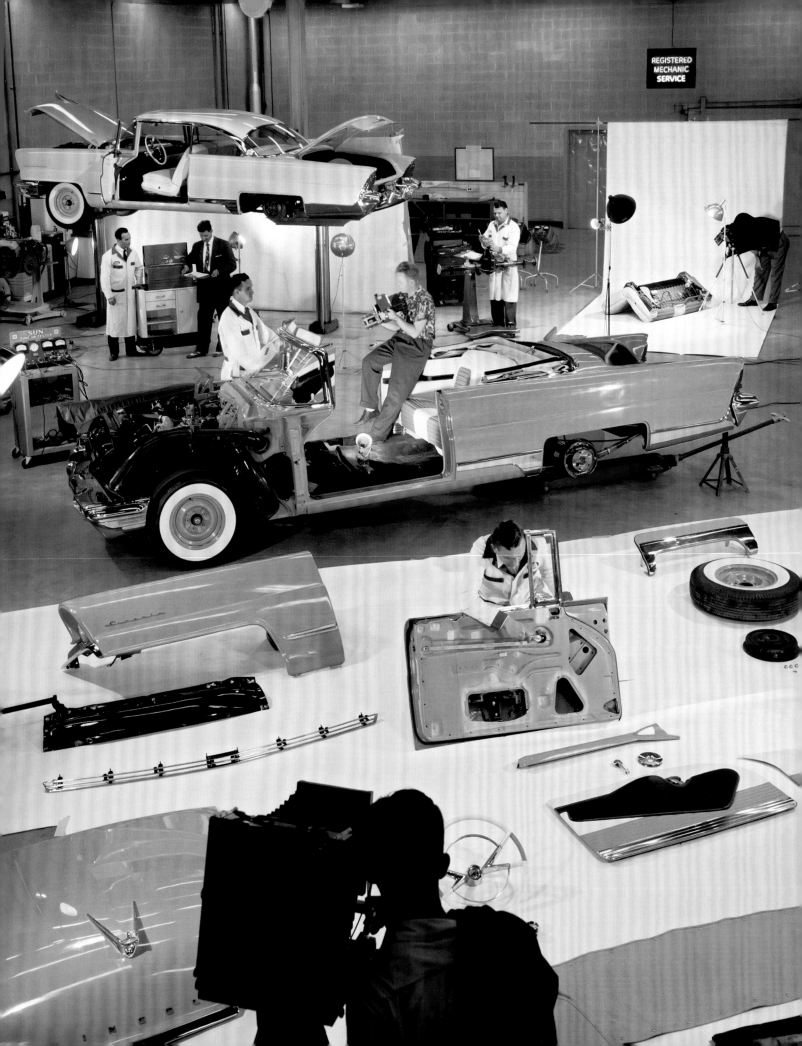

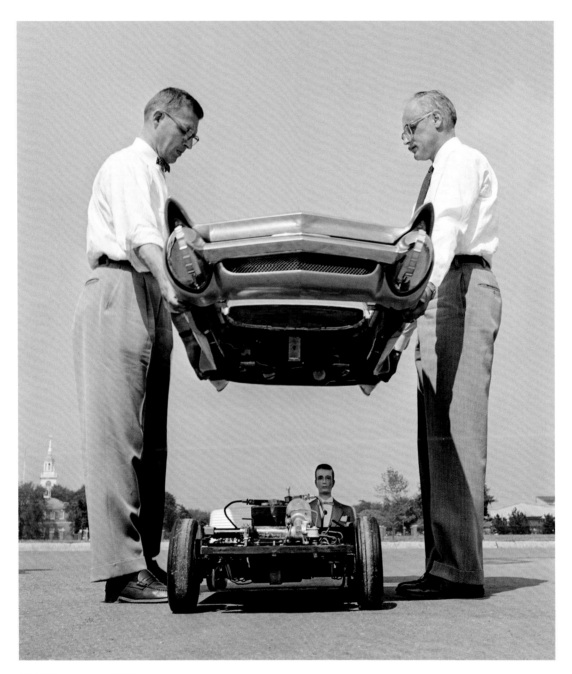

OPPOSITE:
Photographers
capture images of
a dismantled pink
Lincoln (while
Zimmerman takes
theirs).

ABOVE:
Alex Tremulis
(right), whose big
ideas fueled the
Ford Advanced
Styling Studio,
lowers the top on
a model car with
staffer Romeyn
Hammond in 1955.

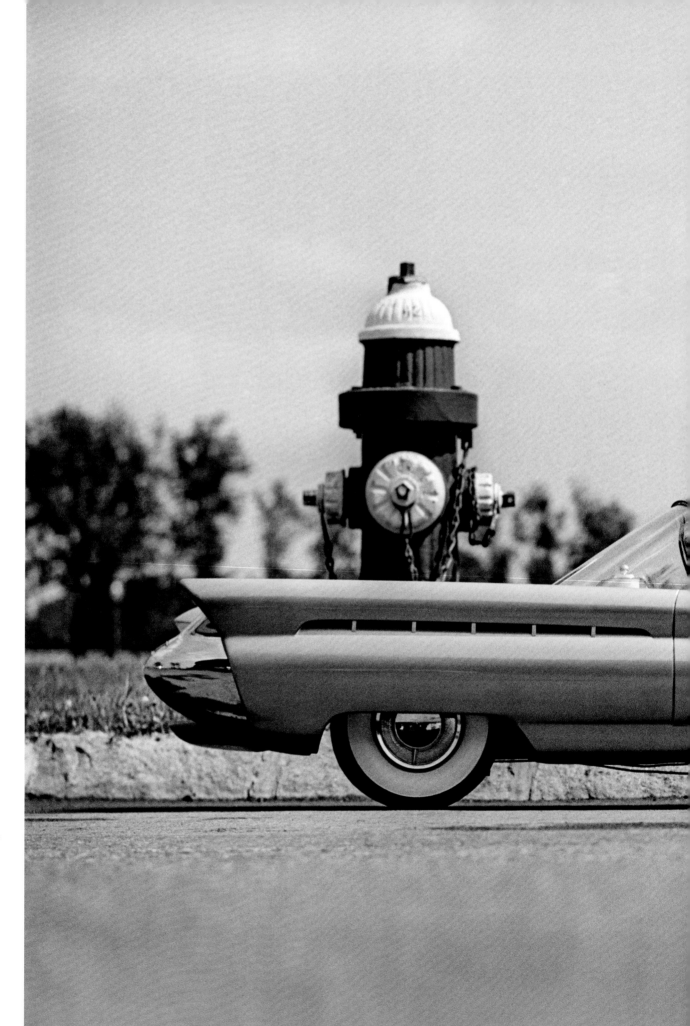

92 The 3/8 scale "La Tosca" was operated by remote control.

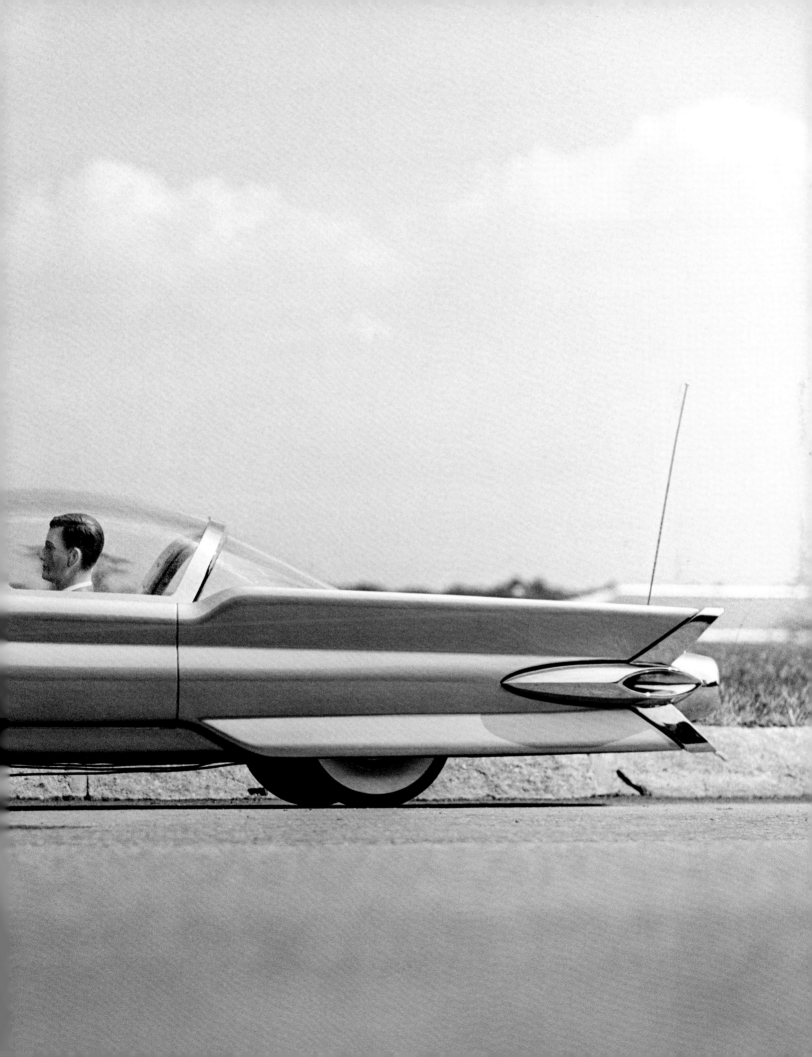

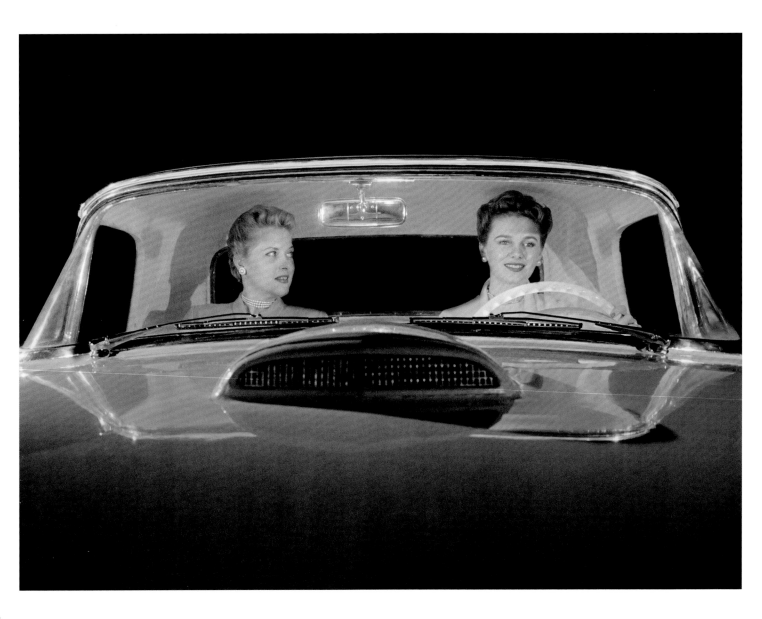

OPPOSITE:
The '55 Ford
Thunderbird,
photographed
here in a publicity
shot in 1954
in advance of
its debut the
following year.

ABOVE:
A double expo-
sure demon-
strates how easy
it is to put the
top down on the
Thunderbird.

FOLLOWING:
Henry Ford II, in
the driver's seat
of a '55 Ford
Thunderbird, with
his new Chairman
of the Board Ernie
Breech.

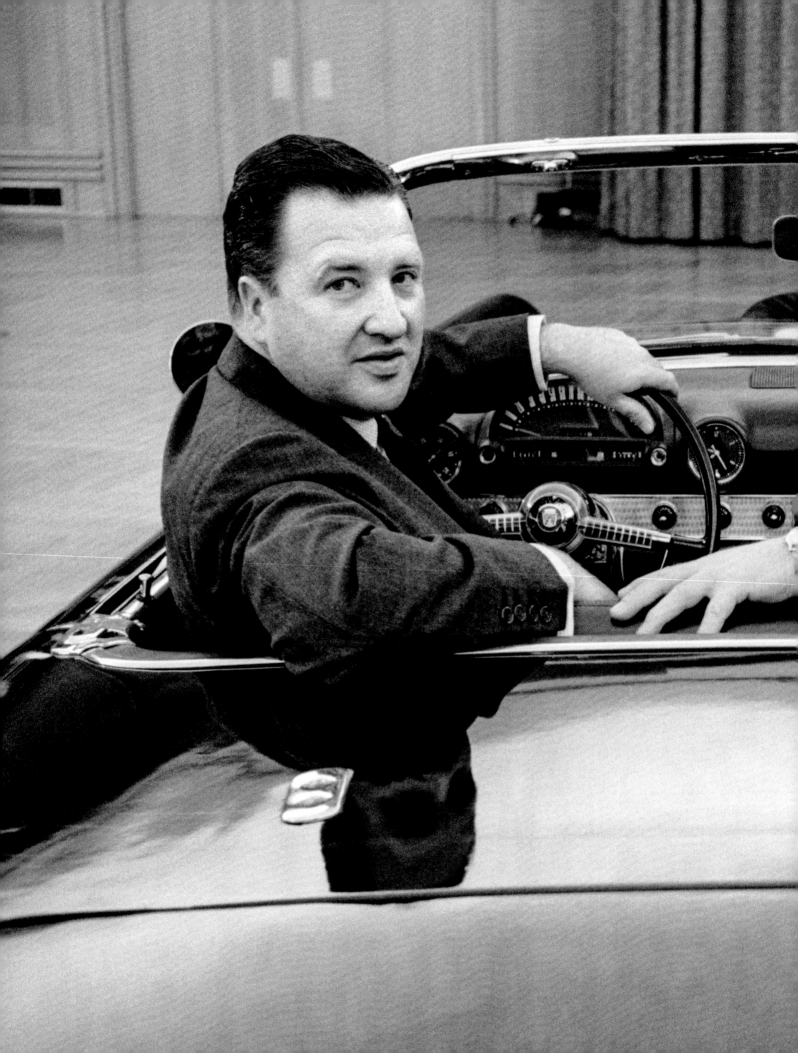

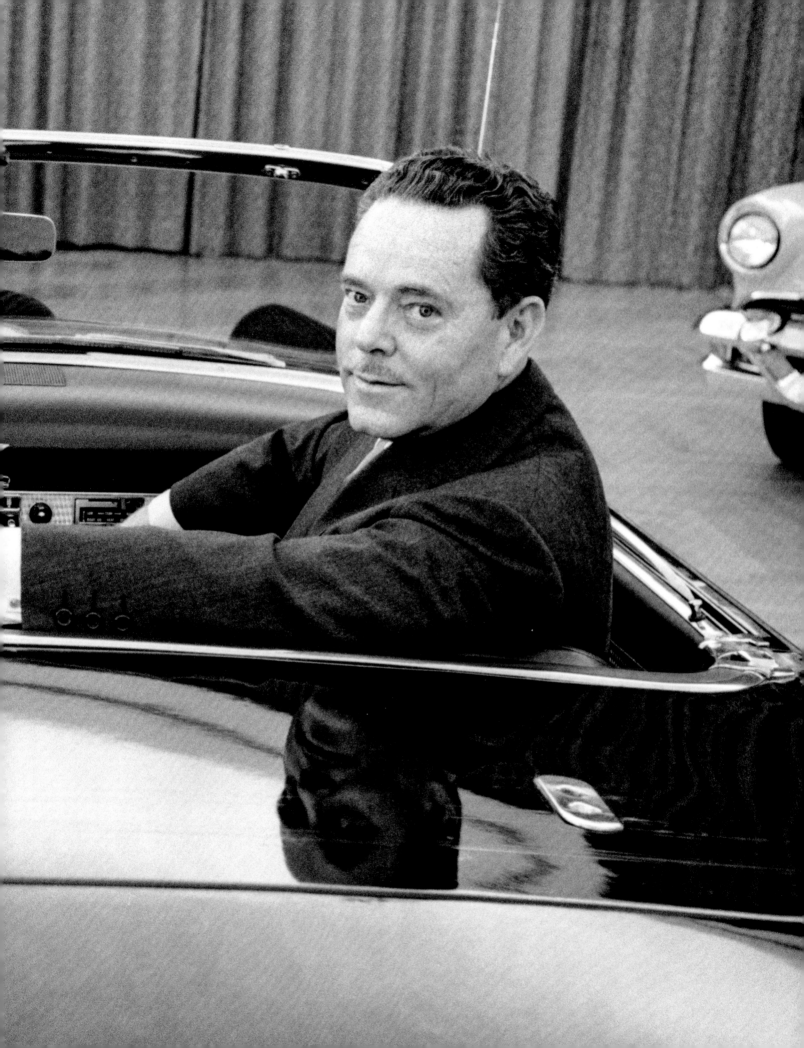

Robert McNamara, who was general manager of the Ford Division in 1955, became US Secretary of Defense in 1961.

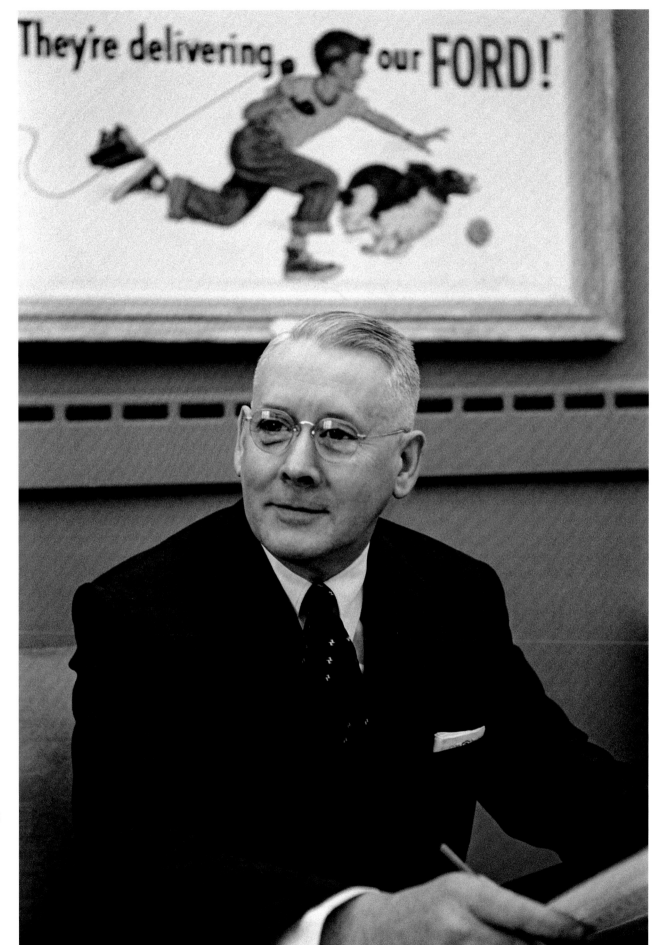

Lewis Crusoe, executive vice president of Car and Truck at Ford in 1955, was instrumental in bringing the Thunderbird to life.

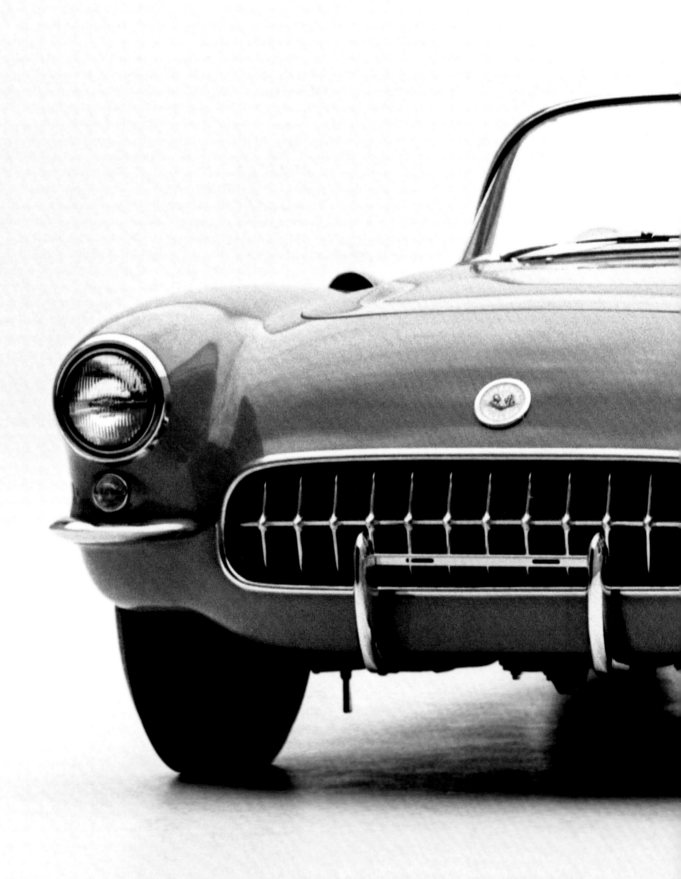

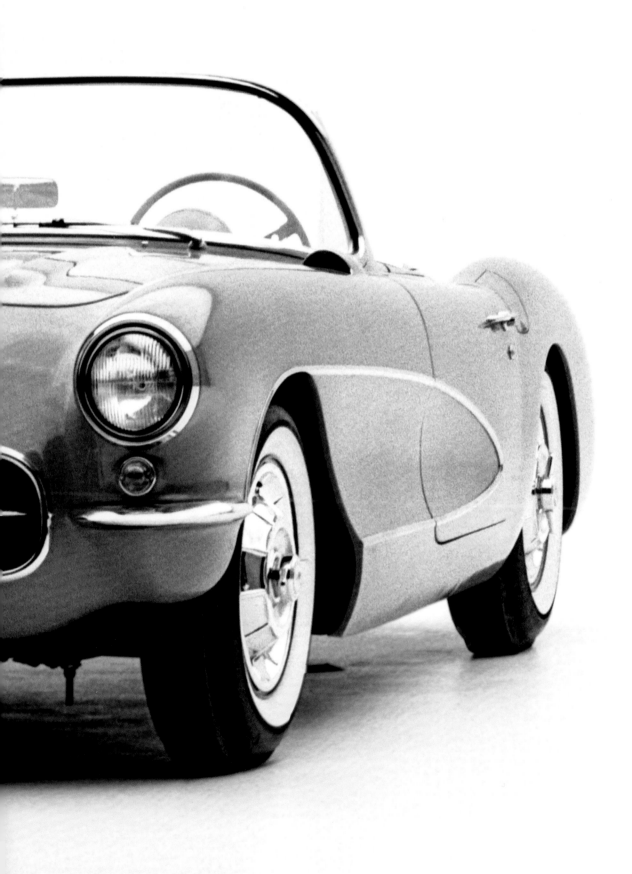

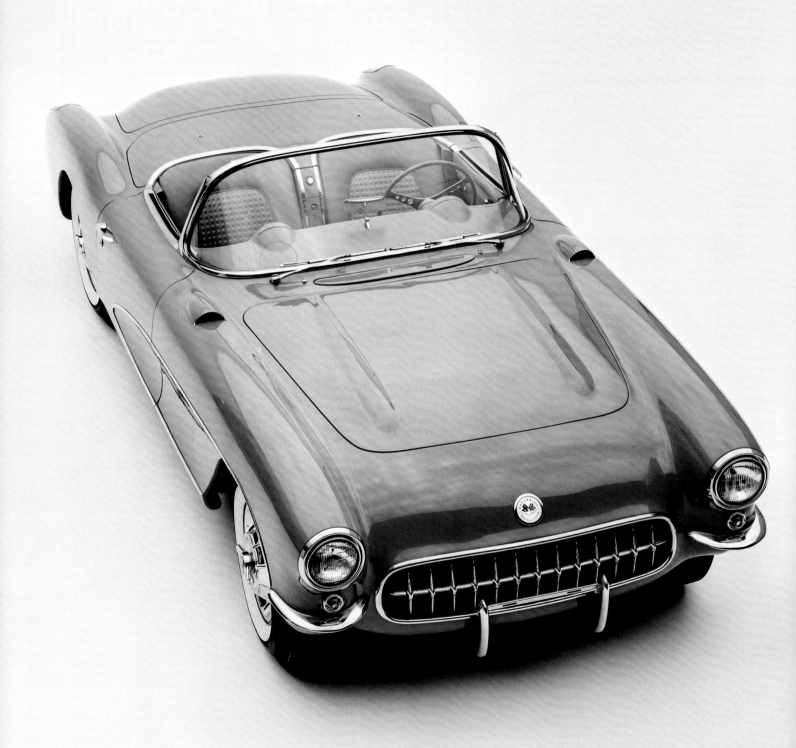

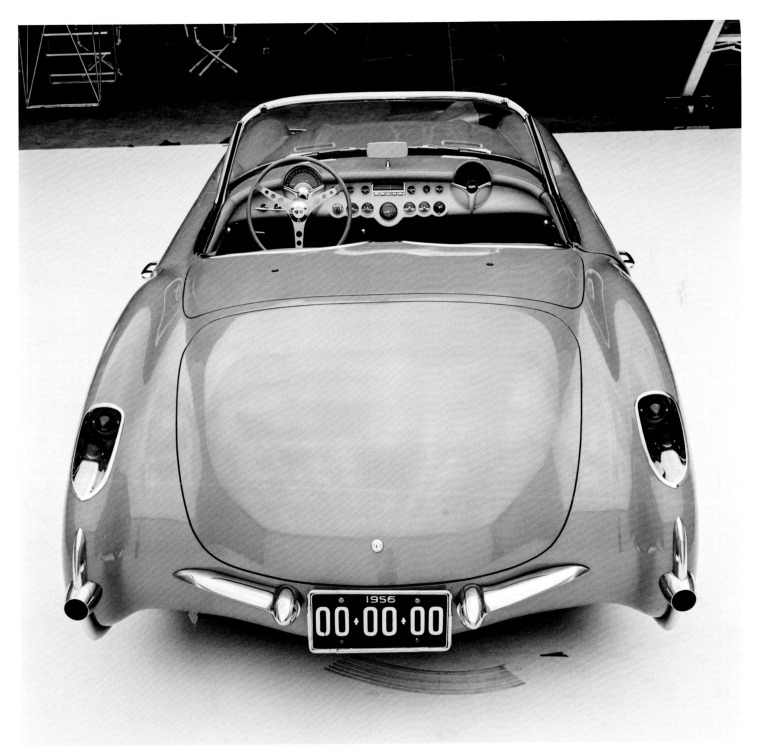

1956

00•00•00

The '56 Corvette, seen here during its introduction in 1955, marked a nearly complete overhaul. Among the changes was the debut of the iconic side cove, with the option of a different color.

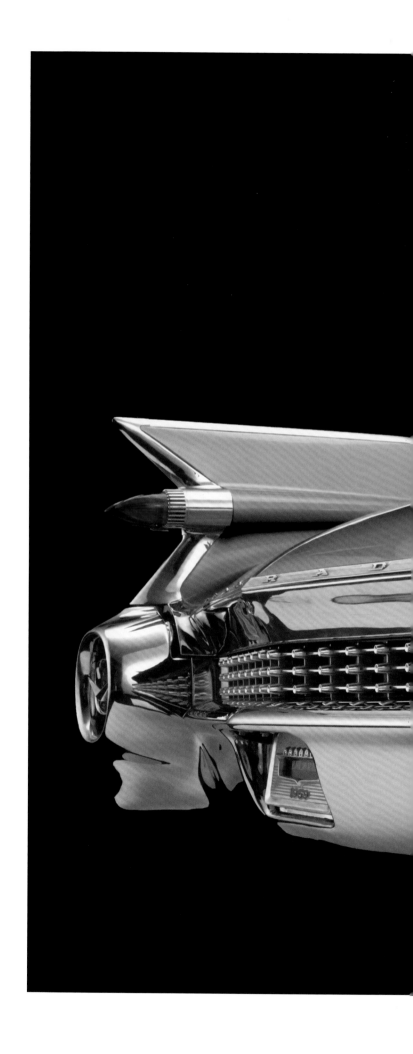

104 '59 Cadillac
Eldorado.

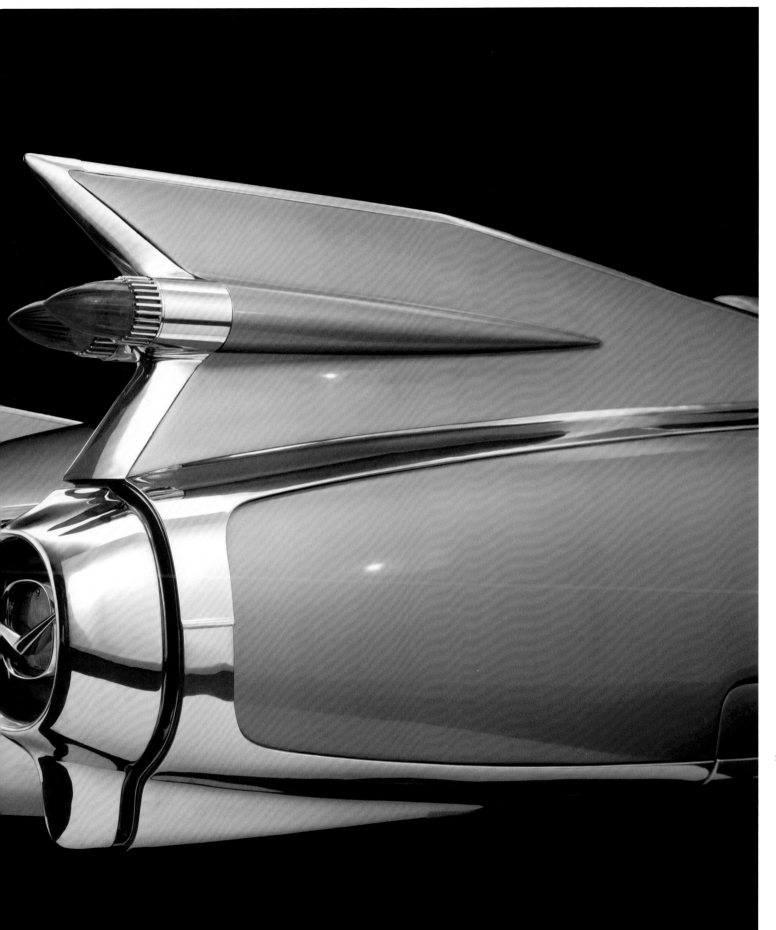

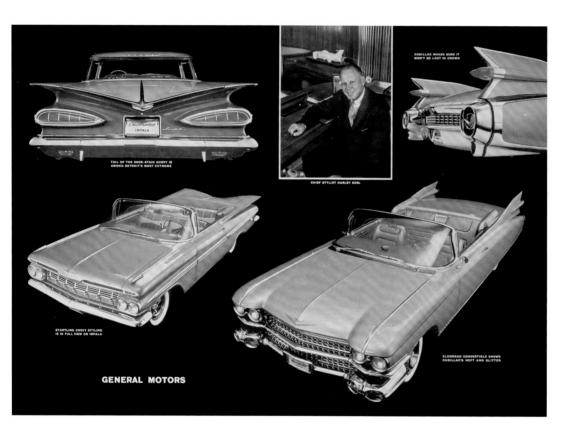

TAIL OF THE ONCE-STAID CHEVY IS
AMONG DETROIT'S MOST EXTREME

CHIEF STYLIST HARLEY EARL

CADILLAC MAKES SURE IT
WON'T BE LOST IN CROWD

STARTLING CHEVY STYLING
IS IN FULL VIEW ON IMPALA

GENERAL MOTORS

ELDORADO CONVERTIBLE SHOWS
CADILLAC'S HEFT AND GLITTER

ABOVE, RIGHT:
The fins of the '59
Eldorado, as part
of a published
Sports Illustrated
photo spread
on GM's chief
stylist Harley Earl,
epitomized the
stylistic flourishes
of the era.

FOLLOWING:
The '59 Chevrolet
Impala had tear-
drop rear lights
and angled rear
fins.

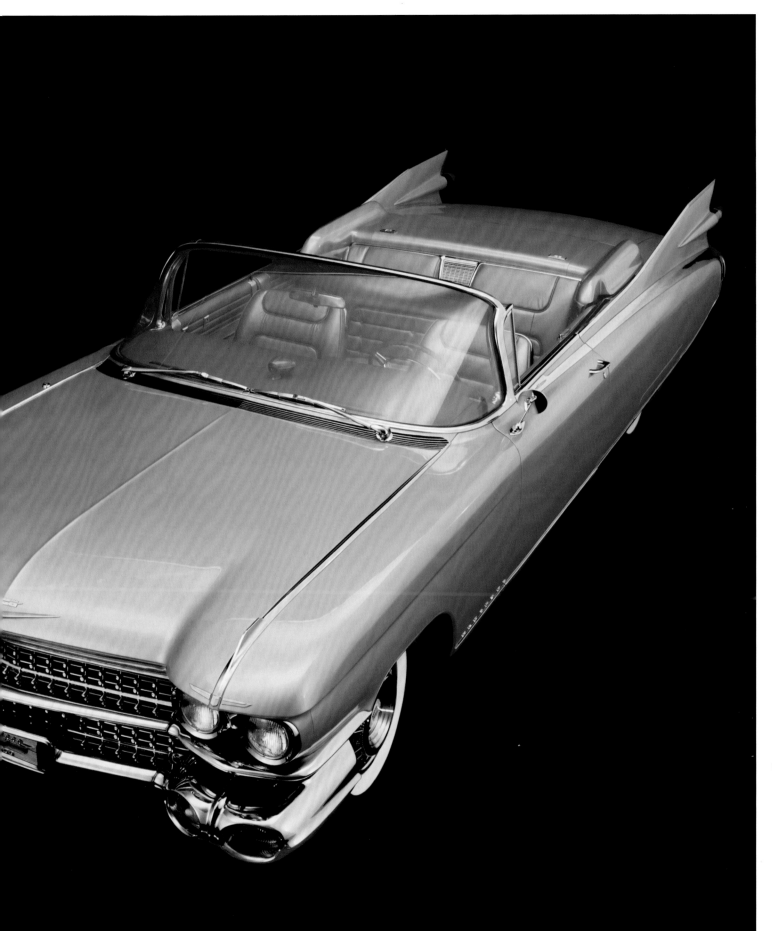

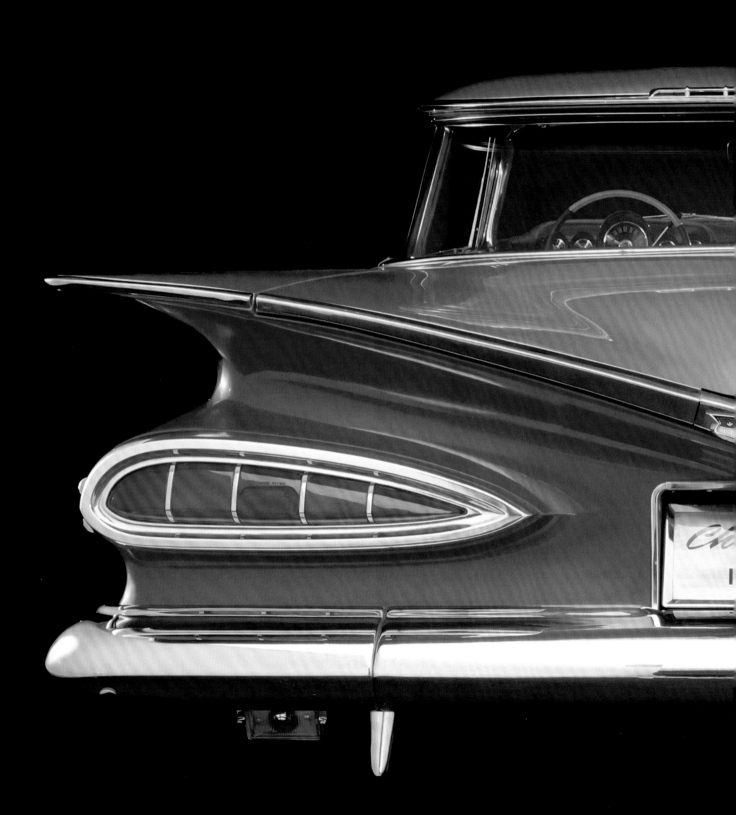

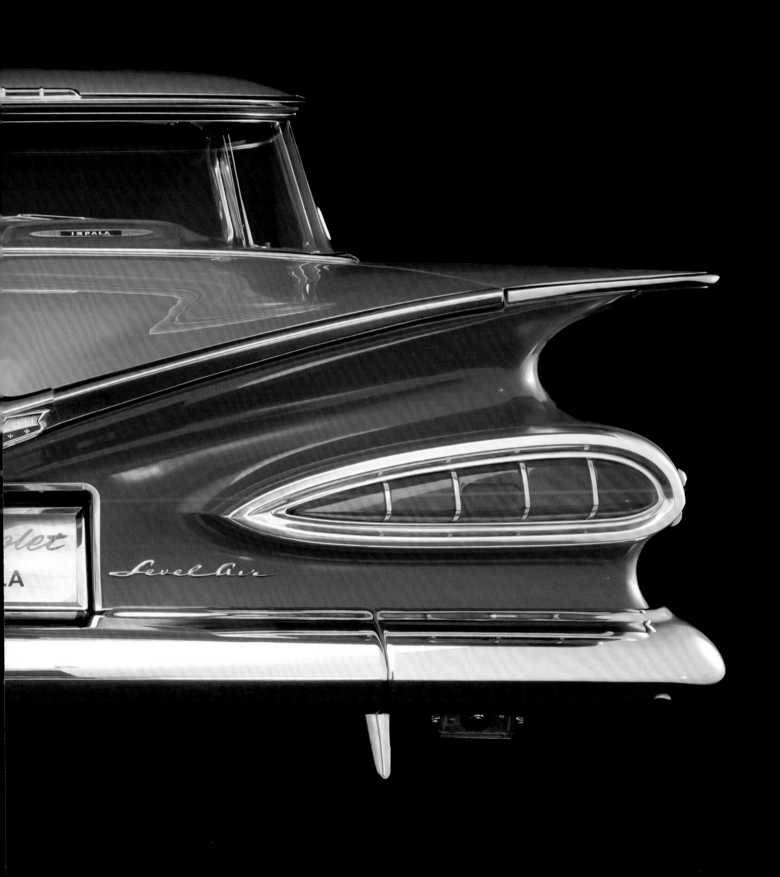

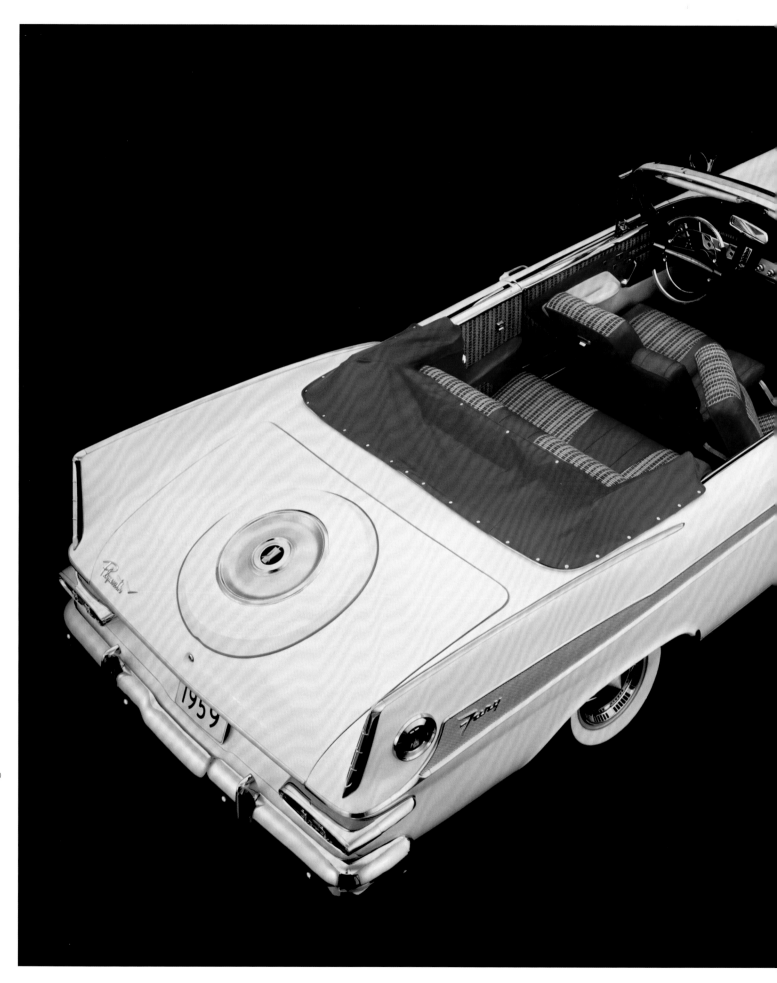

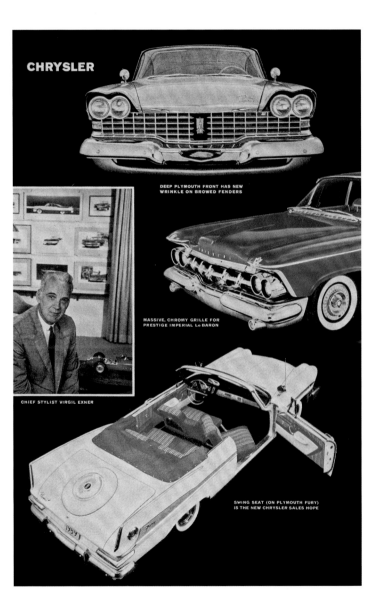

LEFT:
The '59 Chrysler
Plymouth Fury
had rotating seats
to ease entry.

ABOVE:
Automobile
designer Virgil
Exner and the
Chrysler cars that
he steered from
concept to design
are featured in the
October 20, 1958,
issue of *Sports
Illustrated*.

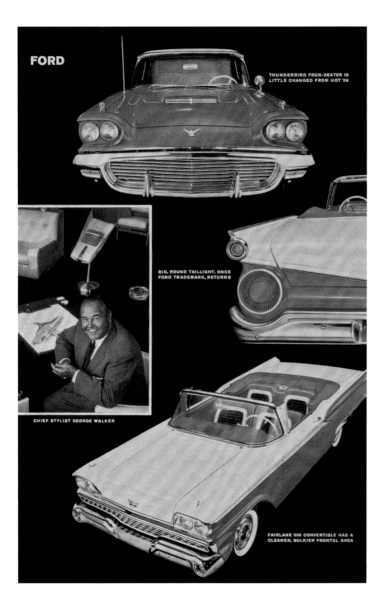

FORD

THUNDERBIRD FOUR-SEATER IS
LITTLE CHANGED FROM HOT '58

BIG, ROUND TAILLIGHT, ONCE
FORD TRADEMARK, RETURNS

CHIEF STYLIST GEORGE WALKER

FAIRLANE 500 CONVERTIBLE HAS A
CLEANER, BULKIER FRONTAL AREA

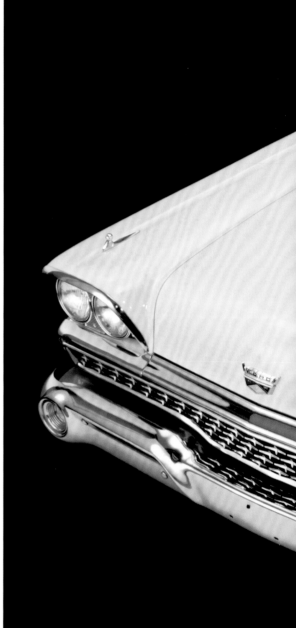

ABOVE:
Ford chief stylist
George Walker
conceived the look
of the '59 Ford
Fairlane 500.

RIGHT:
The '59 Ford
Fairlane 500.

FOLLOWING:
The Fairlane 500,
which was named
after Henry Ford's
estate, had large,
round taillights.

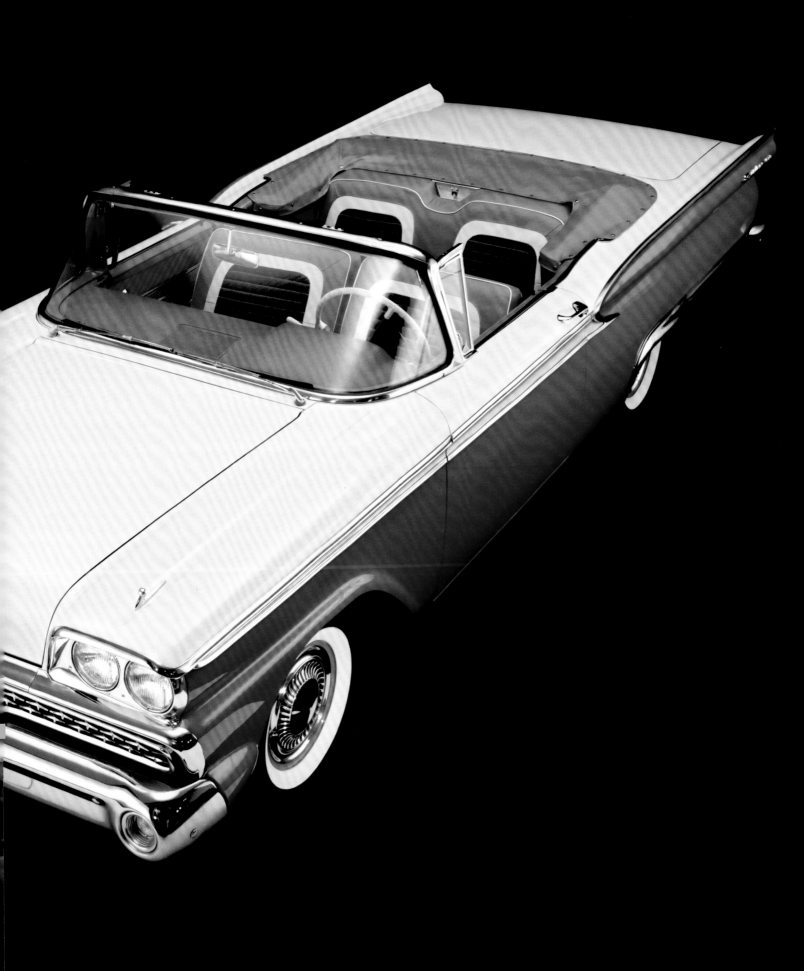

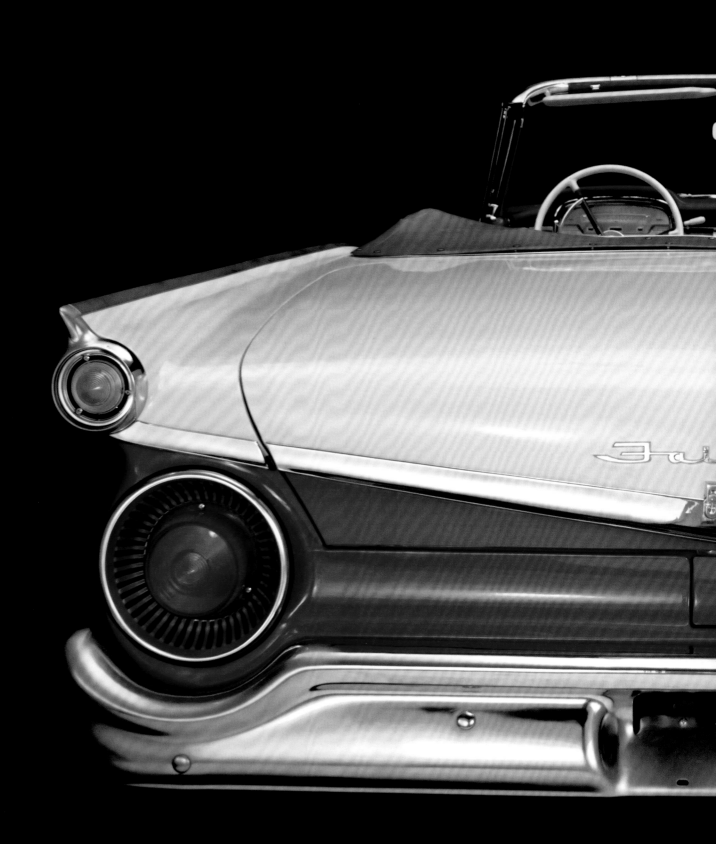

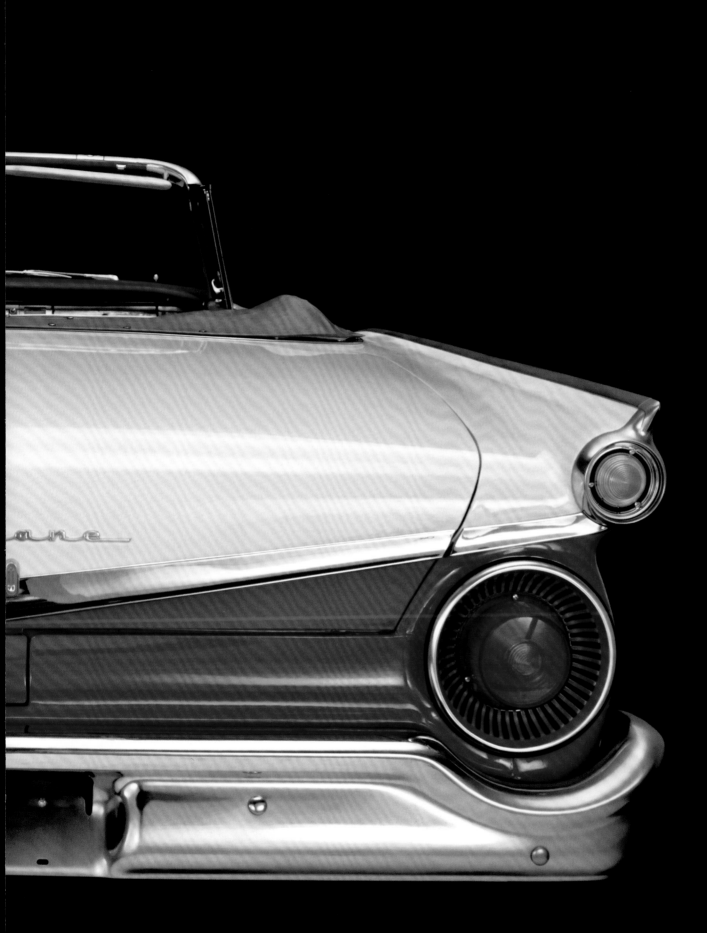

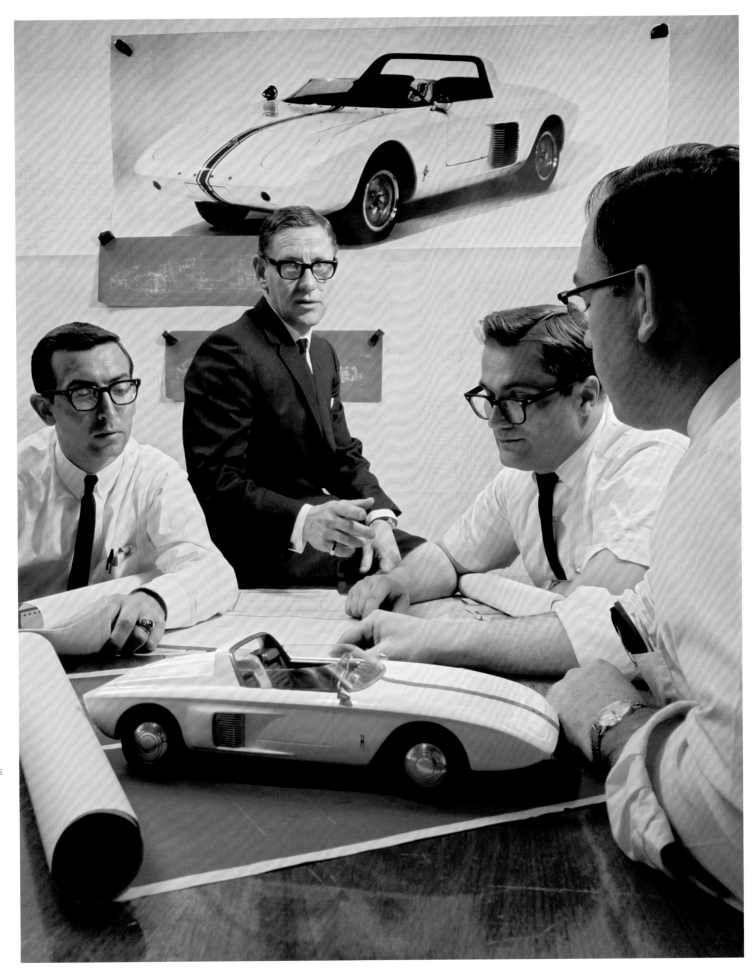

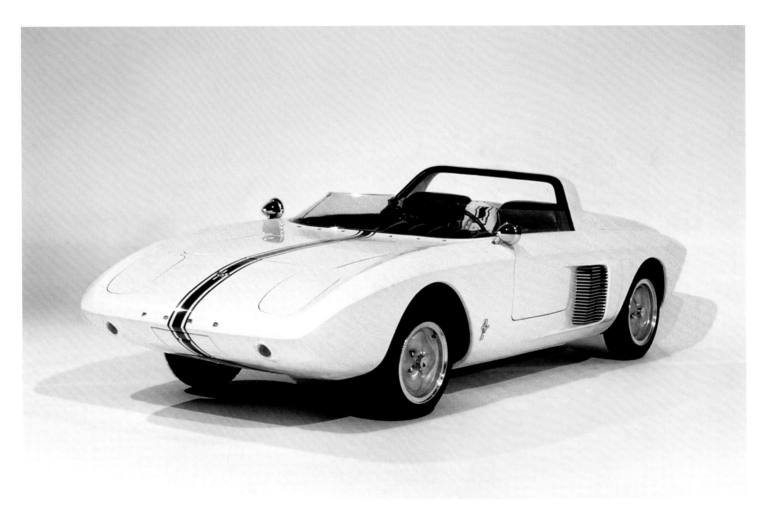

LEFT:
Ford executive
engineer Roy
Lunn reviews a
model of the '62
Ford Mustang I
concept car.

ABOVE:
Famously
designed in 100
days, the Mustang
concept car
inspired the con-
sumer version
but had little in
common with it
besides the name.

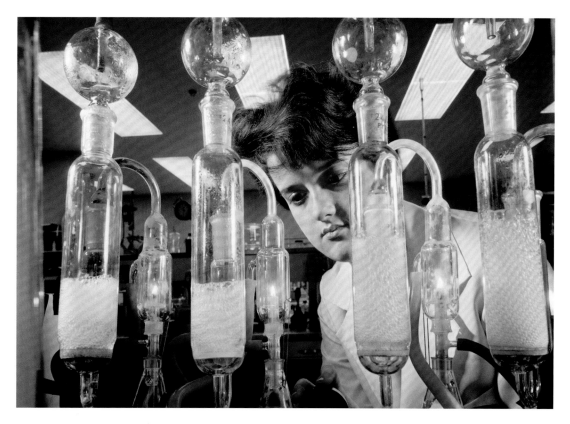

LEFT:
Janet Mackie, a female engineer in what was still a predominantly male industry, measures the sulfur content of high-octane fuel.

BELOW:
For a Time-Life Books photo essay in 1966, Zimmerman captured the conception of the car from soup to (lug) nuts. Here, Ford engineers test a chassis, looking for signs of metal fatigue.

RIGHT:
Sitting safely behind protective glass, a Ford engineer pushes a 600-horsepower race car engine to measure performance on a dynamometer.

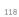

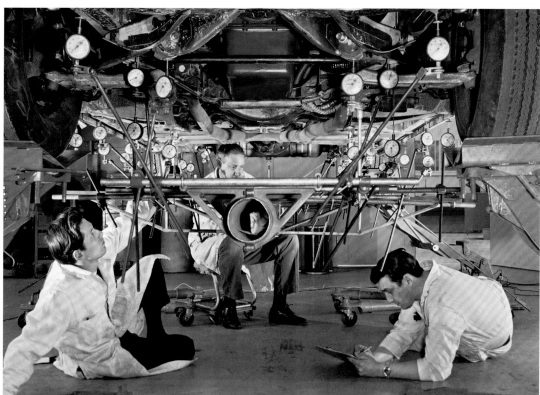

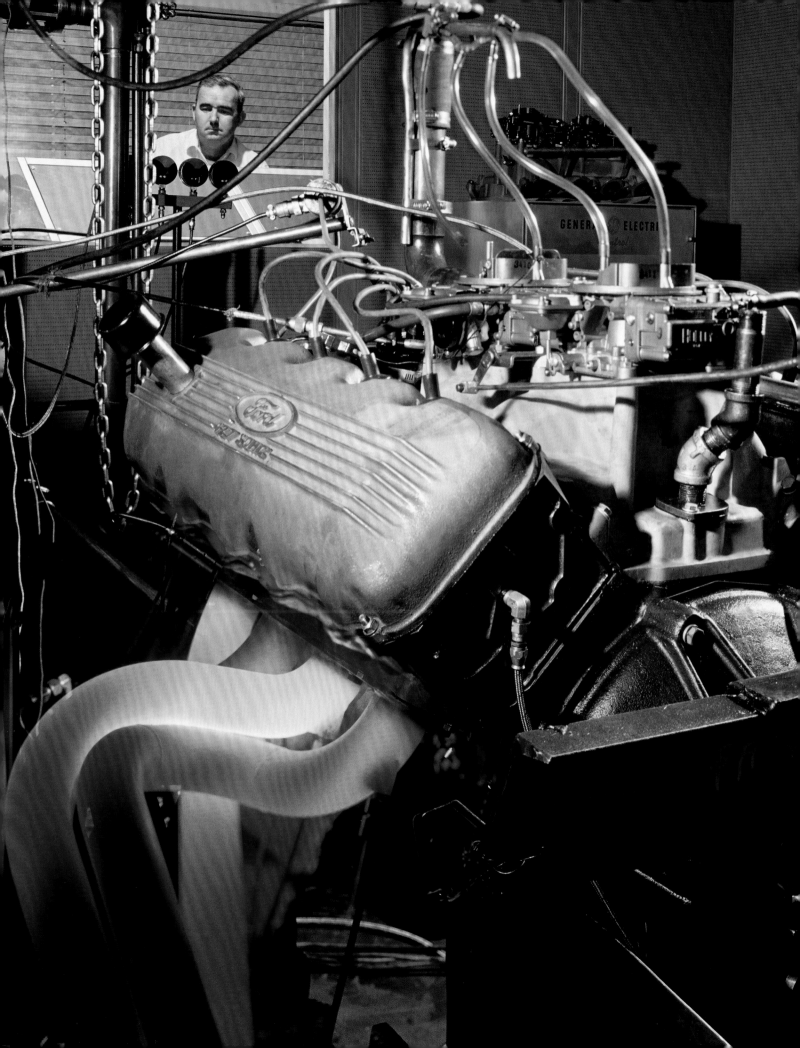

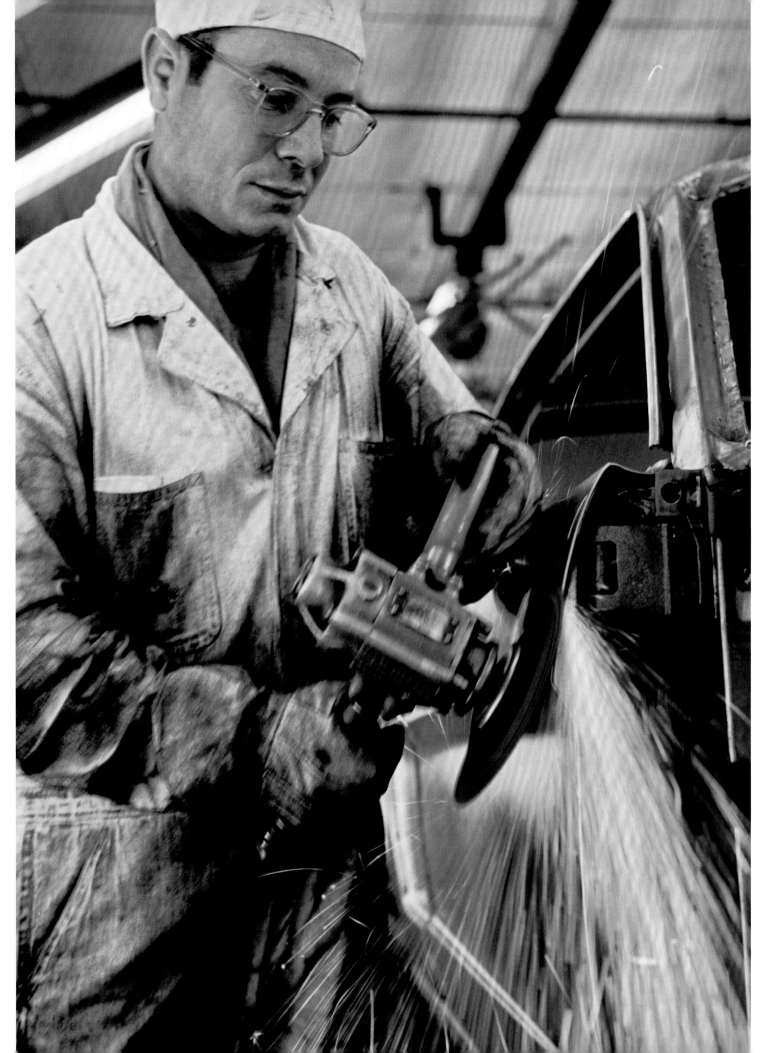

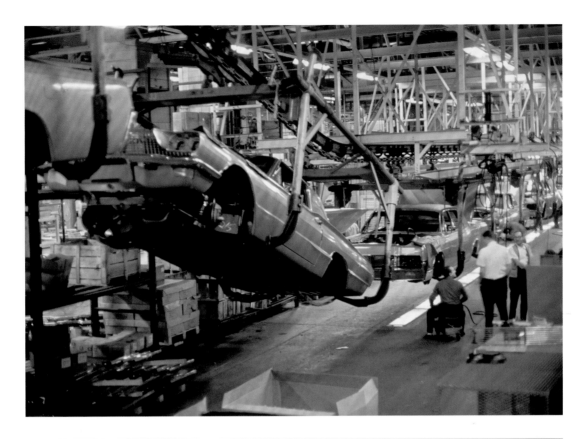

Ford workers labor on the assembly line in Dearborn, Michigan, in 1966.

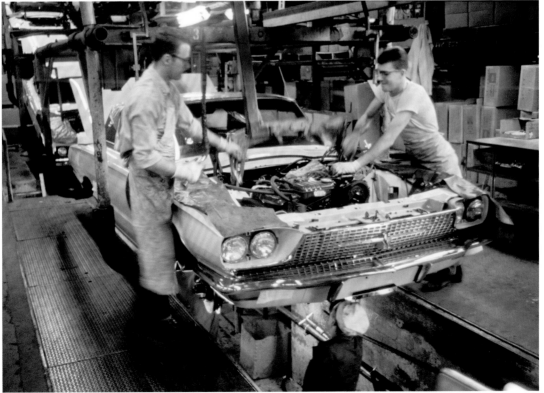

121

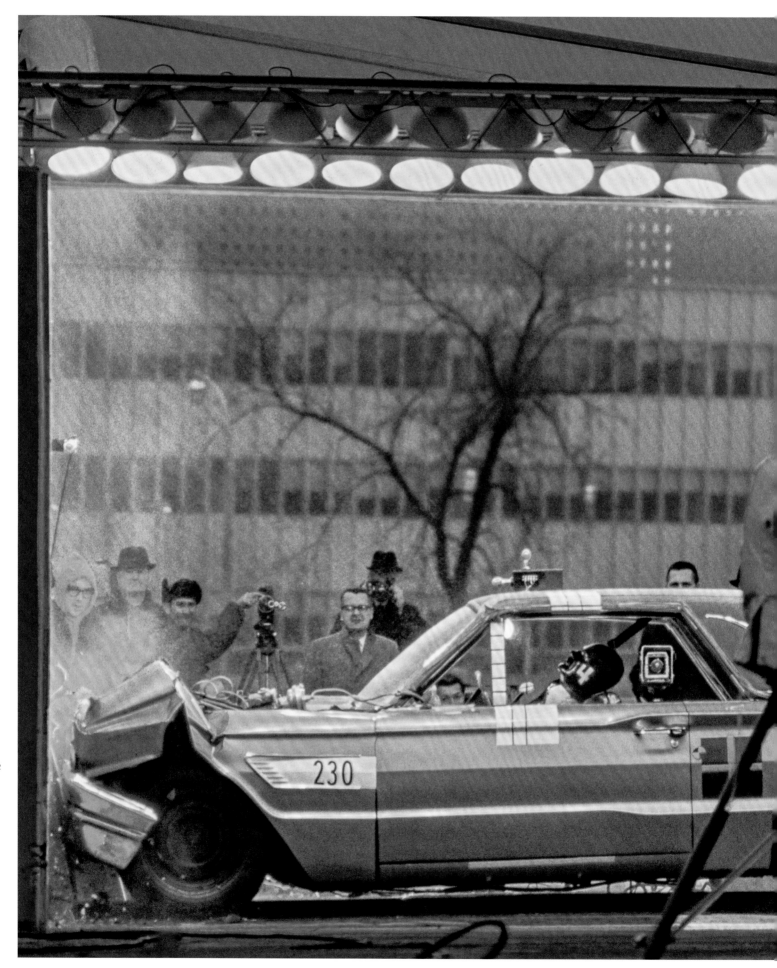

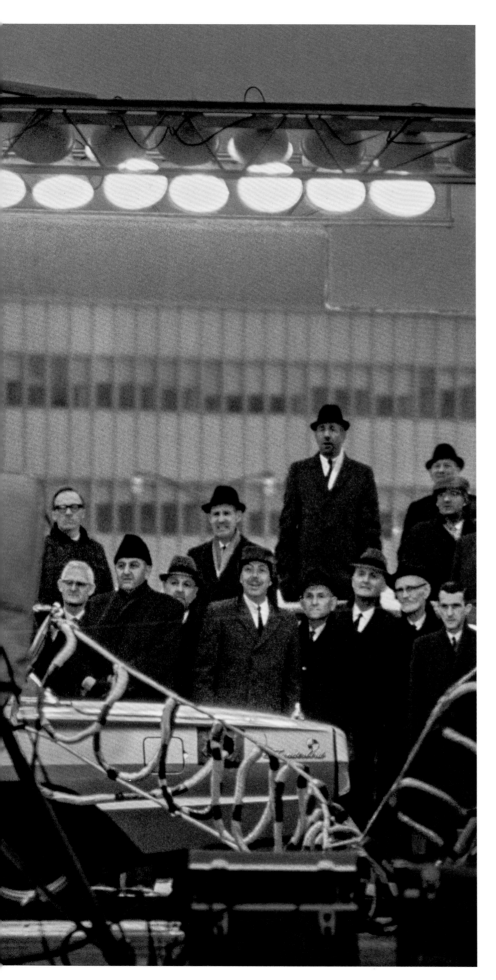

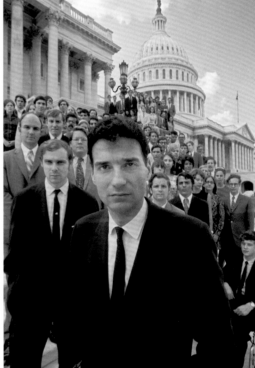

As consumer advocates pushed for safety improvements, the federal government took an assertive stance on regulation.

Ralph Nader, seen here in 1969 on the Capitol steps with his Nader's Raiders, played a role in the regulation.

123

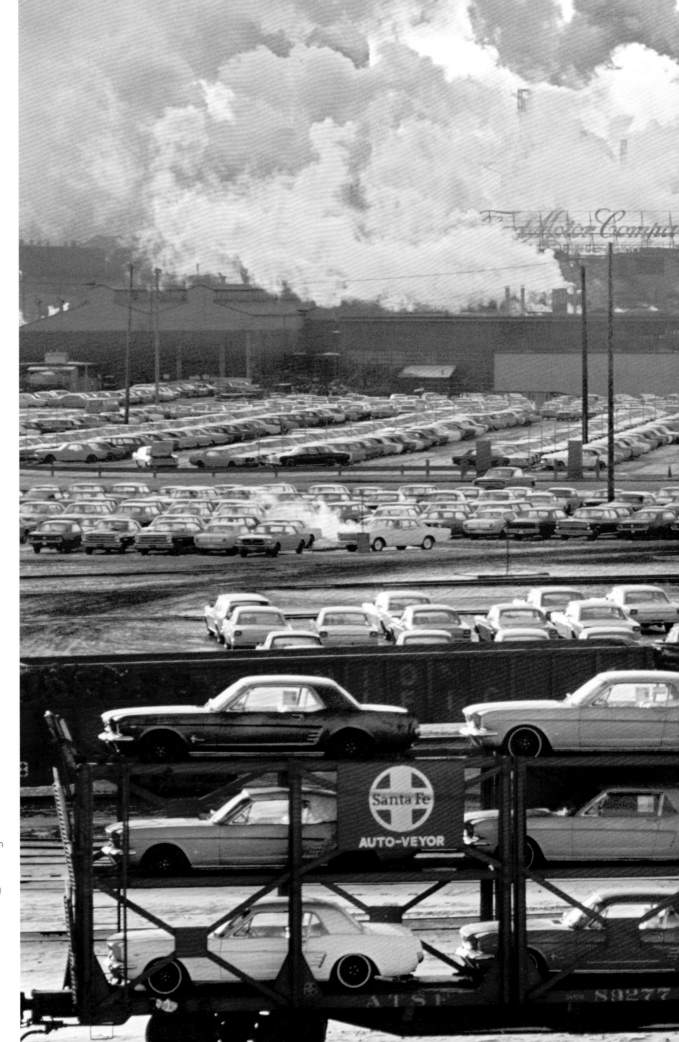

RIGHT:
Mustangs leave
Ford's River
Rouge complex
stacked three high
in January 1966.

FOLLOWING:
'65 Ford Mustang
Fastback 289.

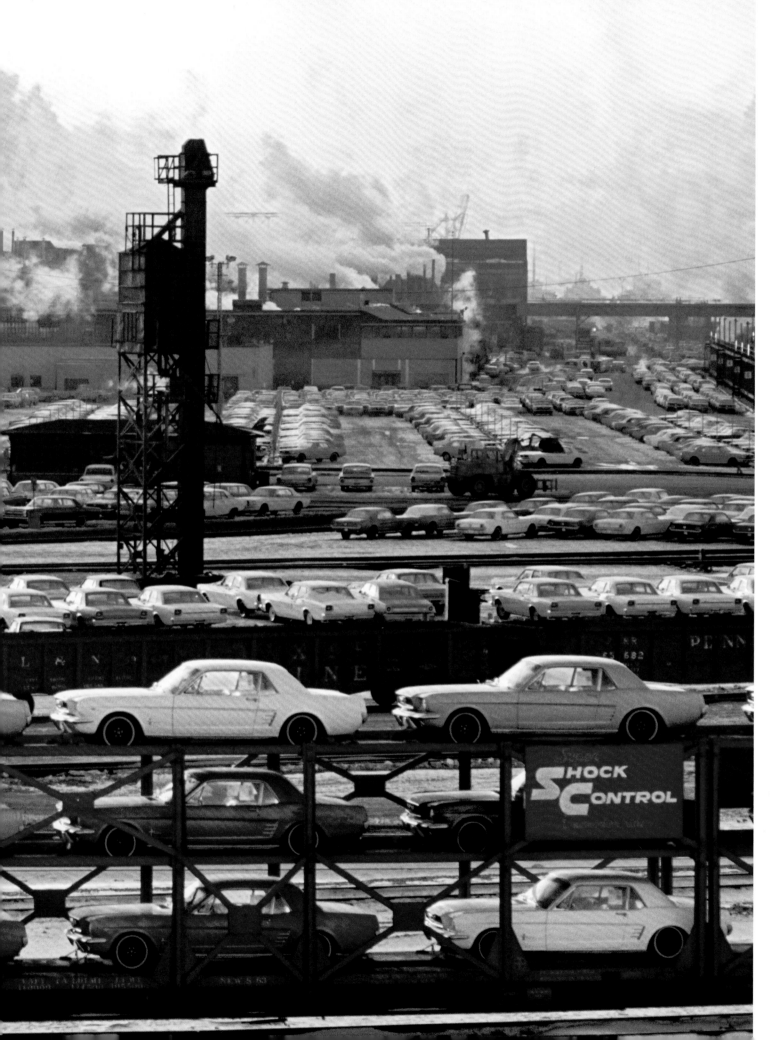

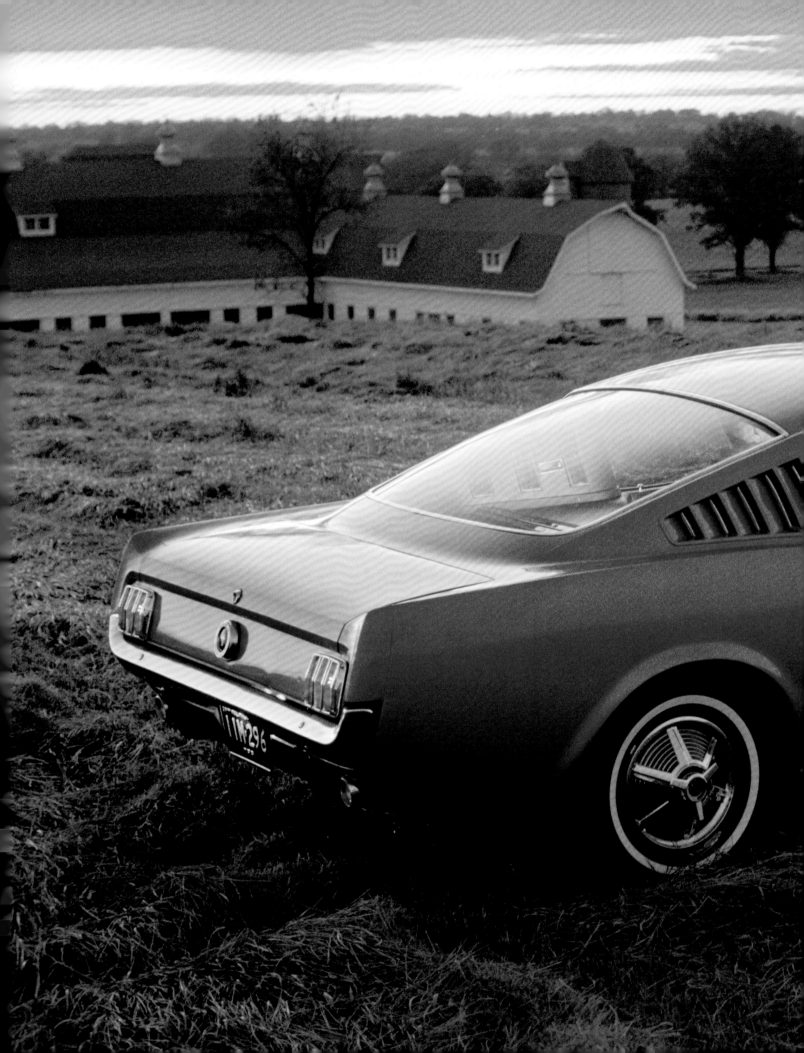

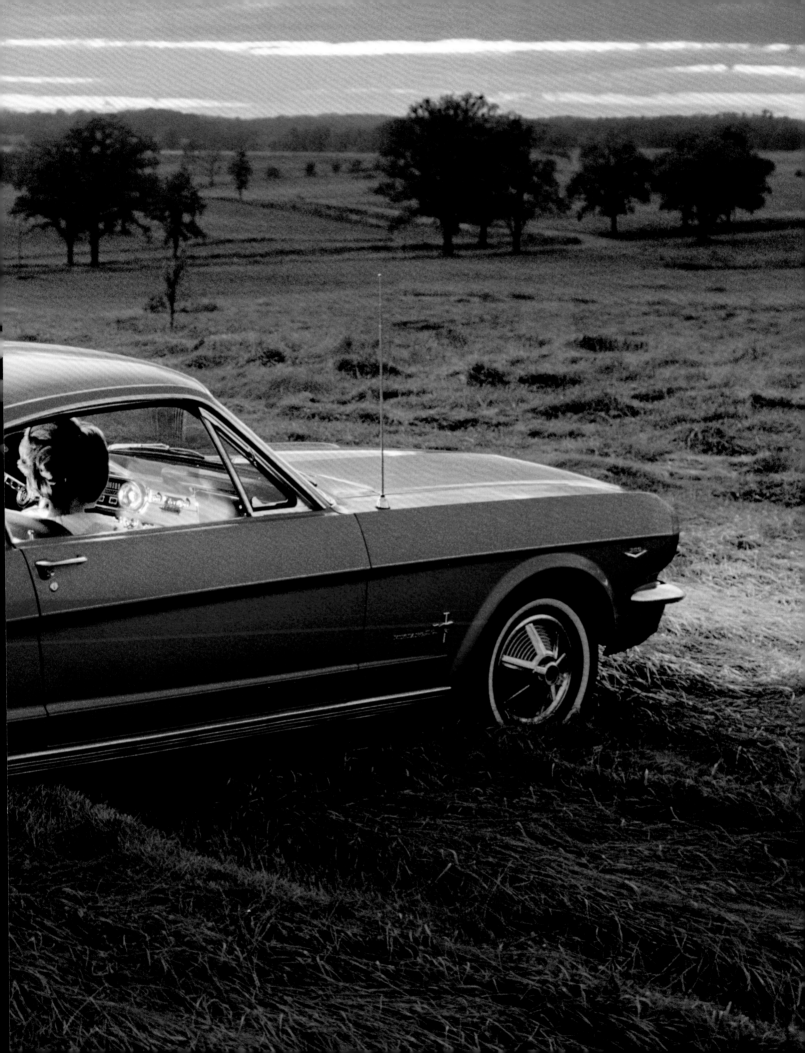

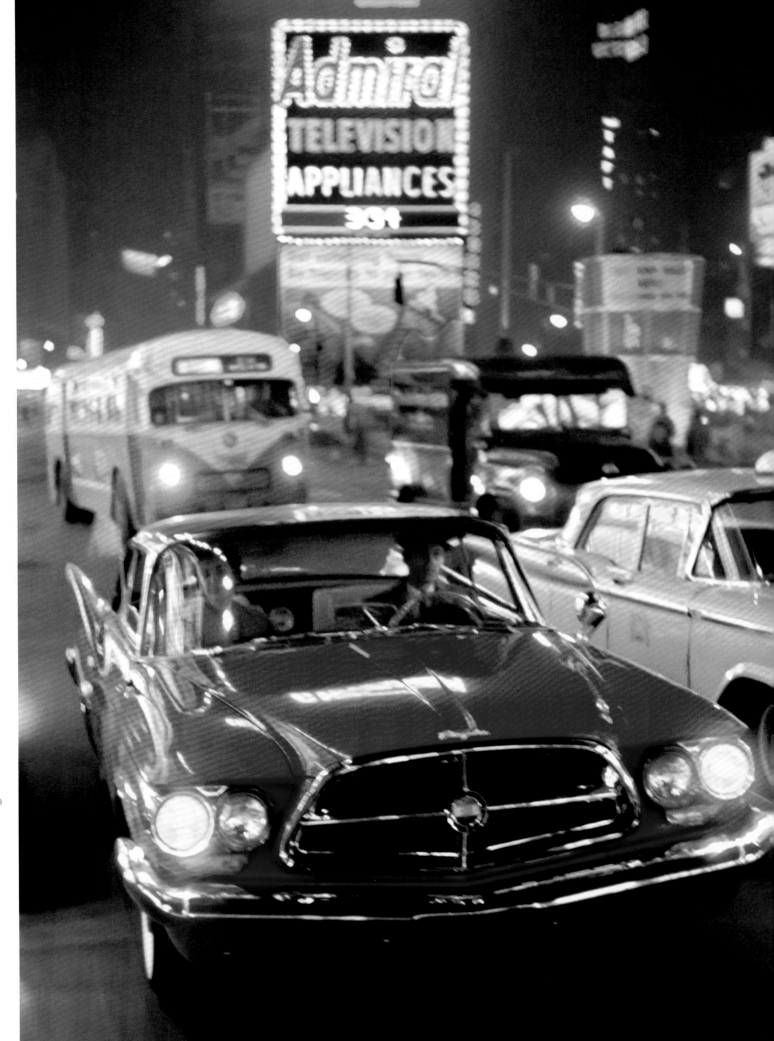

CULTURE

CARS AS FLASHY COMBINATIONS of modernism, consumerism, and popular culture made you want to look, and Zimmerman's images put you in the middle of it all. His prolific sophisticated eye saw deep into the sociology of change from dirt tracks to family station wagons, anticipating our nostalgia for a time when what you drove could matter more than anything. What he saw was fresh and profound— not just on American roads and highways, but at drive-ins, car shows, and just parked in driveways. The cars and people of automobile culture changed America's vision of itself.

—T.M.

PREVIOUS:
A '60 Chrysler 300F outshines the bright lights of Times Square.

OPPOSITE:
Vintage US and Canadian license plates from the early days of the automobile.

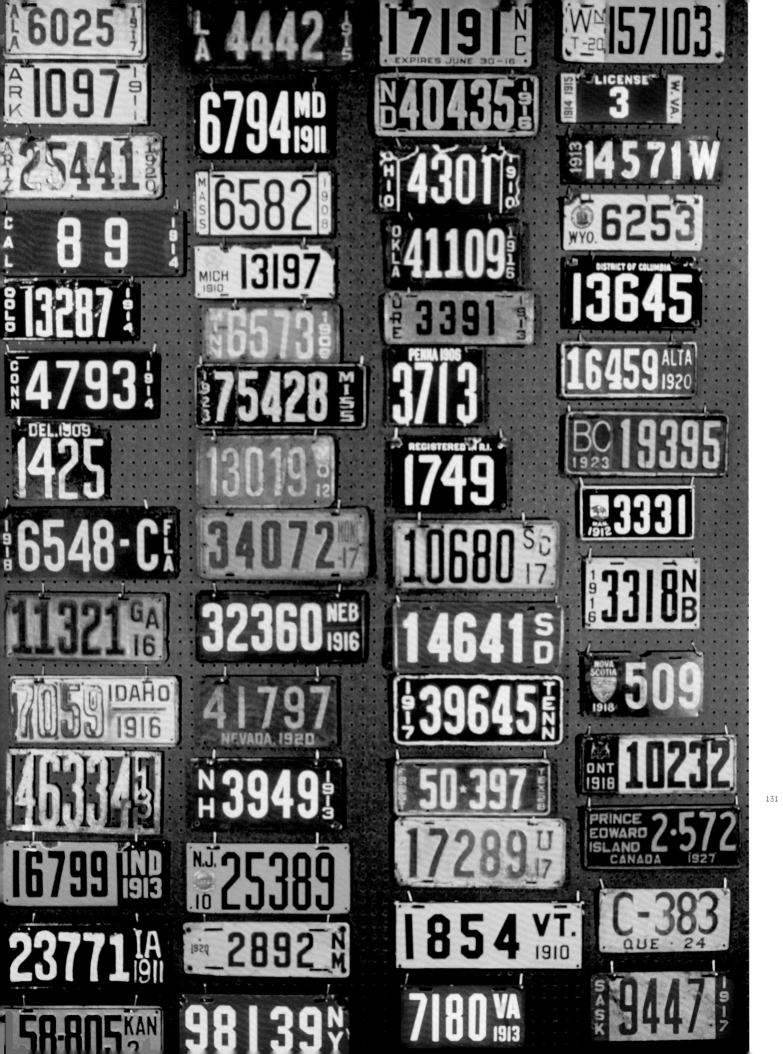

131

132 Mechanic Arthur
Vogel diagnoses a
police officer's car
at his Cleveland
auto shop in 1953.
Vogel designed
and patented a
suspension safety
system called the
Curvemaster.

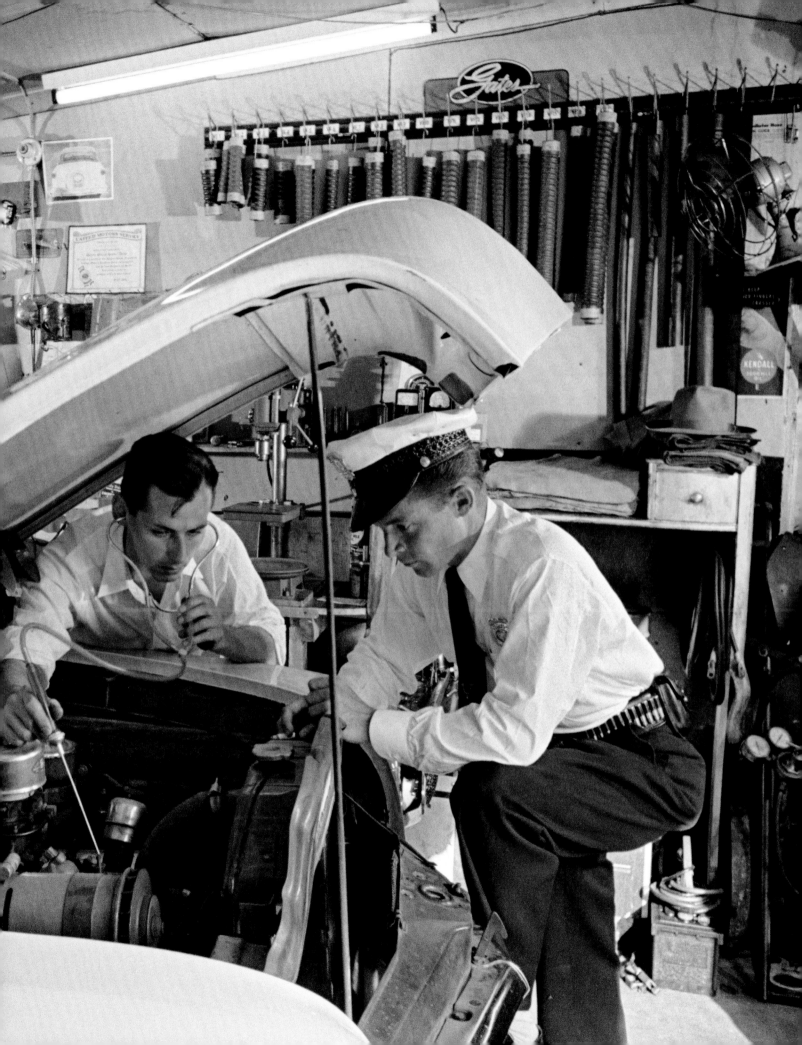

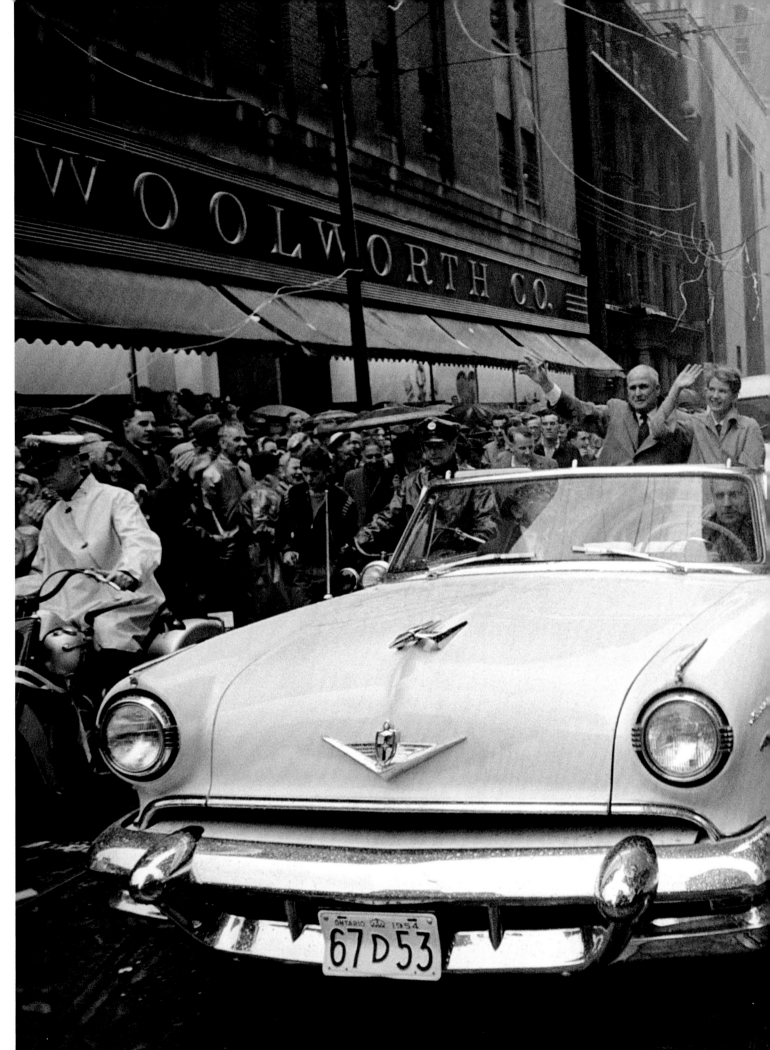

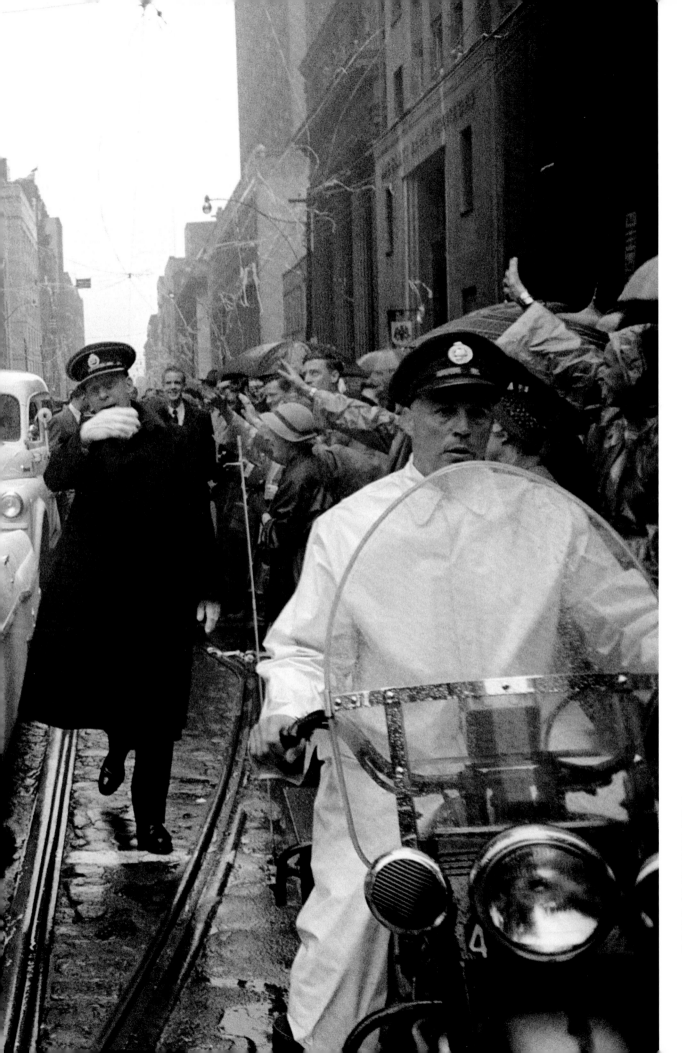

Marilyn Bell, a sixteen-year-old Canadian swimmer who crossed Lake Ontario in twenty-one hours, is greeted by a quarter of a million fans in Toronto in 1954. Her prize for the thirty-two-mile swim: a car, of course.

135

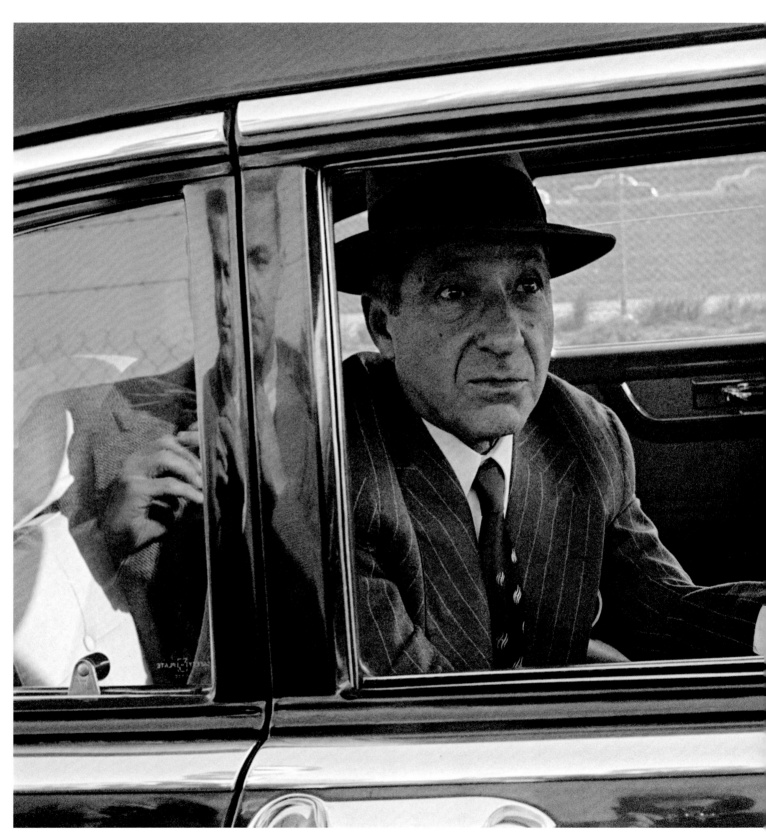

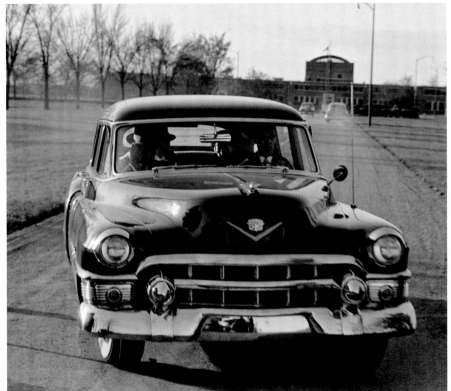

LEFT, ABOVE:
The freedom of the open road takes on a new meaning when leaving prison. Crime boss Frank Costello departs Milan Federal Correctional Institution in Cadillac style in a '53 Fleetwood limousine.

FOLLOWING LEFT:
Marconi C. Smith displays his funeral home's hearses in Sandersville, Georgia, in 1953.

FOLLOWING RIGHT ABOVE:
In 1955, Leonard Hall Jr. of Cleveland shows off his Duesenberg from the Paris coachmaker of Fernandez and Darrin.

FOLLOWING RIGHT BELOW:
The Northland Shopping Center in Southfield, Michigan, offers curbside service in 1955.

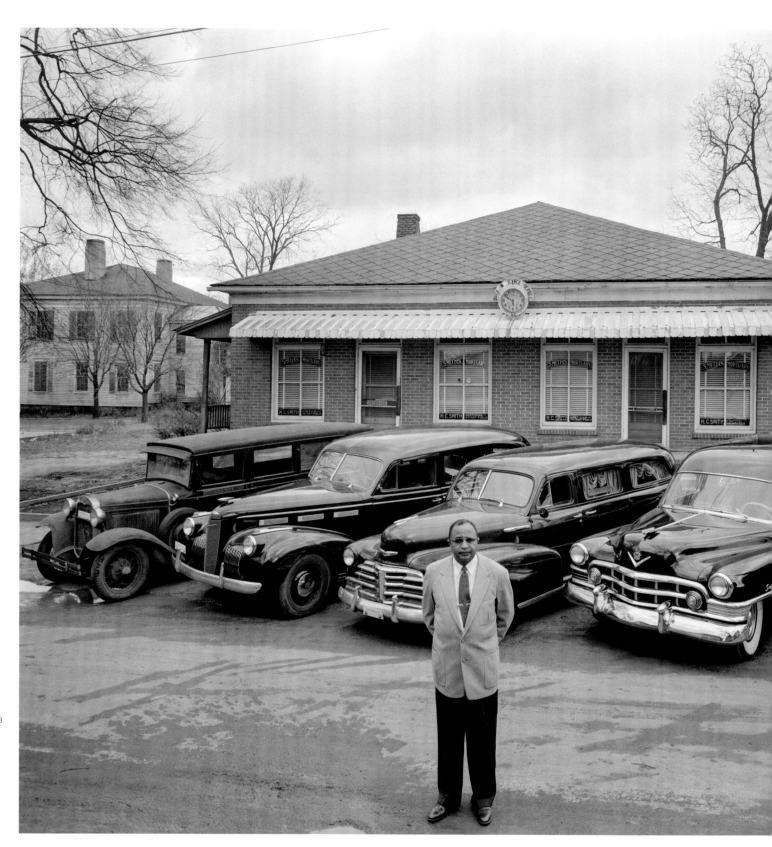

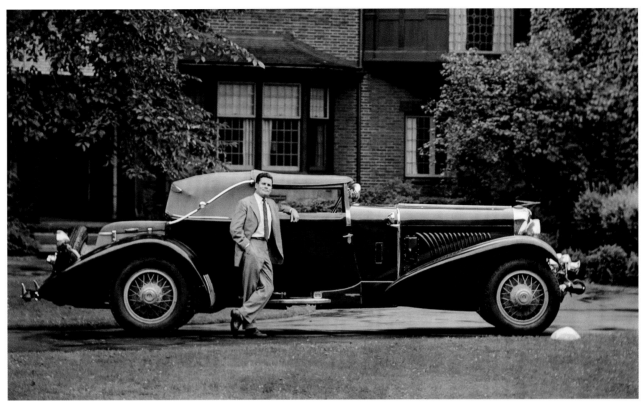

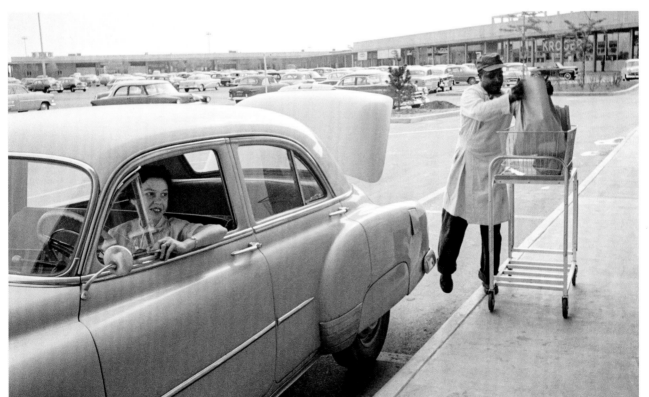

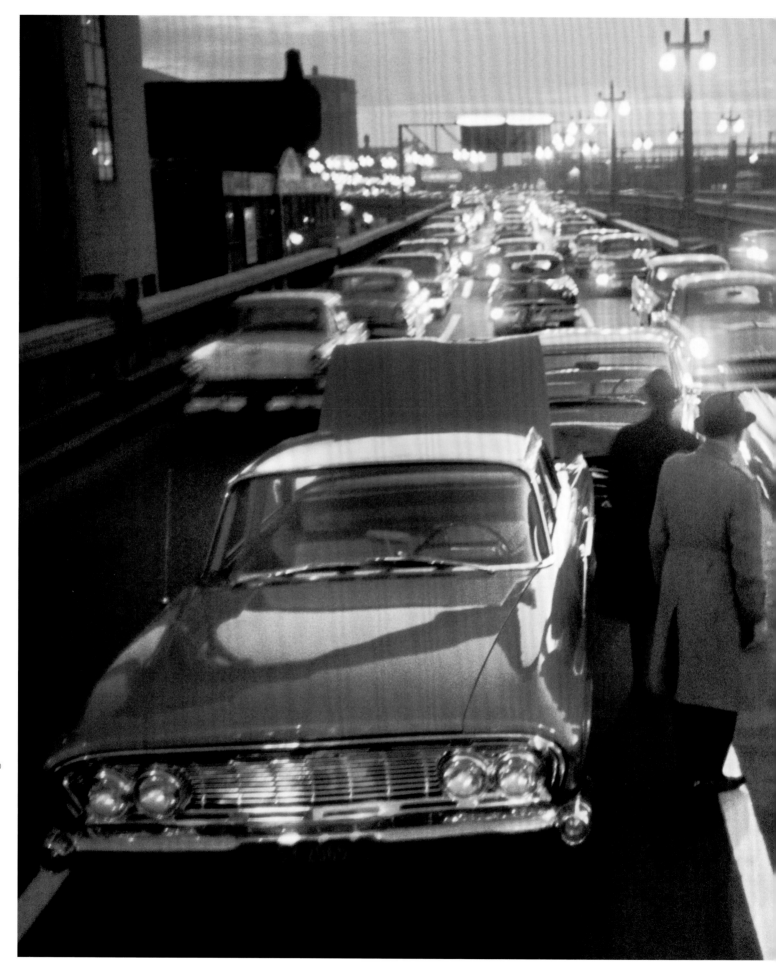

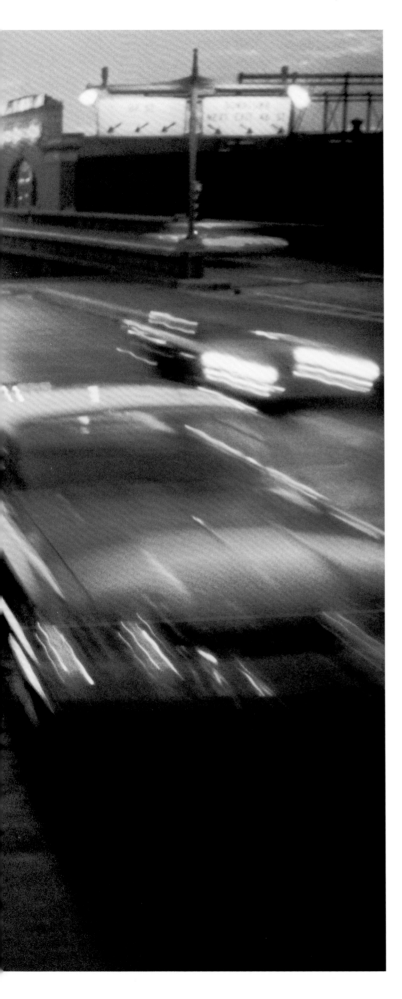

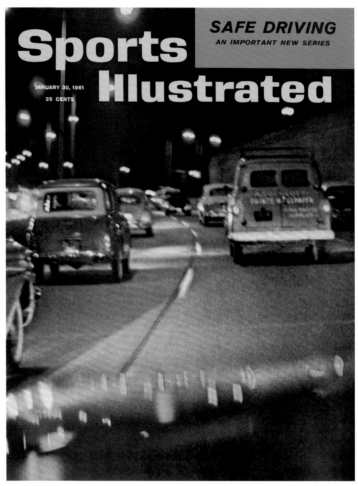

For a 1961 *Sports Illustrated* cover story, Zimmerman took to the roads to report on safe driving. The issue came too late for the cars involved in this accident.

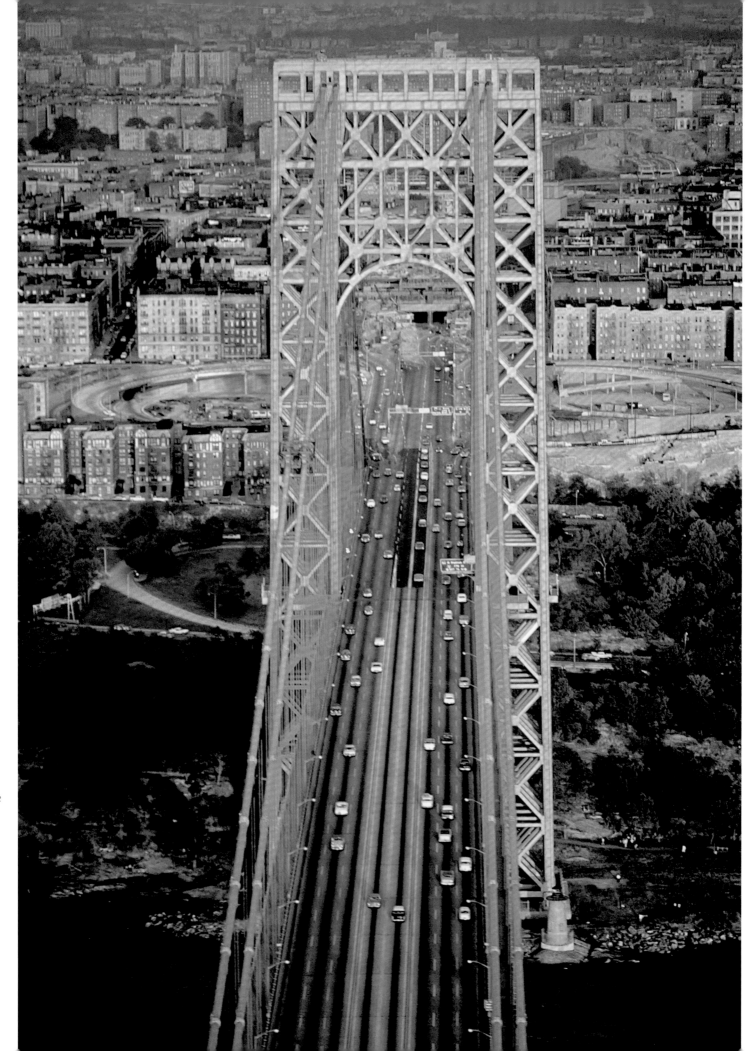

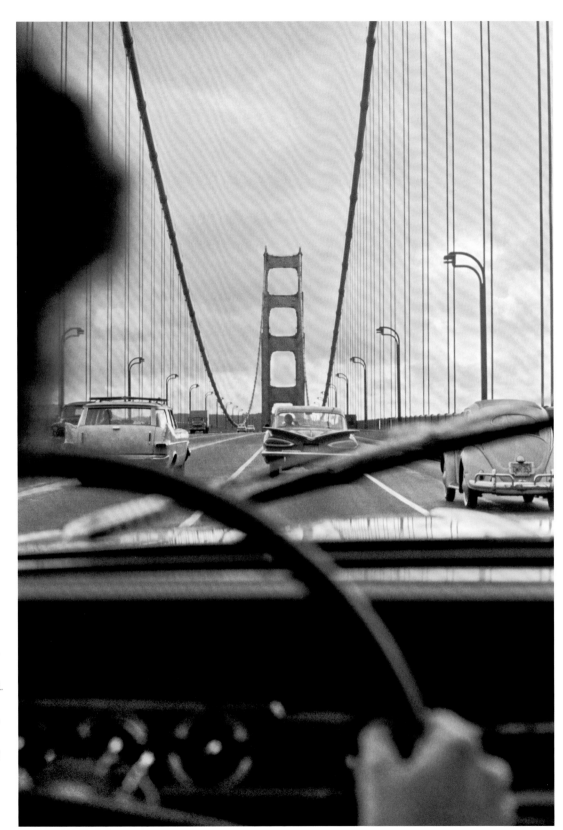

143

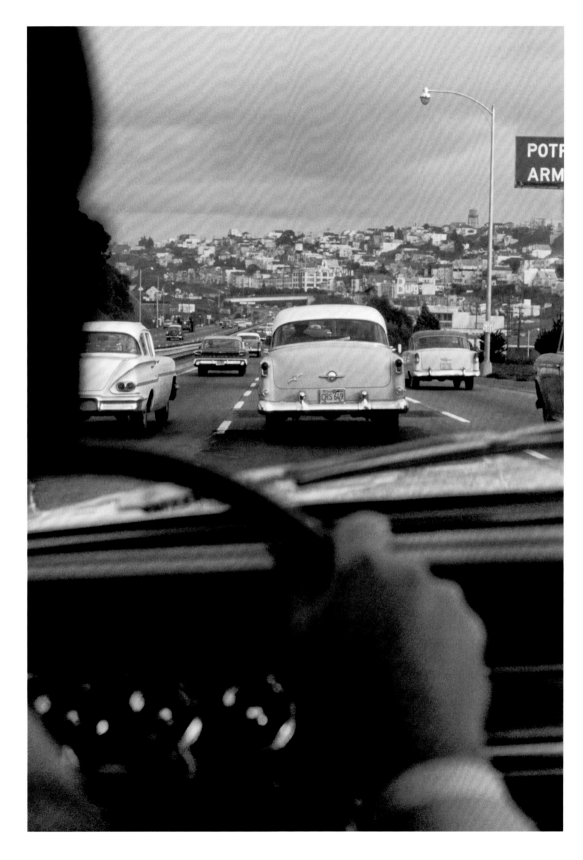

LEFT, OPPOSITE:
Zimmerman
conveyed a real
sense of driving
conditions (as
seen in this *Sports
Illustrated* photo
spread) from San
Francisco's hills
to New York City's
tunnels and the
Pacific Coast's
curves.

FOLLOWING:
Navigating
New York City
in the snow in
1960.

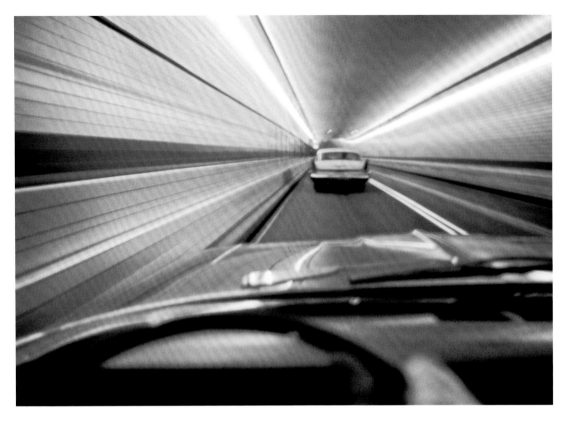

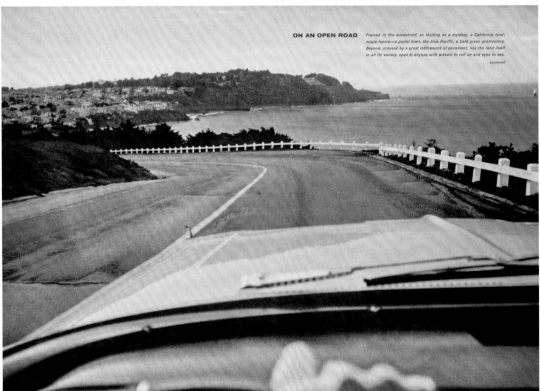

ON AN OPEN ROAD *Framed in the windshield, as inviting as a mystery, a California landscape looms—a pastel town, the blue Pacific, a bold green promontory. Beyond, crossed by a great latticework of pavement, lies the land itself in all its variety, open to anyone with wheels to roll on and eyes to see.*

continued

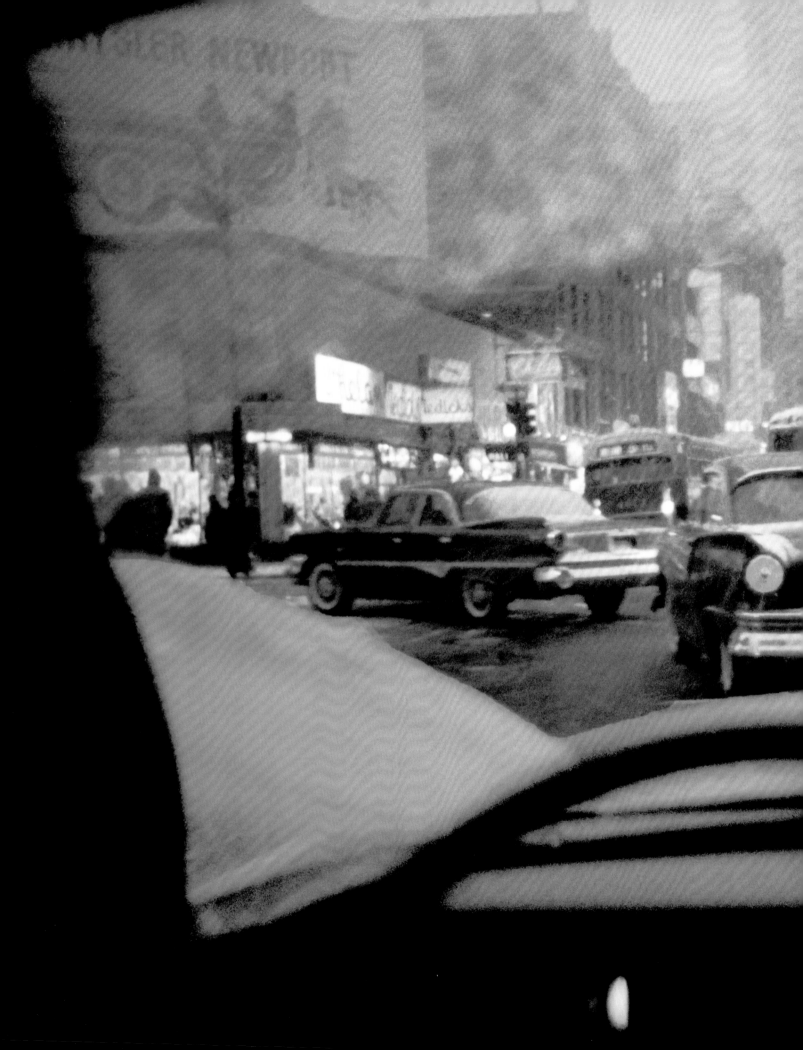

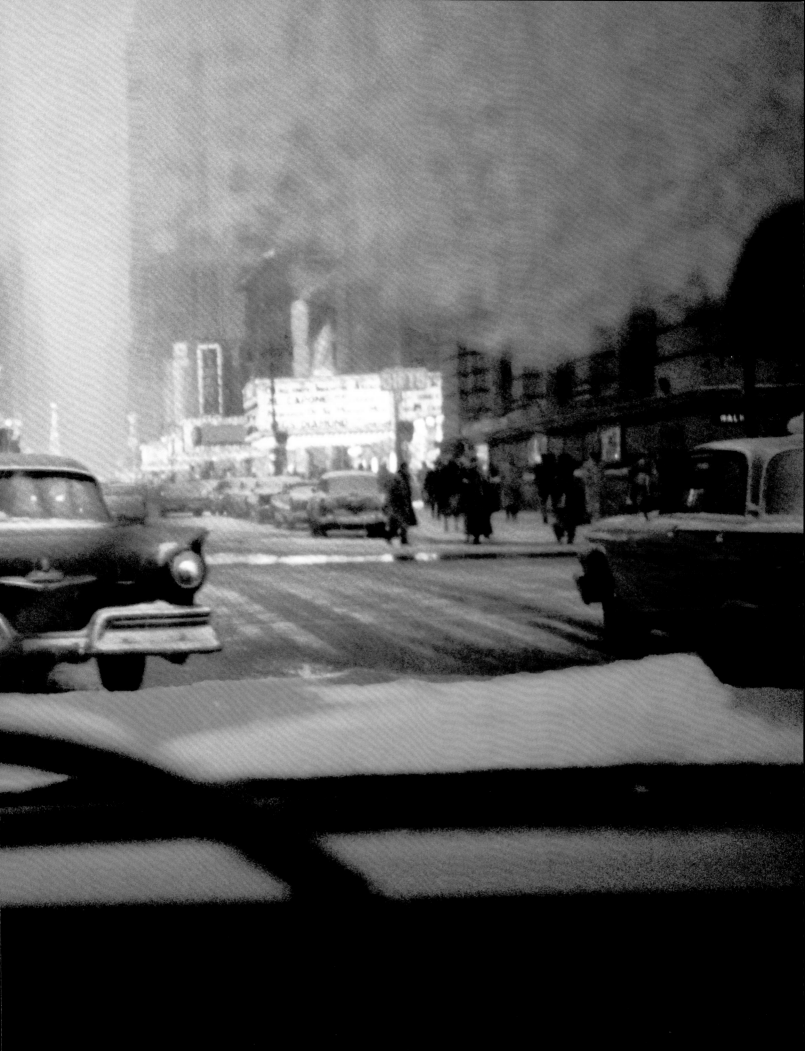

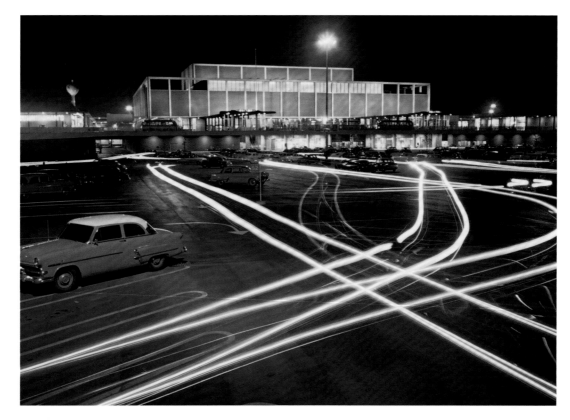

ABOVE:
A long exposure tracks the mall traffic at Northland Shopping Center in 1955.

RIGHT, OPPOSITE:
Zimmerman could capture motion with or without cars (like these crisscrossing overpasses).

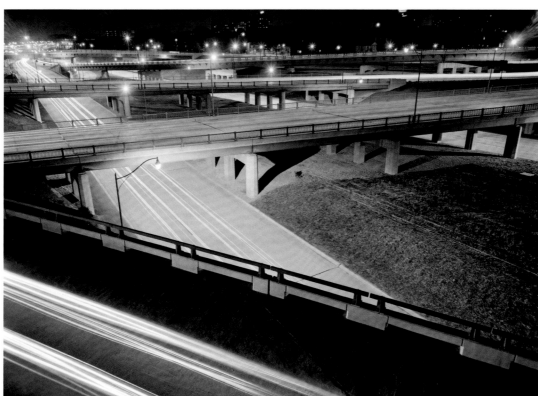

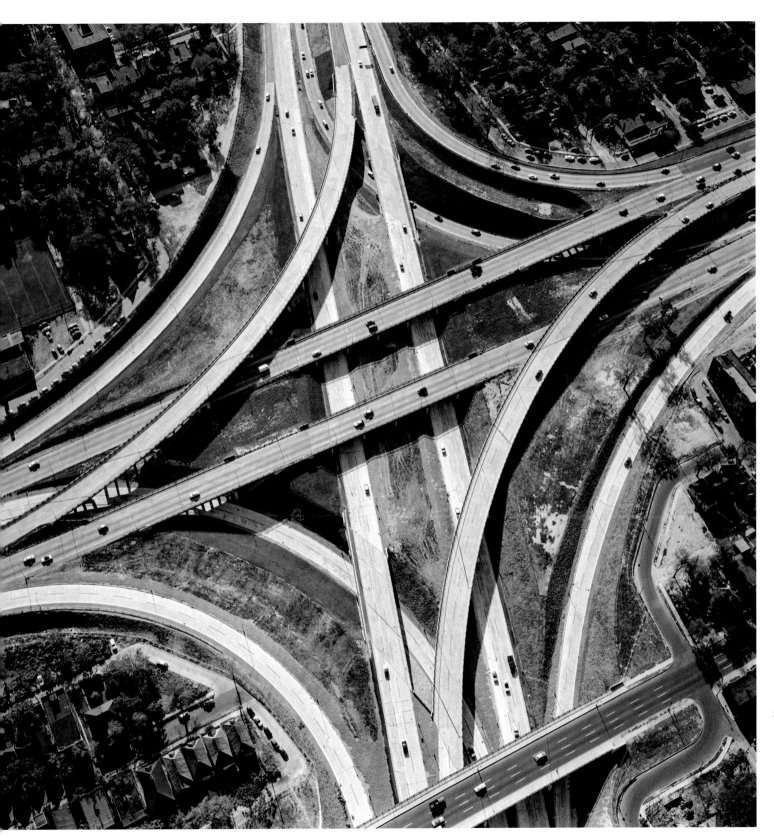

149

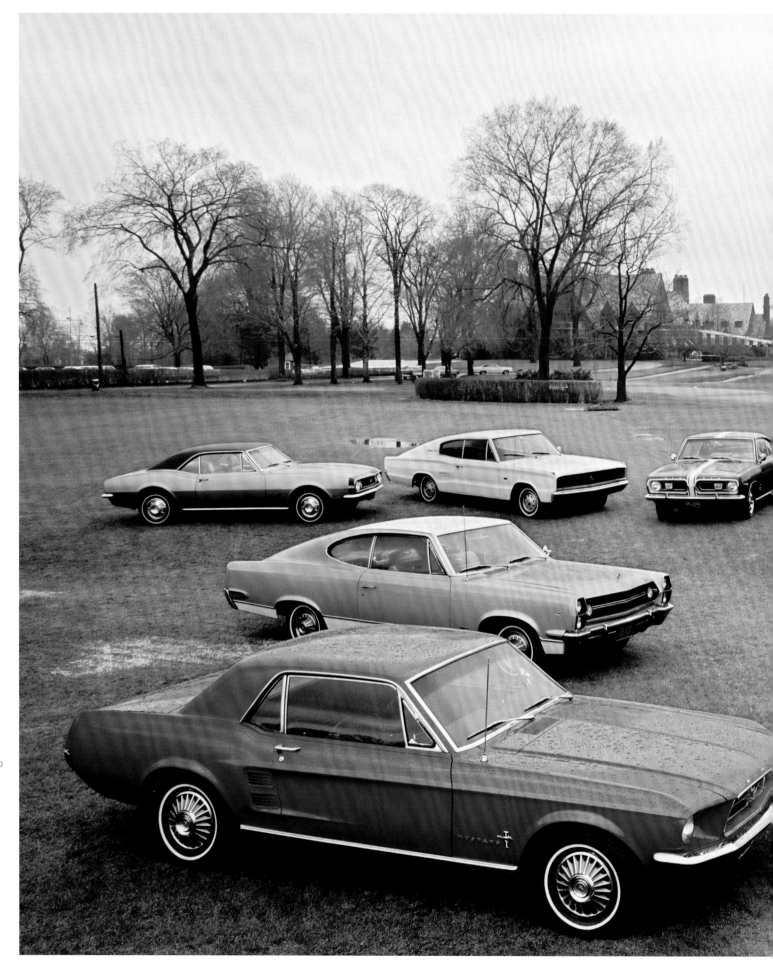

Fast cars on the fairway at Winged Foot Golf Club in Mamaroneck, New York in 1966.

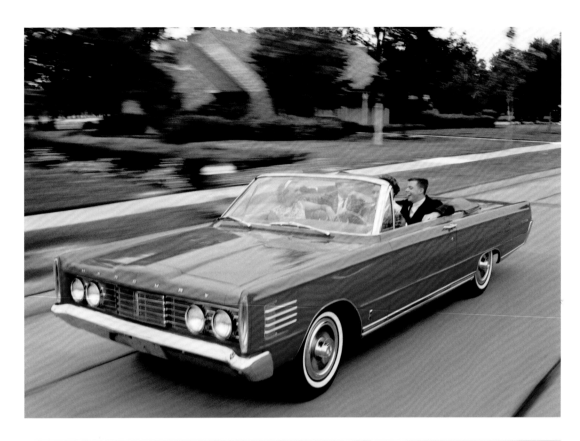

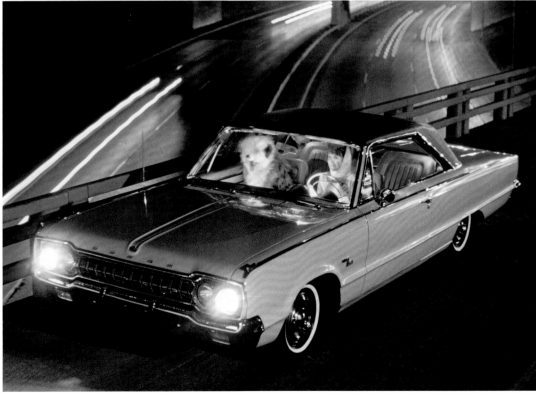

ABOVE:
'65 Mercury Park Lane.

LEFT:
Delores Zimmerman, the wife of the photographer, gamely plays model in a '65 Dodge Monaco.

OPPOSITE:
'65 Oldsmobile 98.

FOLLOWING:
In 1970, some 200 enterprising students who were devoted to lowering fossil fuel emissions created forty-four clean air cars—powered by electricity, steam, turbo engines, and more—to race across the country from MIT to Caltech.

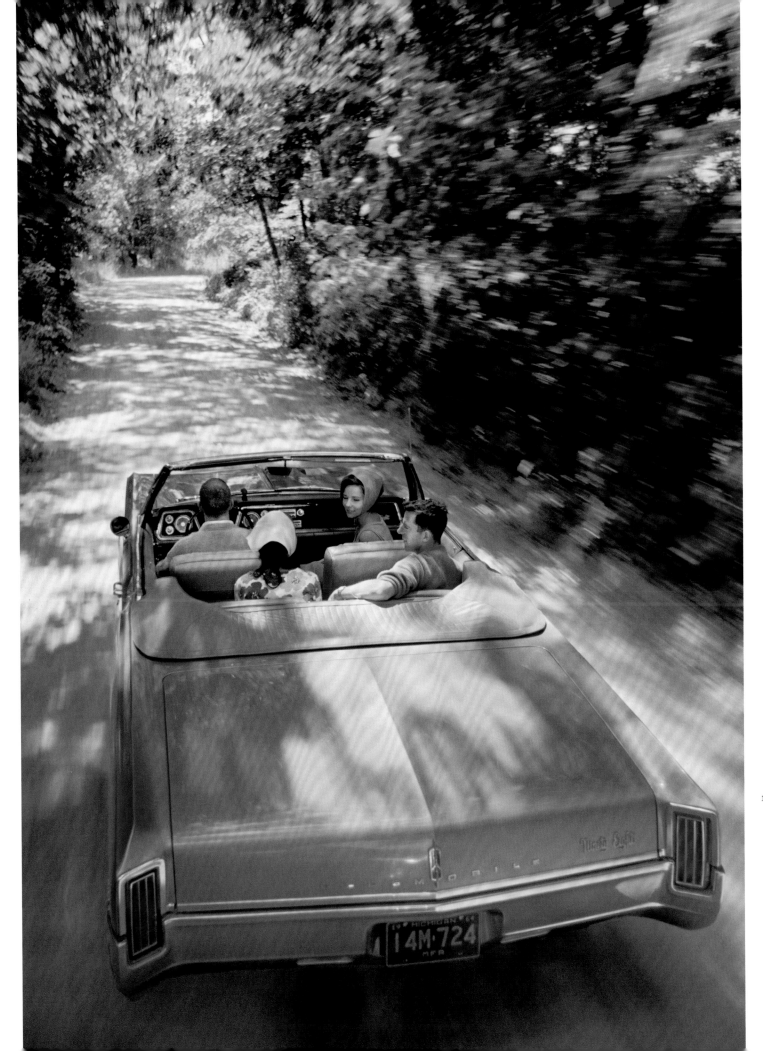

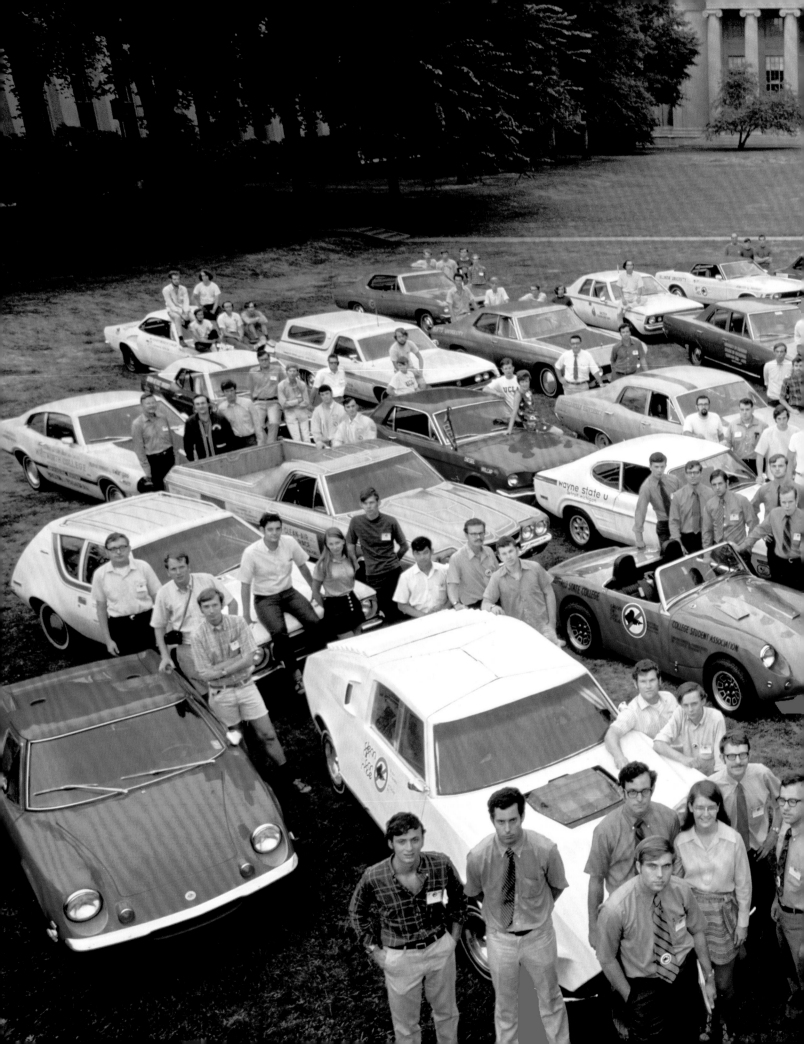

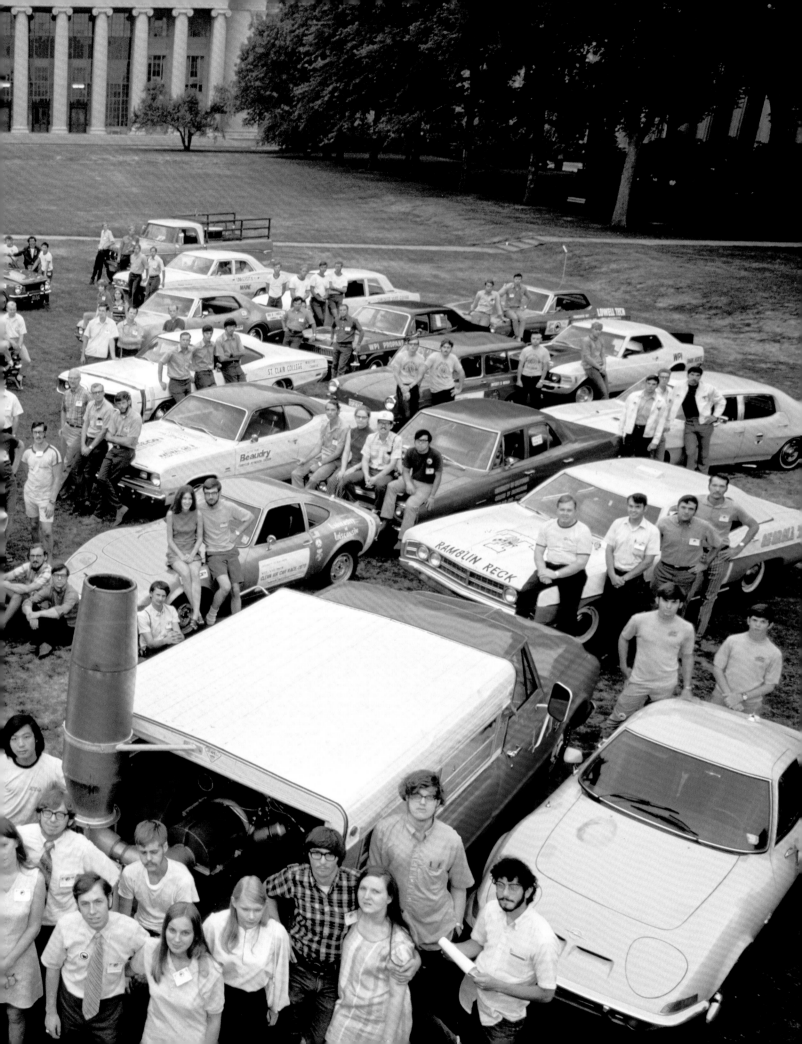

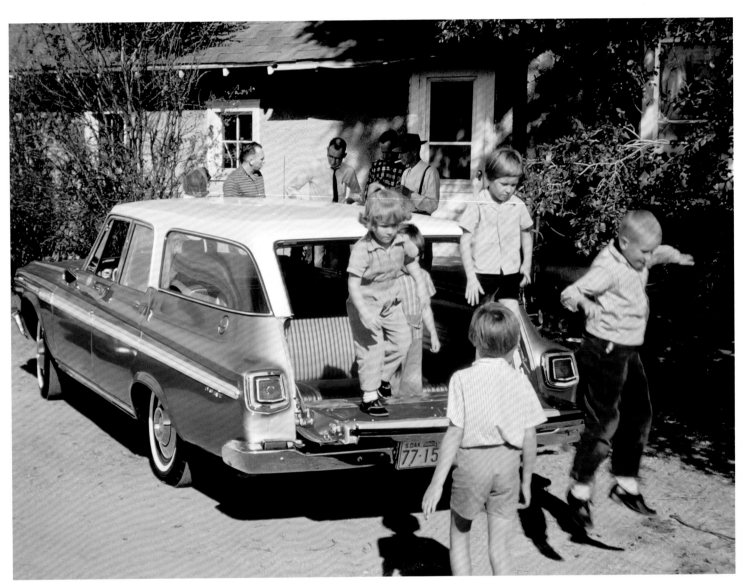

ABOVE:
Children jump
off the tailgate
of a Dodge Dart
Station Wagon in
Aberdeen, South
Dakota in 1963.

OPPOSITE:
A '65 Pontiac is a
big hit on campus.

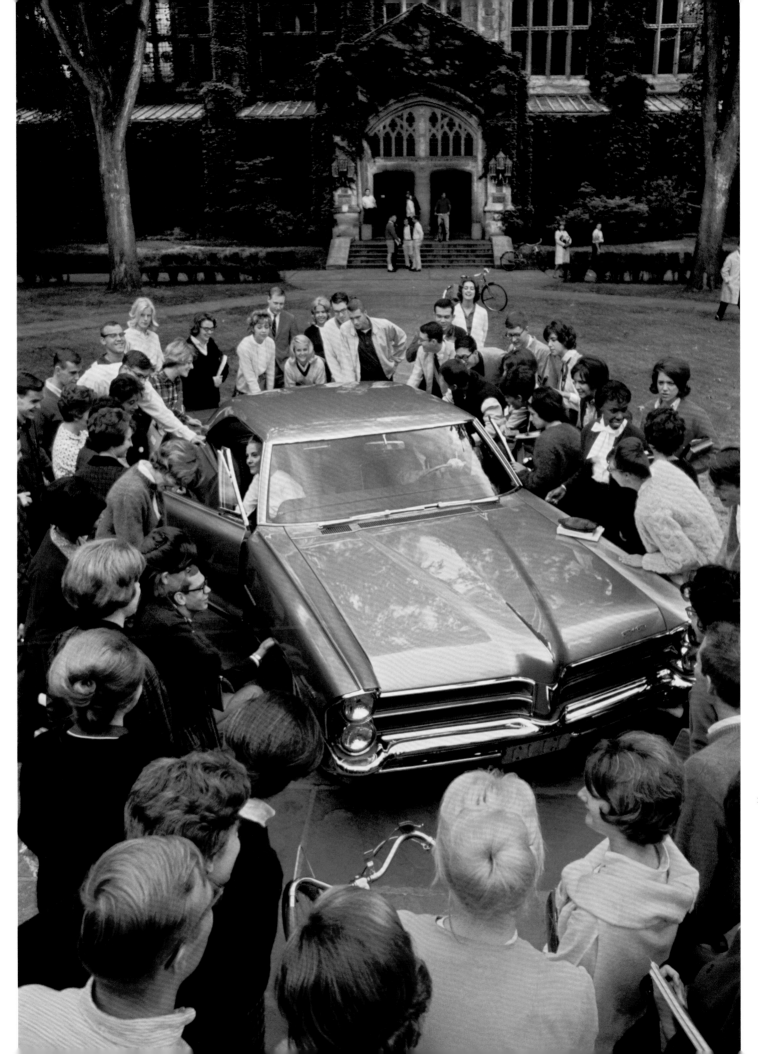

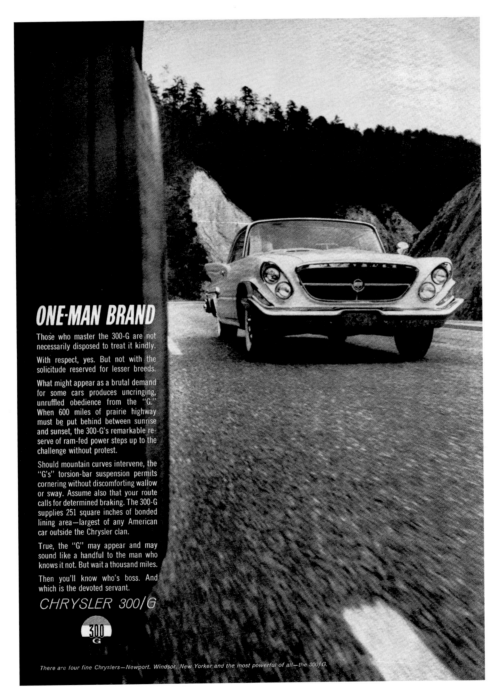

ONE-MAN BRAND

Those who master the 300-G are not necessarily disposed to treat it kindly.

With respect, yes. But not with the solicitude reserved for lesser breeds.

What might appear as a brutal demand for some cars produces uncringing, unruffled obedience from the "G." When 600 miles of prairie highway must be put behind between sunrise and sunset, the 300-G's remarkable reserve of ram-fed power steps up to the challenge without protest.

Should mountain curves intervene, the "G's" torsion-bar suspension permits cornering without discomforting wallow or sway. Assume also that your route calls for determined braking. The 300-G supplies 251 square inches of bonded lining area—largest of any American car outside the Chrysler clan.

True, the "G" may appear and may sound like a handful to the man who knows it not. But wait a thousand miles.

Then you'll know who's boss. And which is the devoted servant.

CHRYSLER 300/G

There are four fine Chryslers—Newport. Windsor. New Yorker and the most powerful of all—the 300/G.

ABOVE:
A '61 Chrysler 300G ad shot by Zimmerman.

OPPOSITE:
A '61 Chrysler 300G sits in front of the sprawling Biltmore Estate in Asheville, North Carolina.

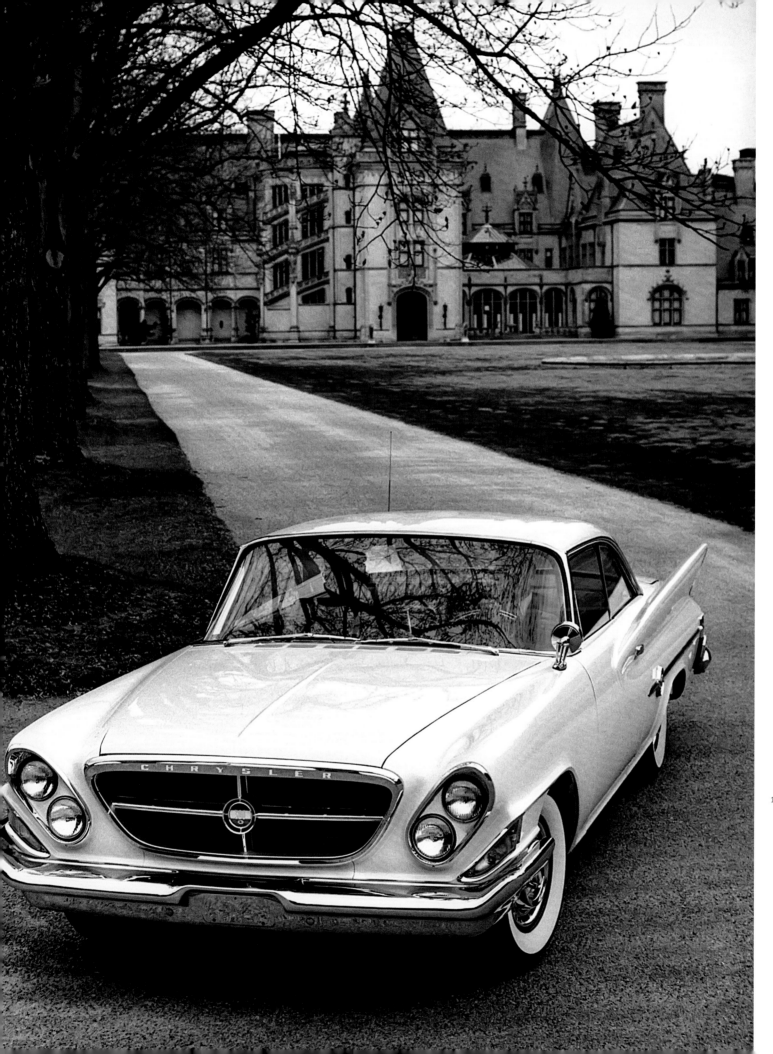

159

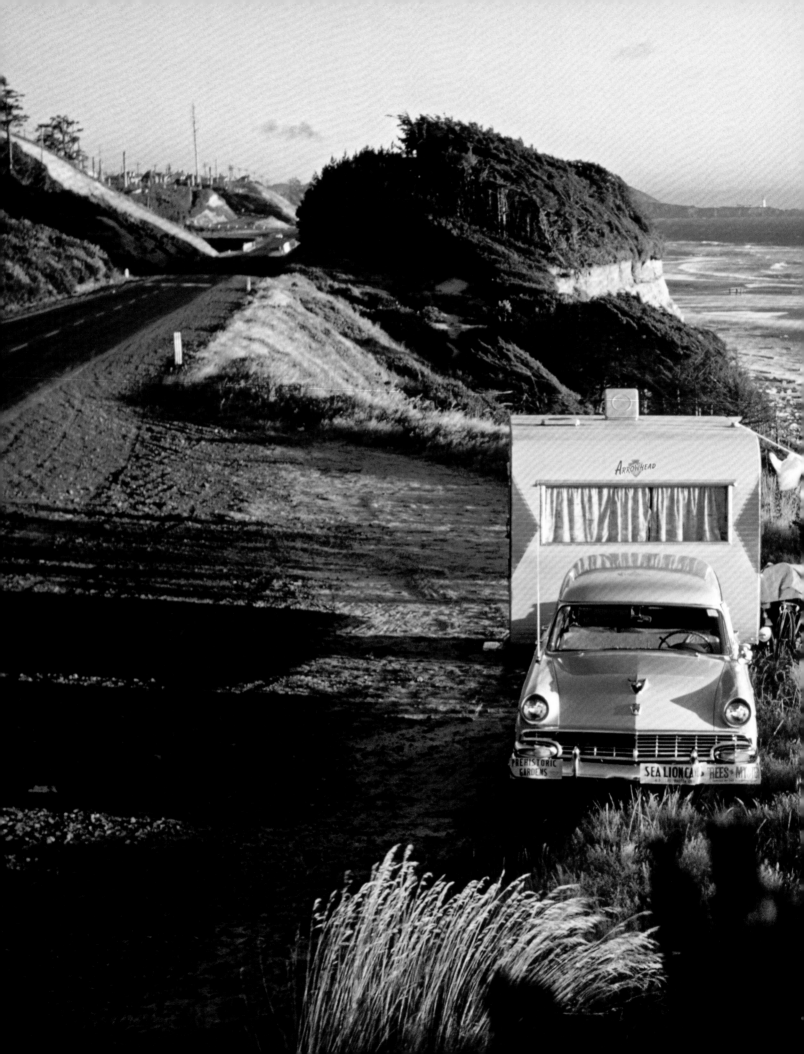

Car camping in an
Arrowhead trailer
on the Oregon
coast, 1958.

161

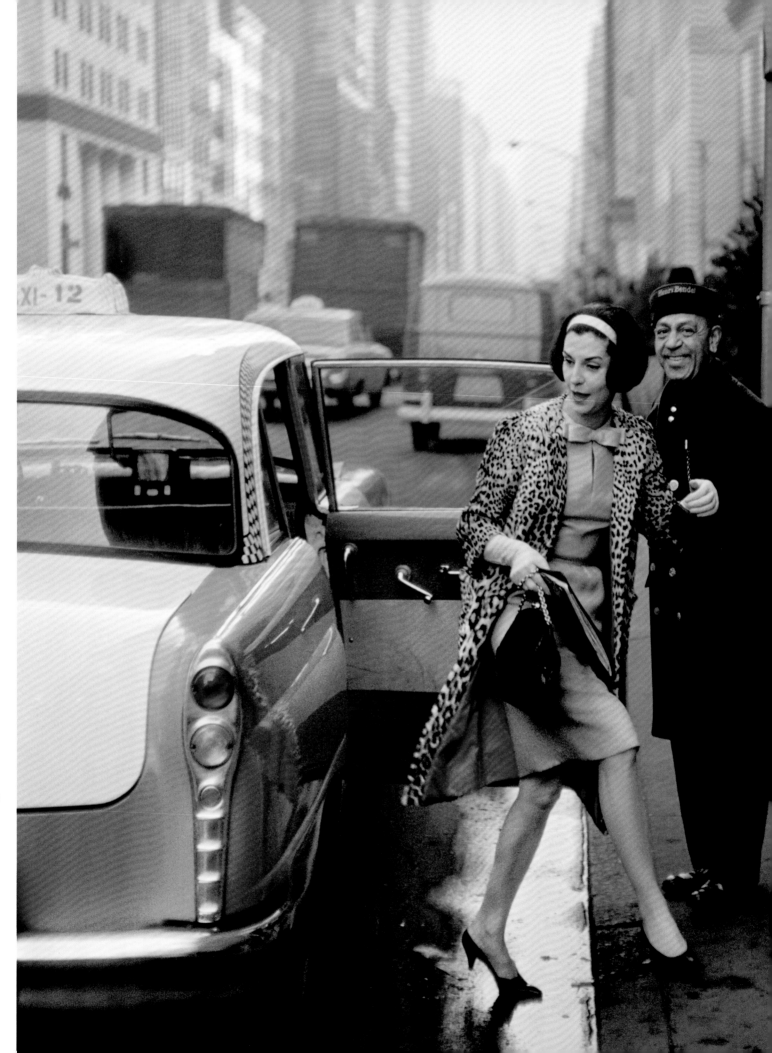

Geraldine Stutz,
president of
retailer Henri
Bendel, exits a taxi
with the help of
doorman James
"Buster" Jarrett in
New York City
in 1963.

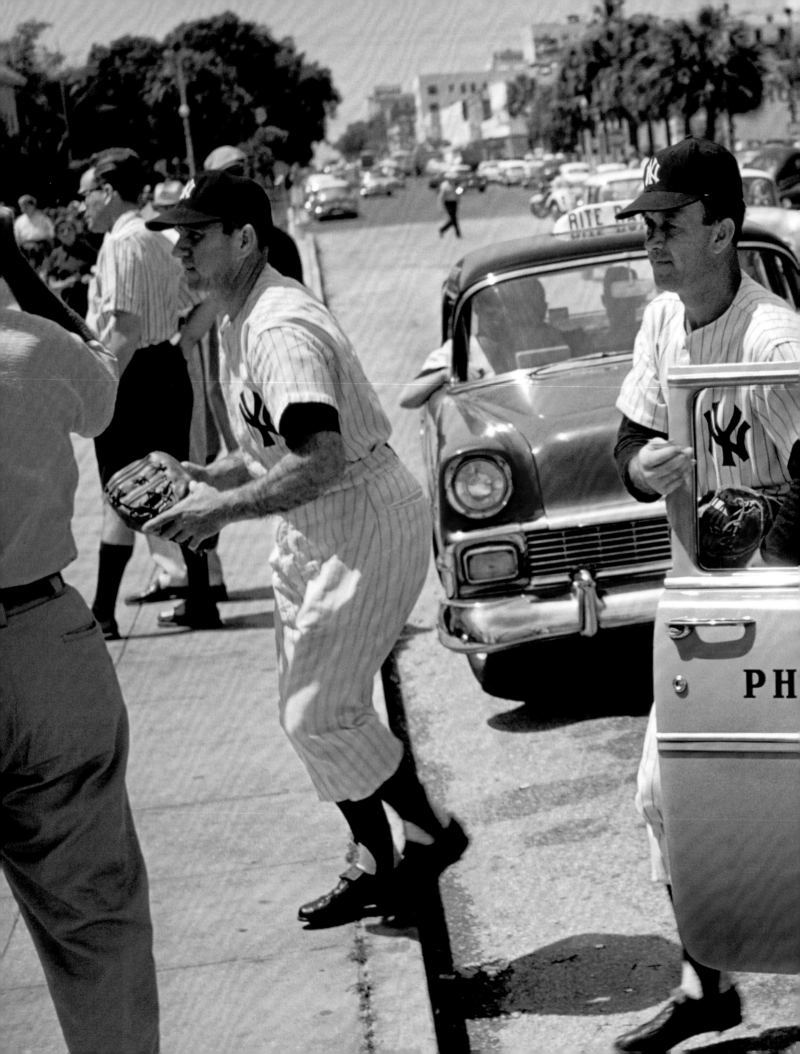

Enos Slaughter 165
and Joe Collins
(*right*) of the
New York Yankees
arrive by taxi to
a 1958 spring
training game in
St. Petersburg,
Florida.

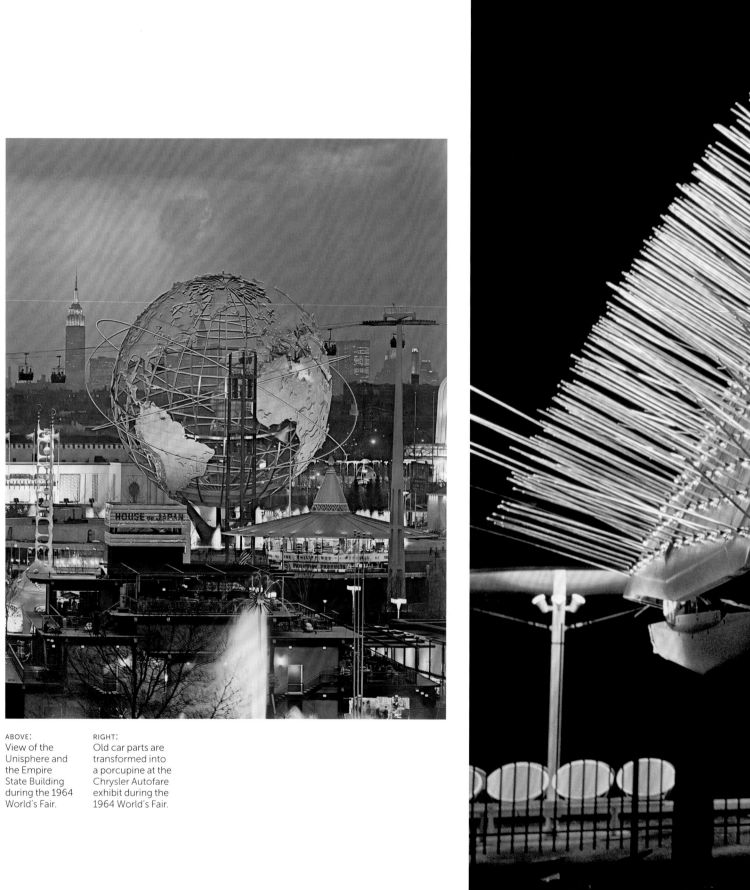

ABOVE:
View of the
Unisphere and
the Empire
State Building
during the 1964
World's Fair.

RIGHT:
Old car parts are
transformed into
a porcupine at the
Chrysler Autofare
exhibit during the
1964 World's Fair.

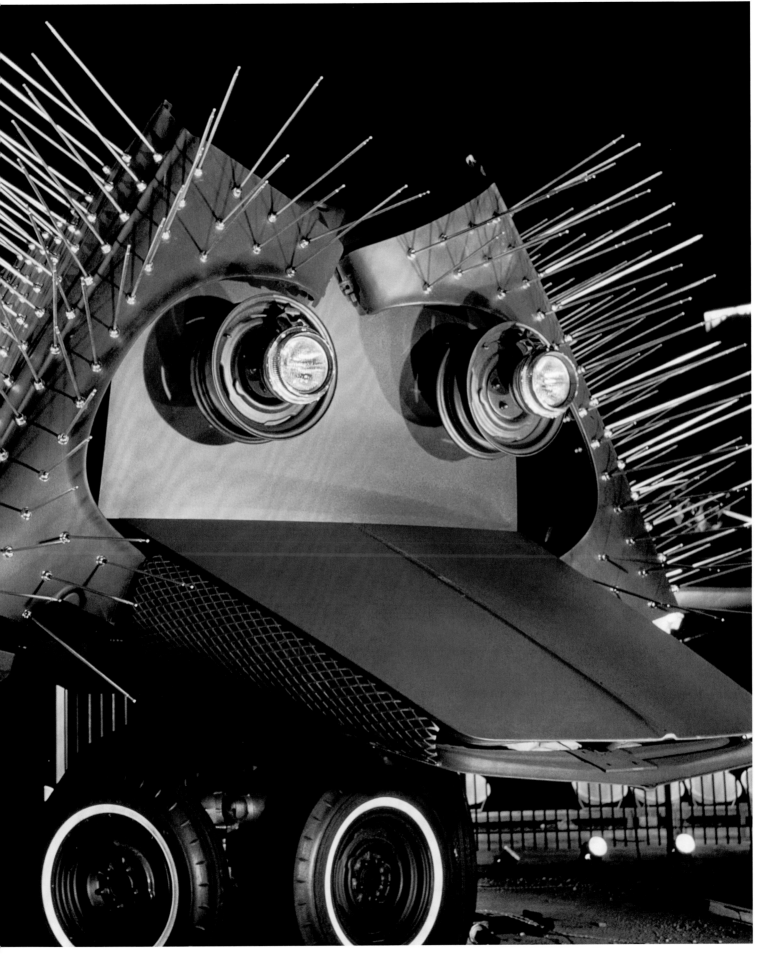

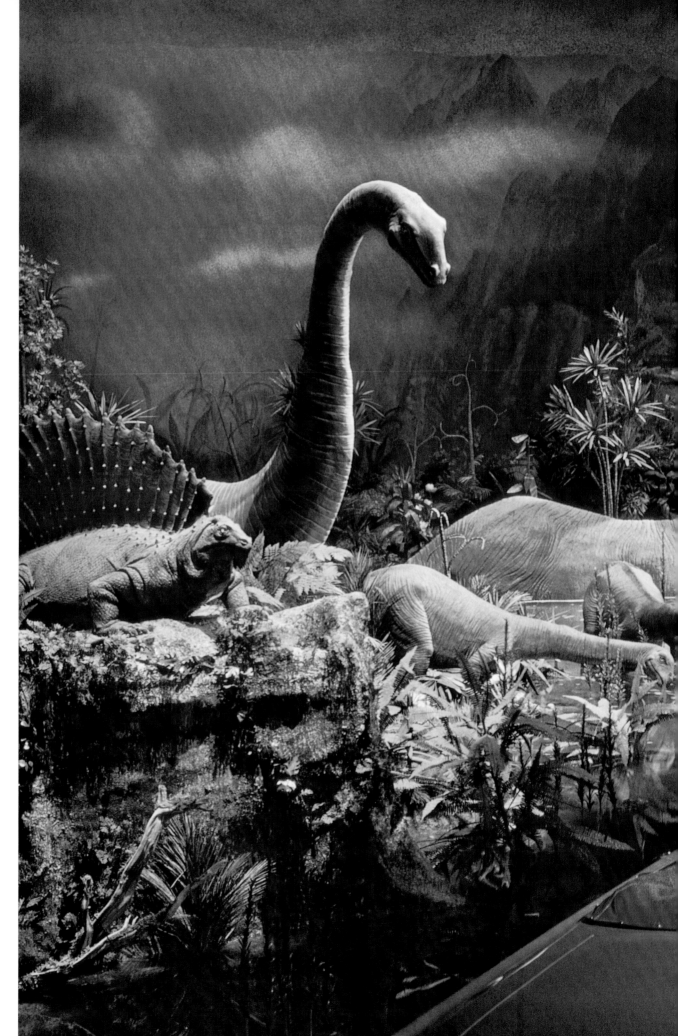

From ferocious to fossil fuels: dinosaurs at the 1964 World's Fair captivate passengers in Ford convertibles on a ride dreamed up by Walt Disney's Imagineers.

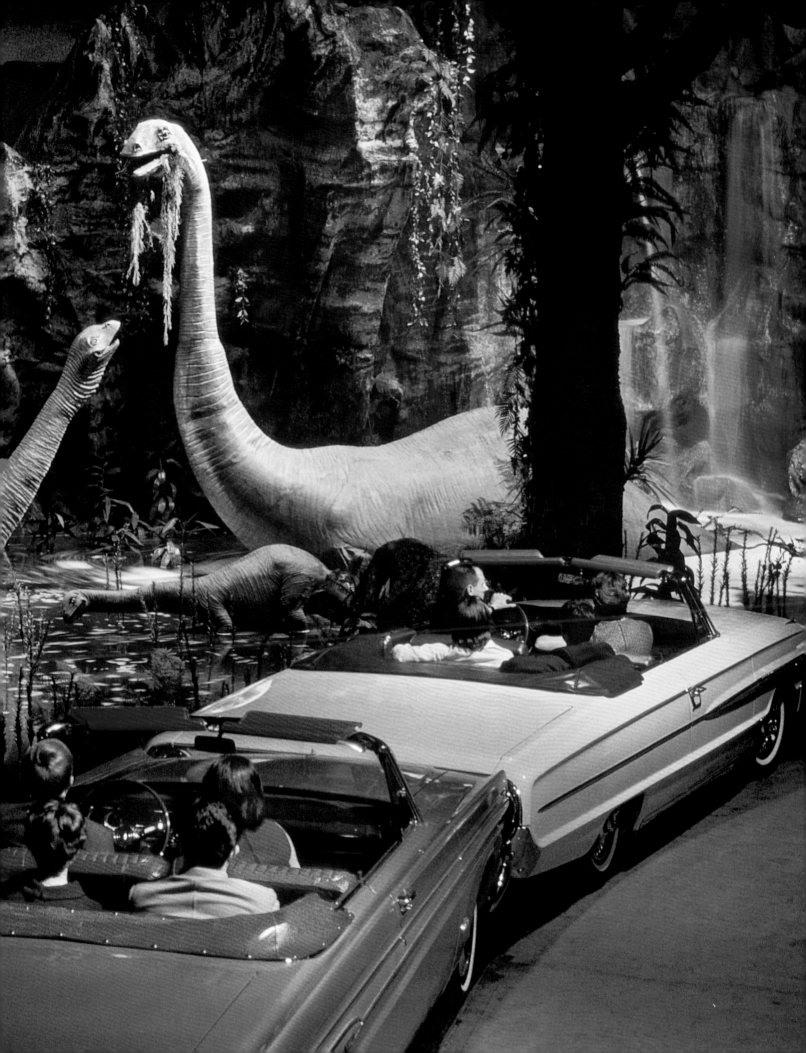

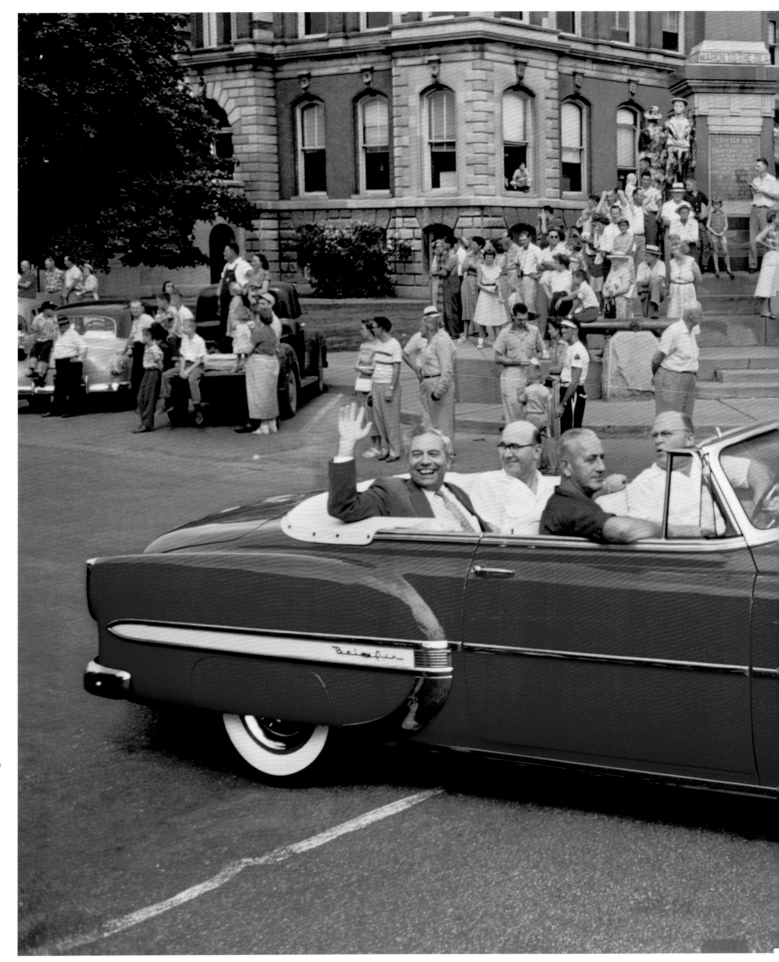

Indiana Congress-
man William G.
Bray greets his
constituents from
a Chevrolet Bel
Air convertible in
Princeton, Indiana,
during the 1954
Labor Day parade.

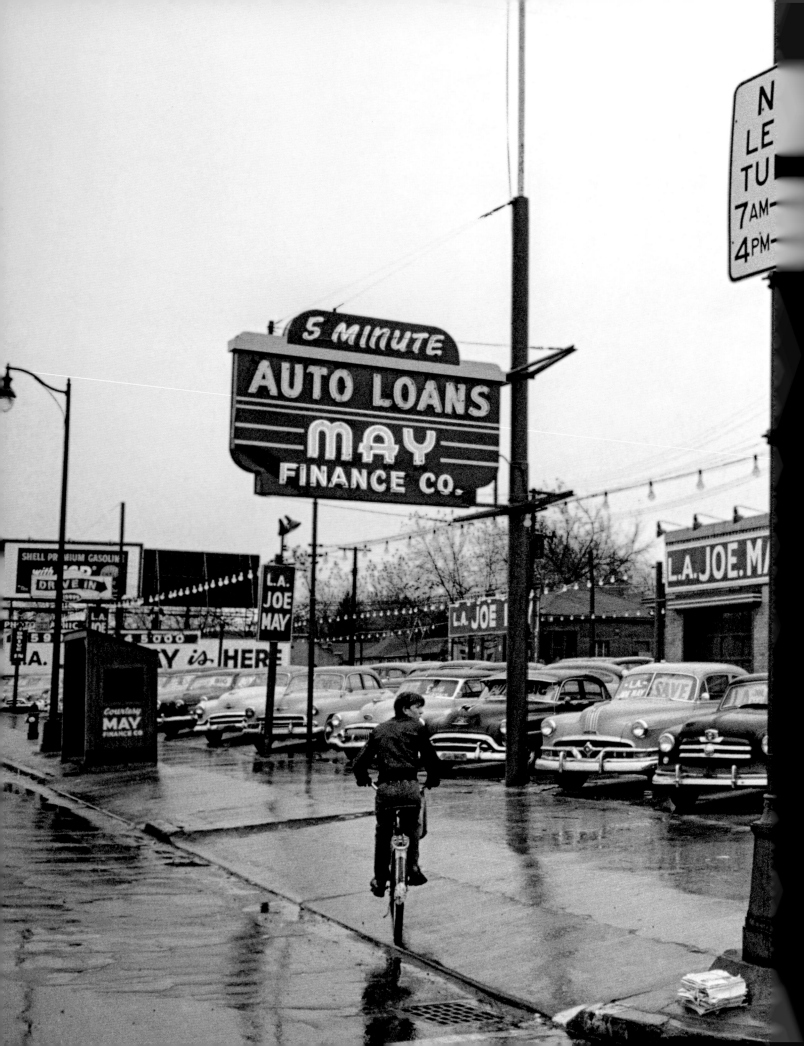

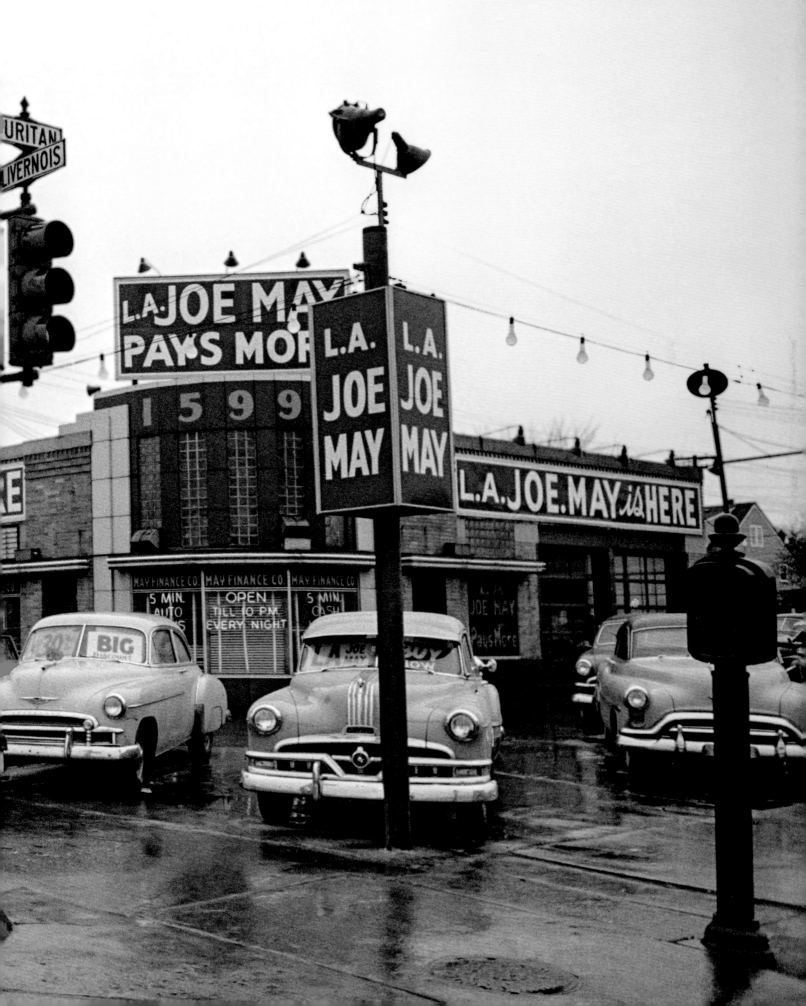

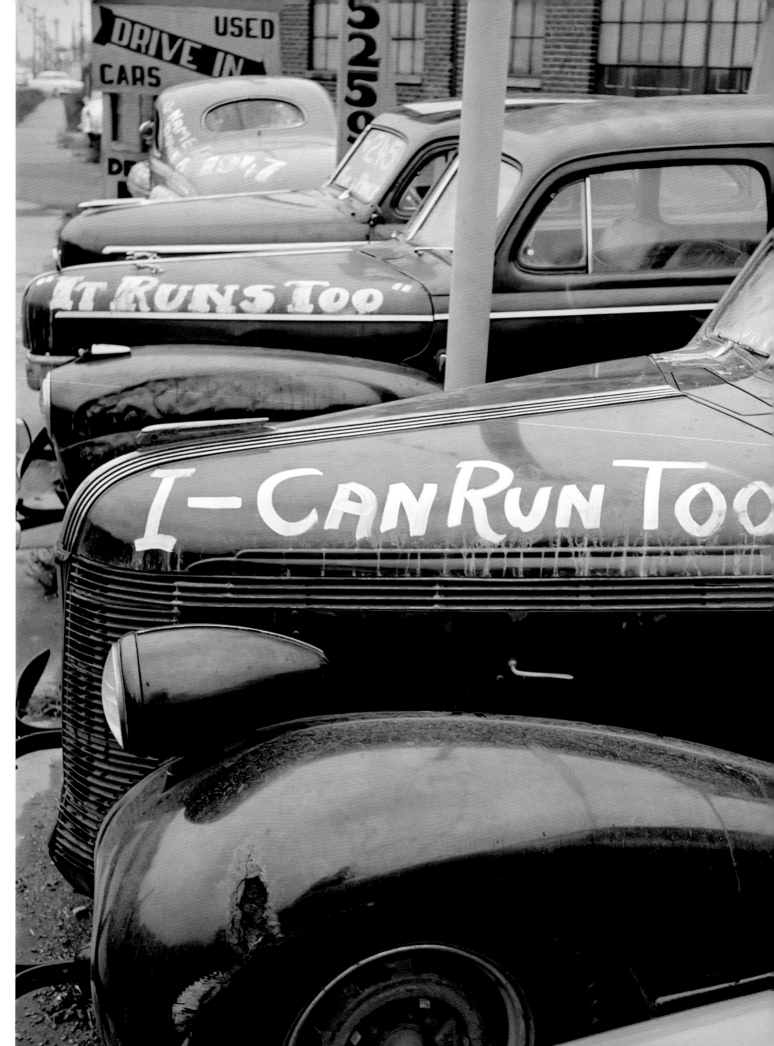

PREVIOUS, LEFT:
Livernois Avenue
in Detroit, which
had 200 dealers
in a seven-mile
span, was con-
sidered the used
car capital of the
world in 1954.

Yale Simons not only offered deals but also analyzed your signature—preferably, on the dotted line.

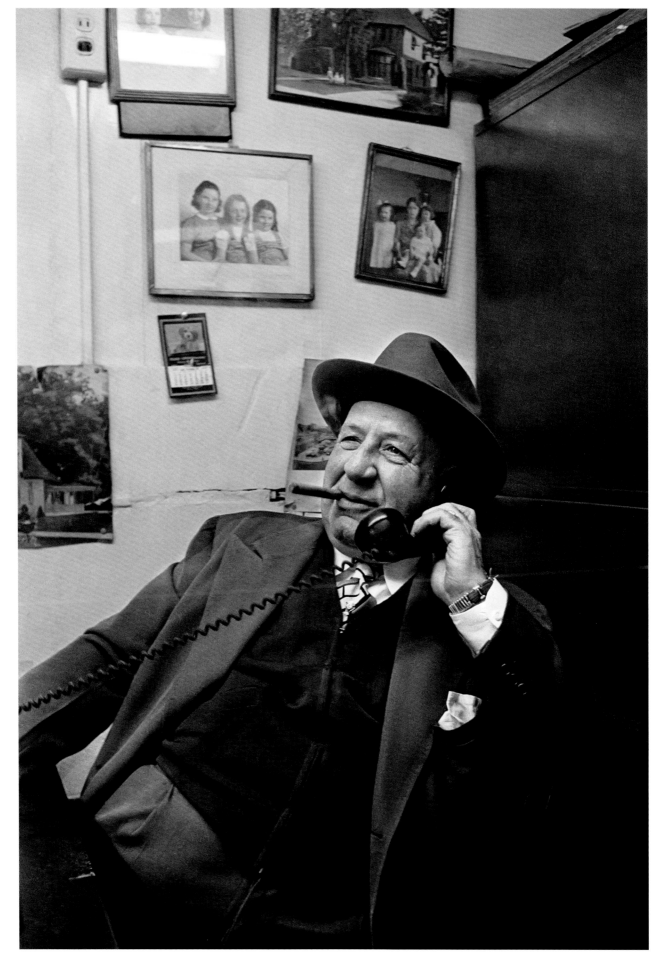

Selling on Livernois since 1929, Bert Baker pioneered the used car scene in Detroit.

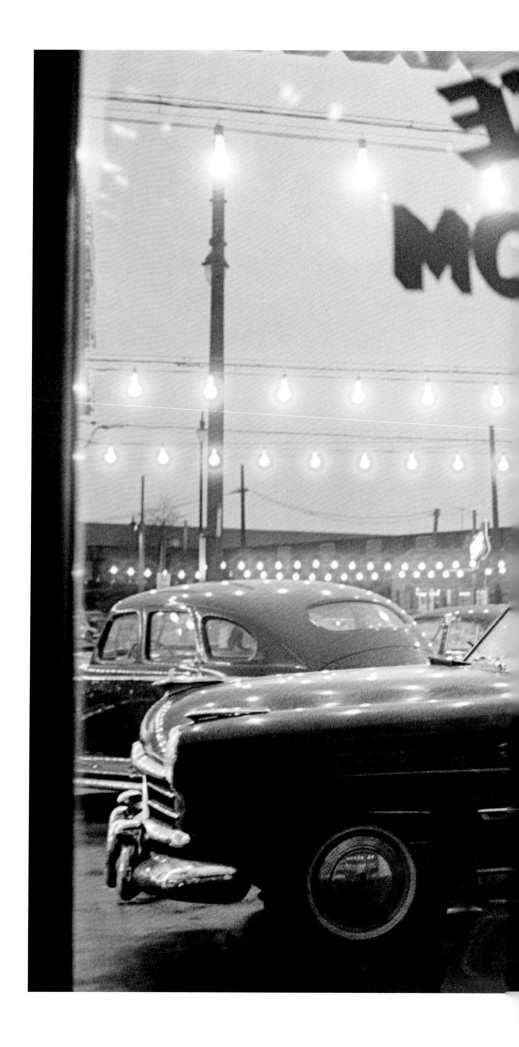

178 Sam Forman gets
an unsatisfactory
appraisal on his
Hudson.

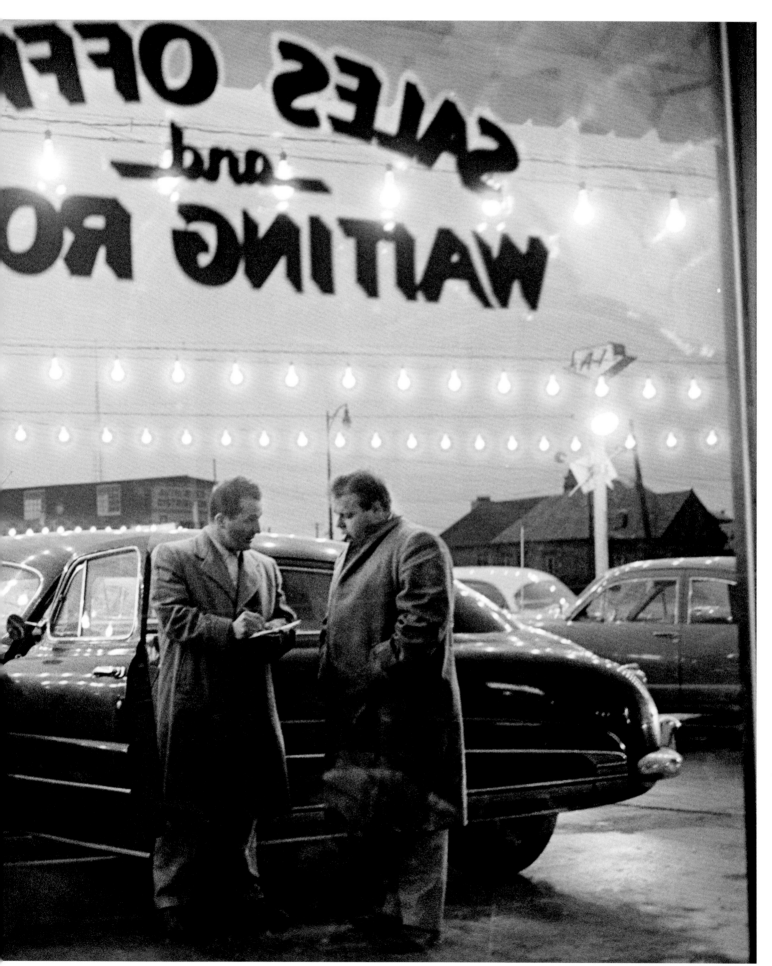

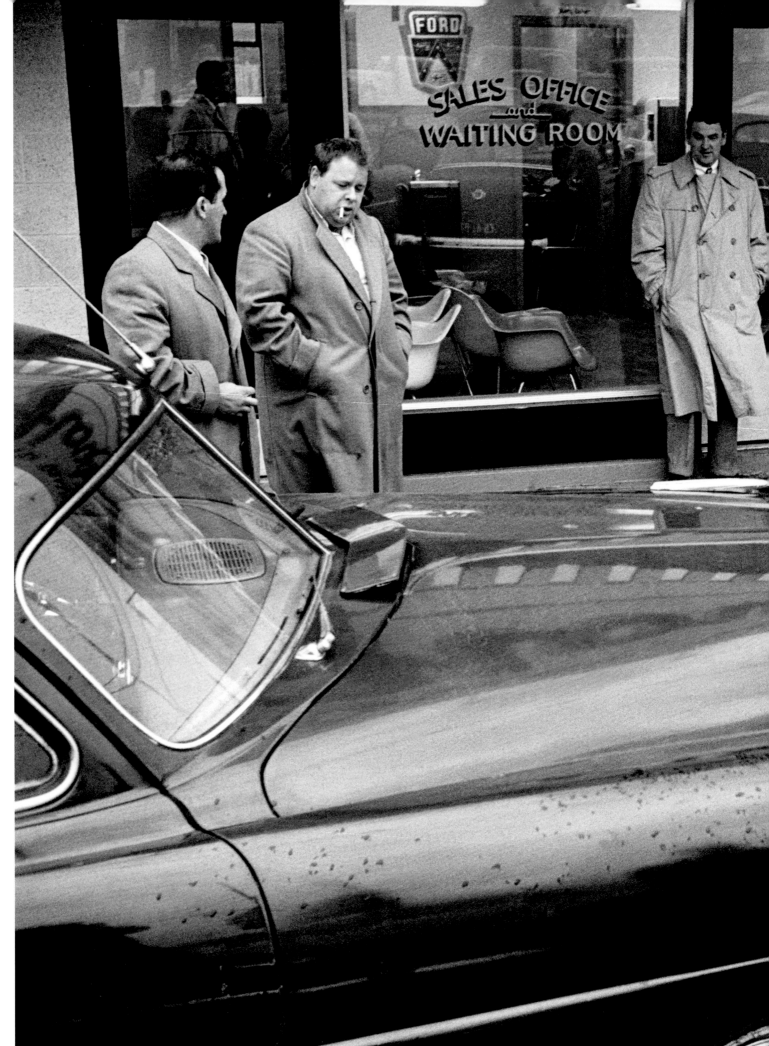

180

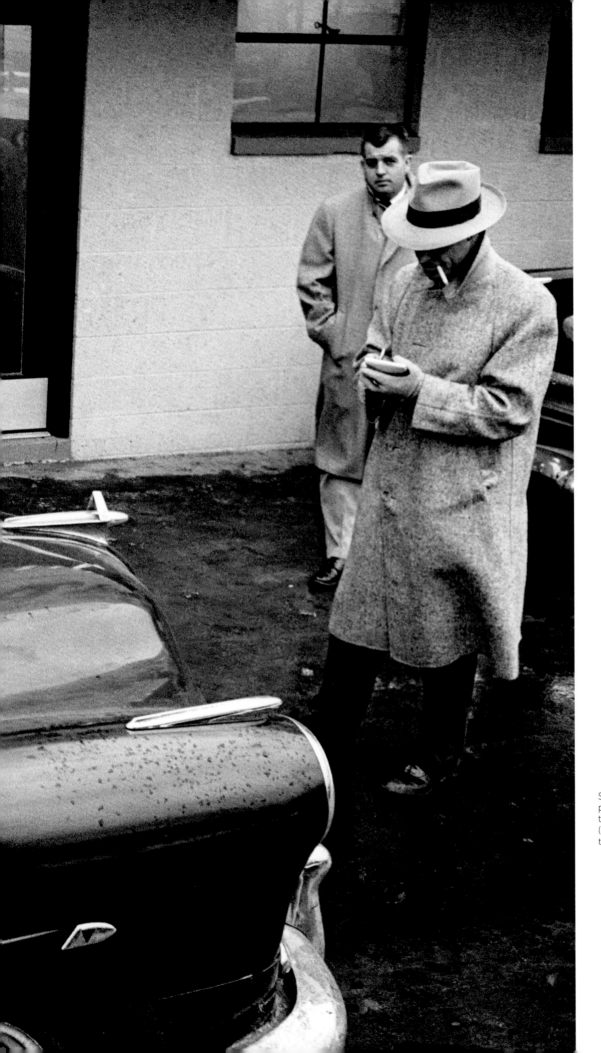

Sam Forman's
pushback only led
to more salesmen
(and a lower
trade-in value).

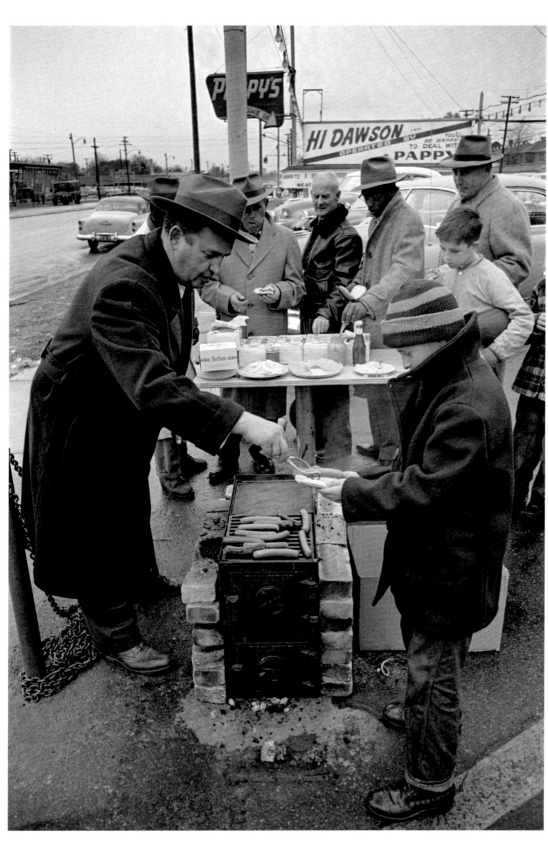

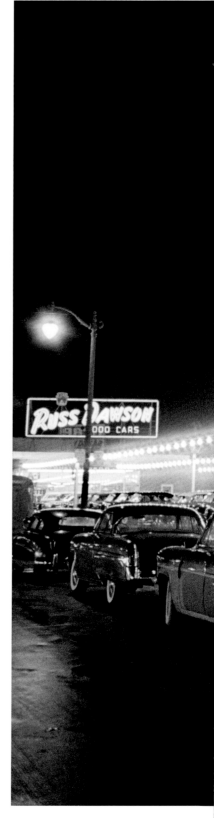

ABOVE:
Pappy's pulled in customers with free food and notoriety, once accepting a live bear as a trade-in.

OPPOSITE:
The bar next to Russ Dawson's lot could offer a drink to celebrate your new car—or to forget the price you paid for it.

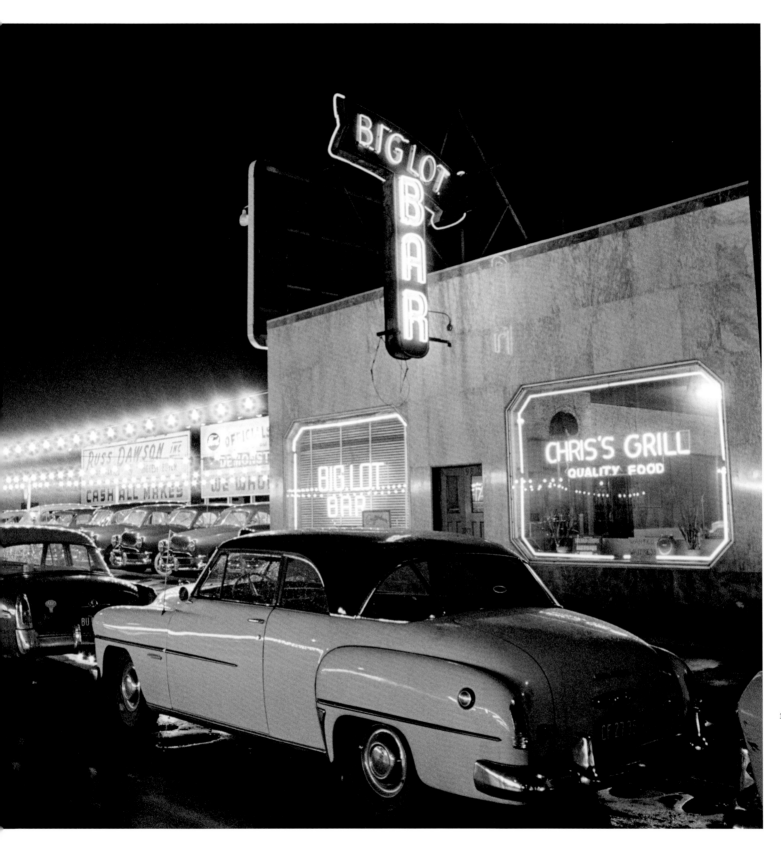

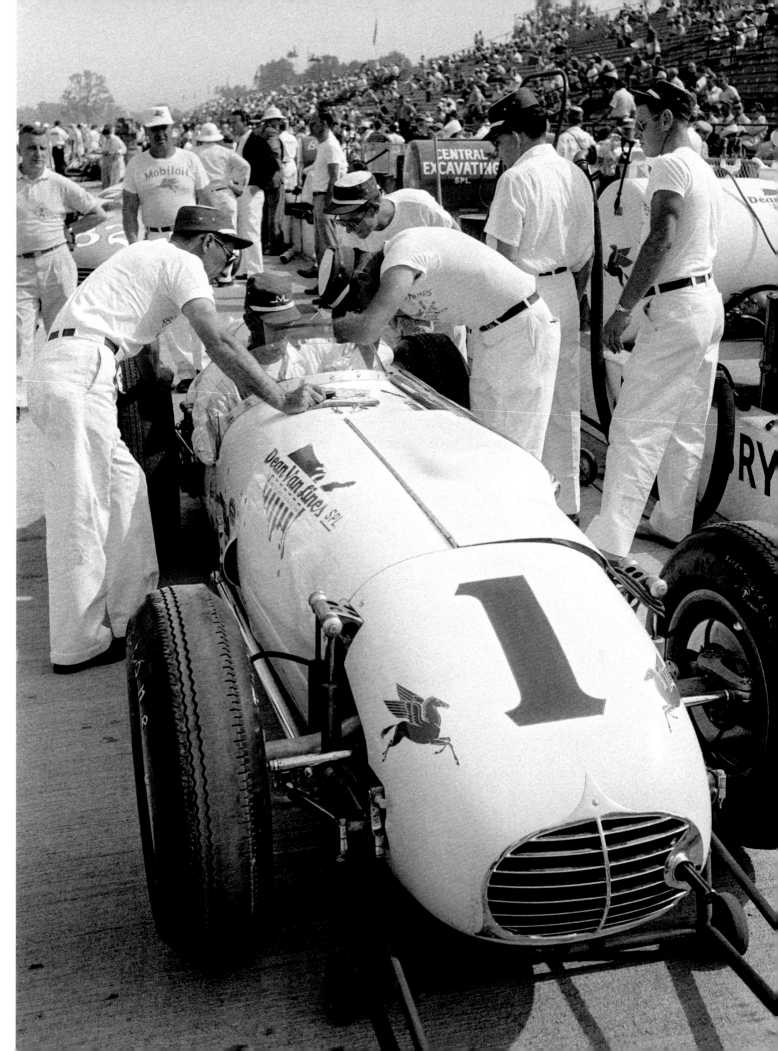

RACING

RACING

IN 1956, ZIMMERMAN JOINED the staff of *Sports Illustrated*, where his innovations revolutionized sports photography, including auto racing. From the Indianapolis 500 to dirt tracks and early NASCAR, Zimmerman's finish-line shots were moments in time caught by his pioneering techniques. His images of fans and details from the pits told the stories of classic races. His telling portraits of drivers were glamorous and charismatic, and their cars were never just cars but icons of speed and motion in American culture as well as on American racetracks.

—T.M.

PREVIOUS:
Jimmy Bryan's
crew prepare for
the 1957 Indy 500.

OPPOSITE:
Indy drivers race
around Turn 1 in
1957.

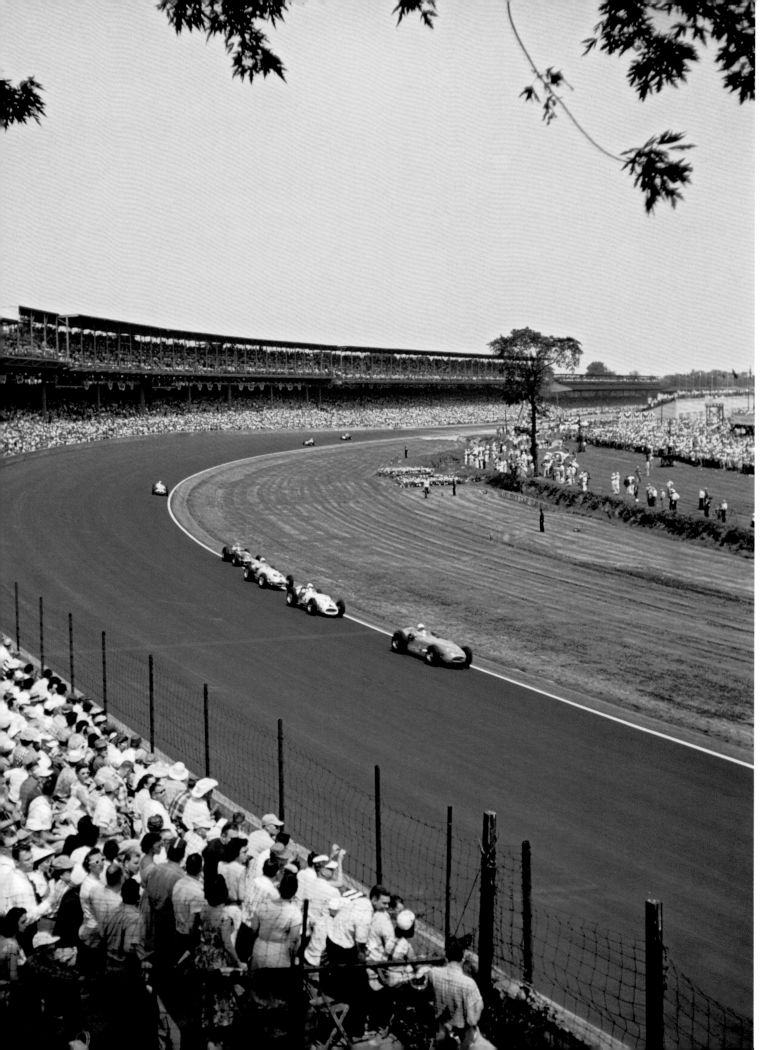

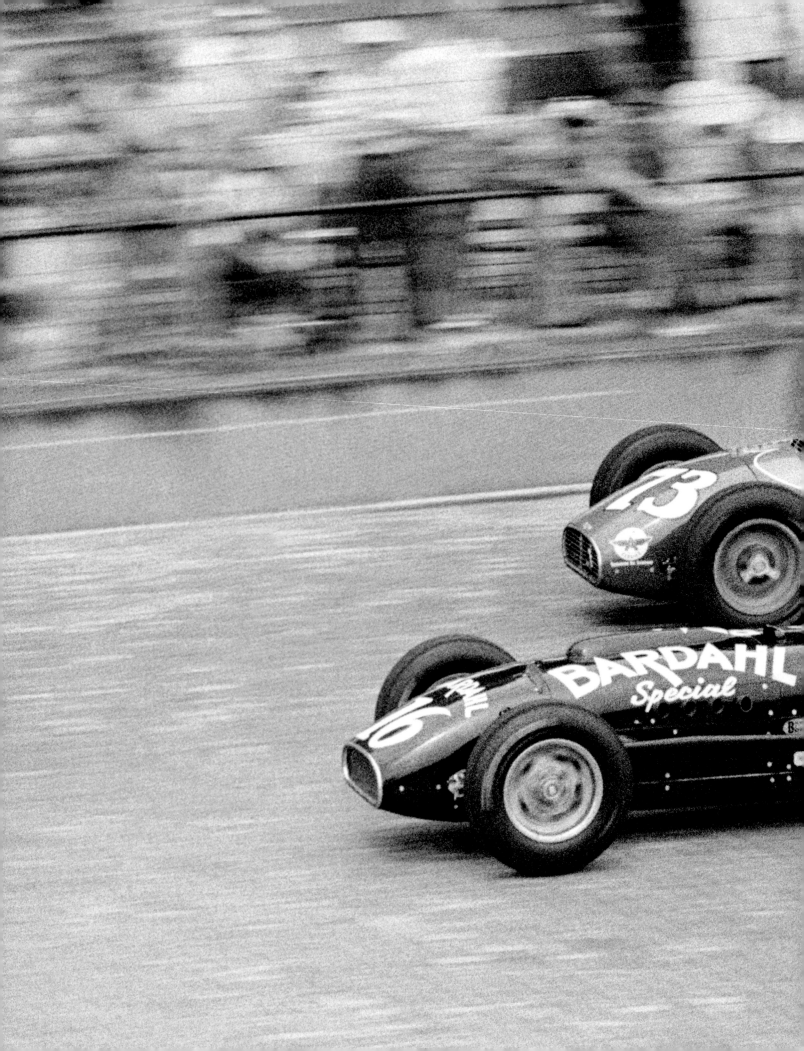

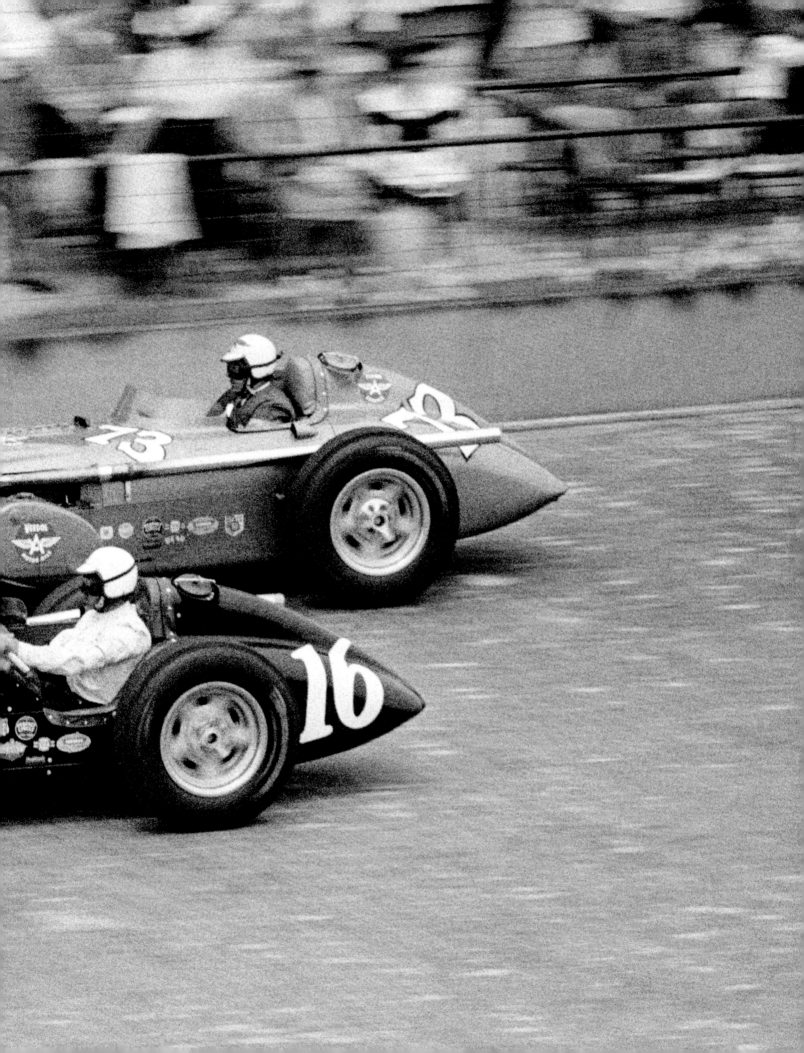

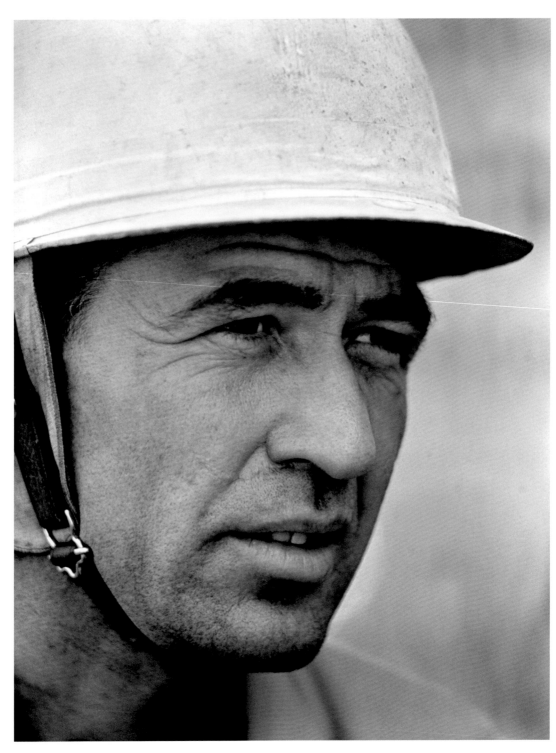

PREVIOUS:
Al Keller (driving
the #16 car) and
Andy Linden ride
the bricks on the
front straight.

ABOVE:
Racer, car
designer, and
manufacturer
Carroll Shelby in
Havana during the
1958 Cuban
Grand Prix.

OPPOSITE:
Phil Hill poses
on the hood of
his Ferrari for the
March 16, 1959,
cover of *Sports
Illustrated*.

SPORTS ILLUSTRATED

MARCH 16, 1959

America's National Sports Weekly

25 CENTS
$7.50 A YEAR

SEBRING PREVIEW

PHIL HILL
Sports Car Driver of the Year

191

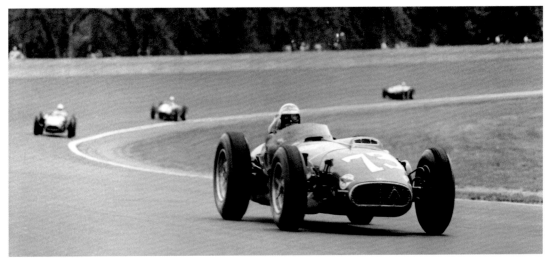

ABOVE:
Andy Linden
steers his car to
fifth place during
the 1957 Indy 500.

RIGHT:
Sam Hanks, with
wife Cindy, wins
the 1957 Indy 500
and walks away
from racing.

OPPOSITE:
The Borg-Warner
Trophy.

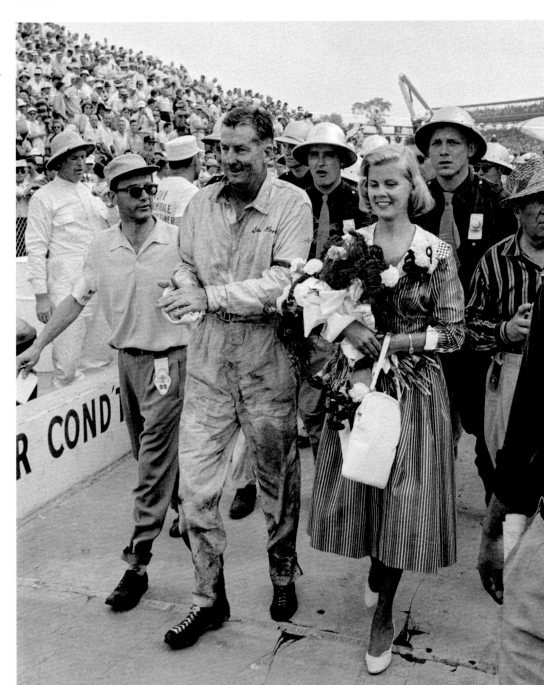

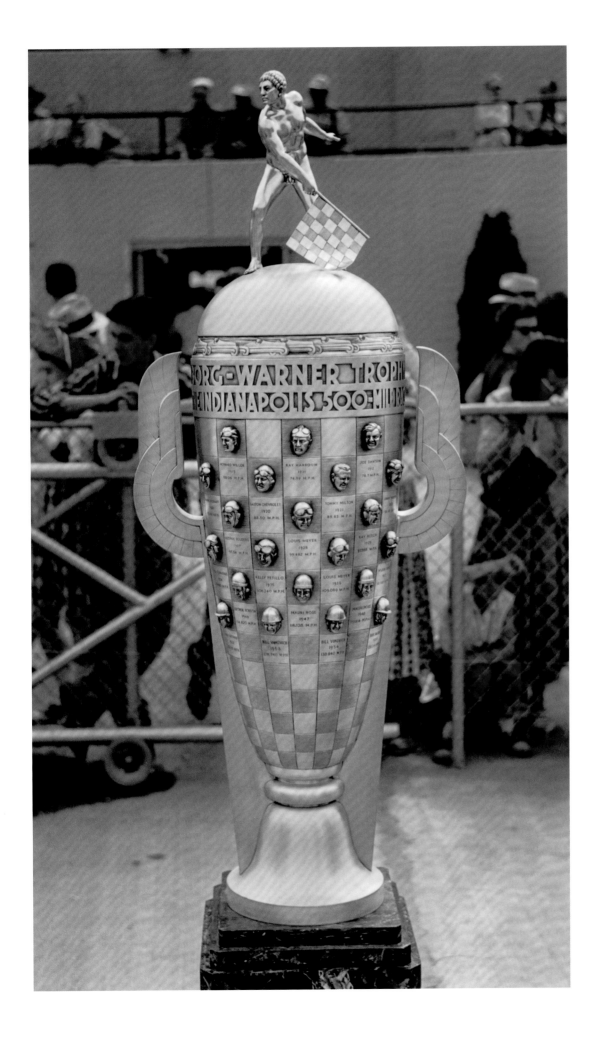

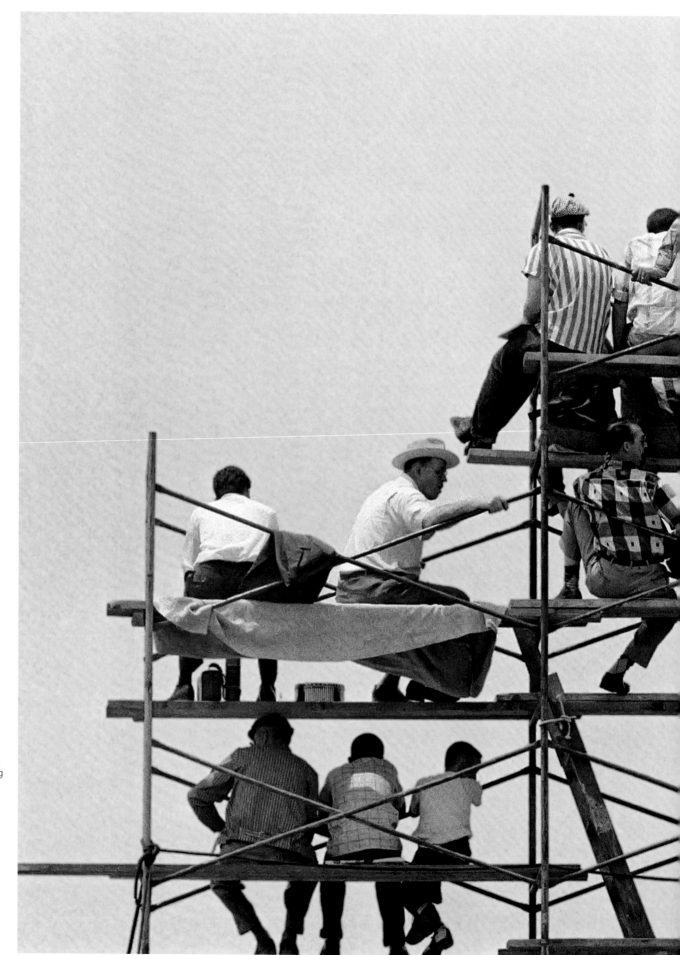

194 The view from the
scaffolding during
the 1957 Indy.

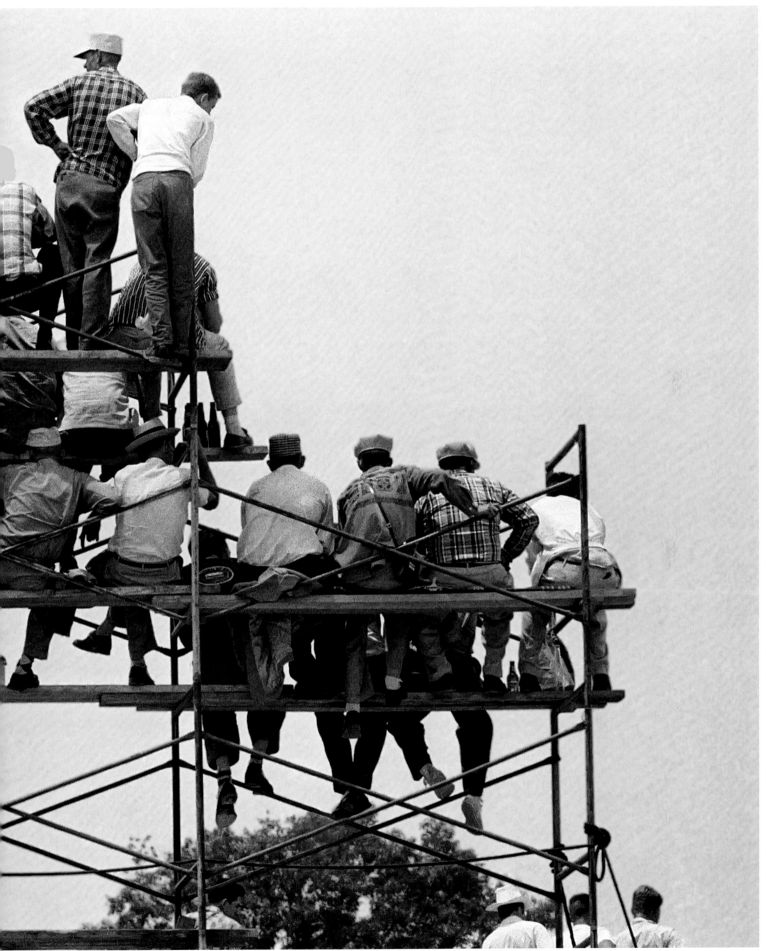

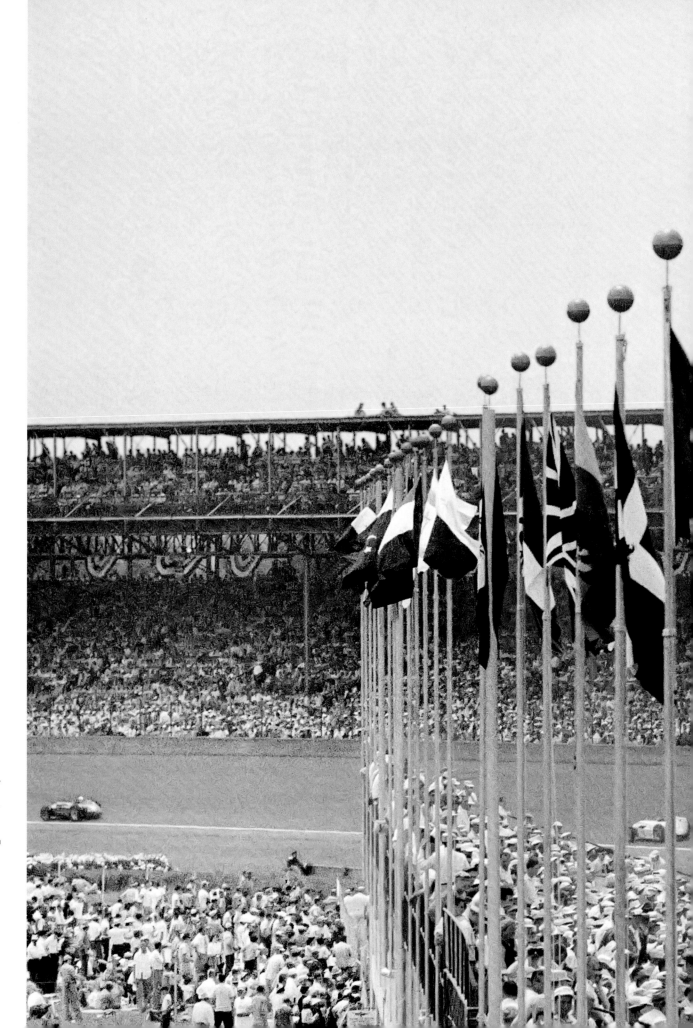

Flags flutter
during the 1957
Indy 500, while
the Prest-o-lite
chimney emits
smoke and
clues drivers on
changes in the
wind.

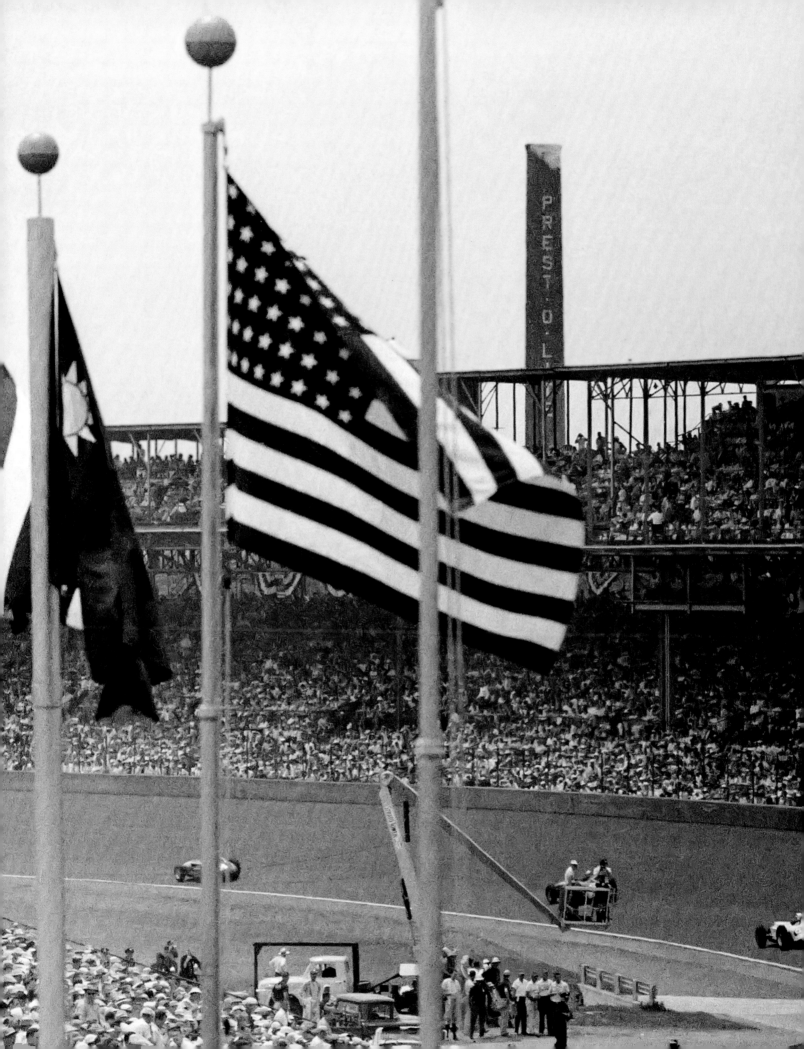

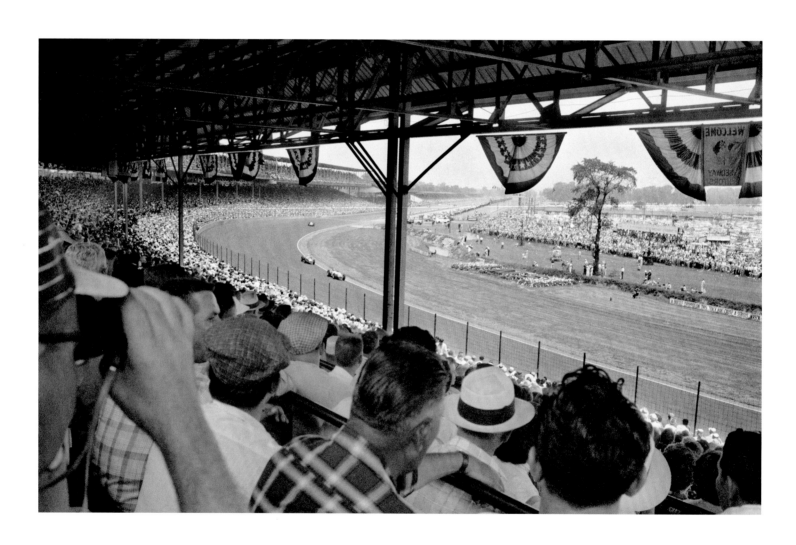

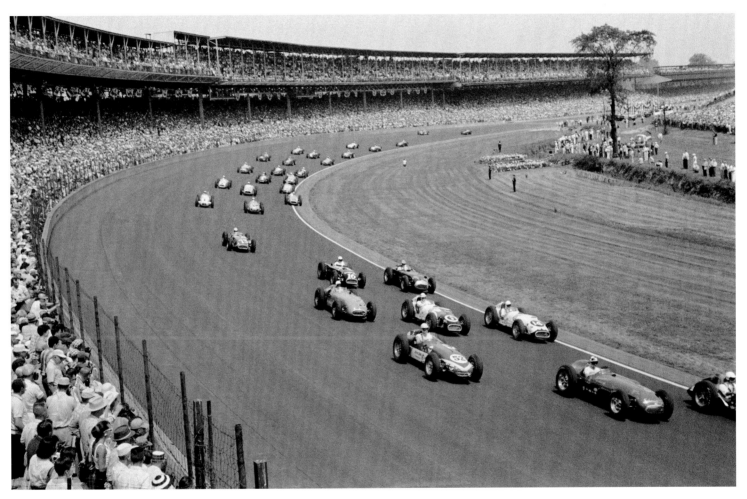

OPPOSITE:
Grandstand seat-
ing at Turn 1.

ABOVE:
1957 Indy drivers
pace themselves
before the action
begins.

FOLLOWING:
This photo of the
field of roadsters
at the 1961 Indy
500 was captured
from the pace car.

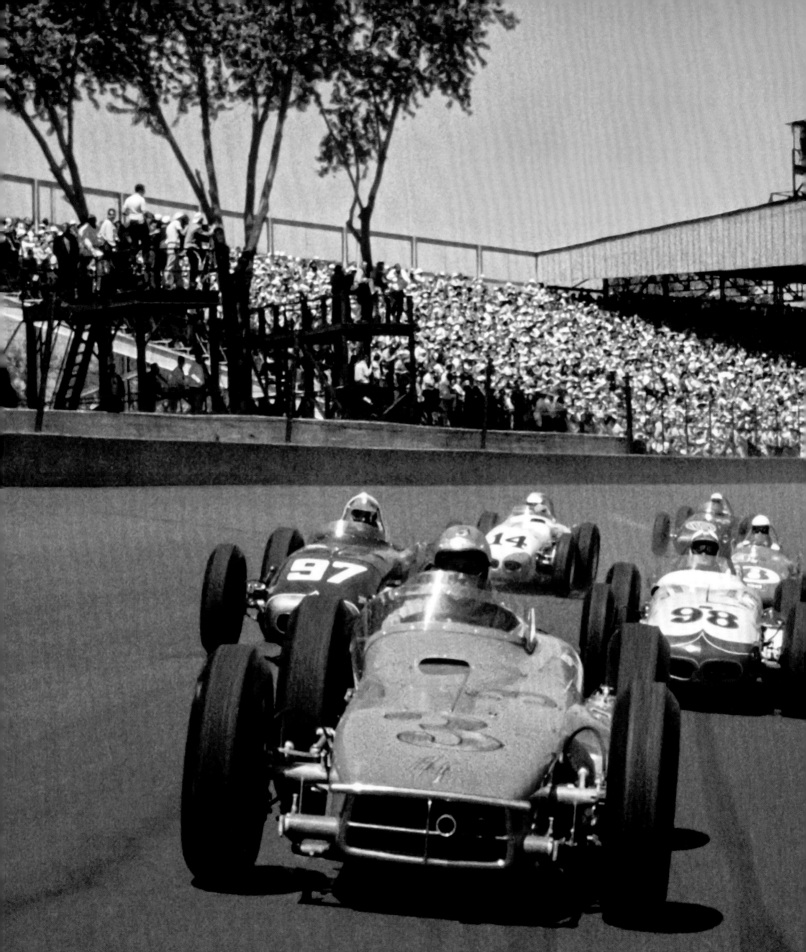

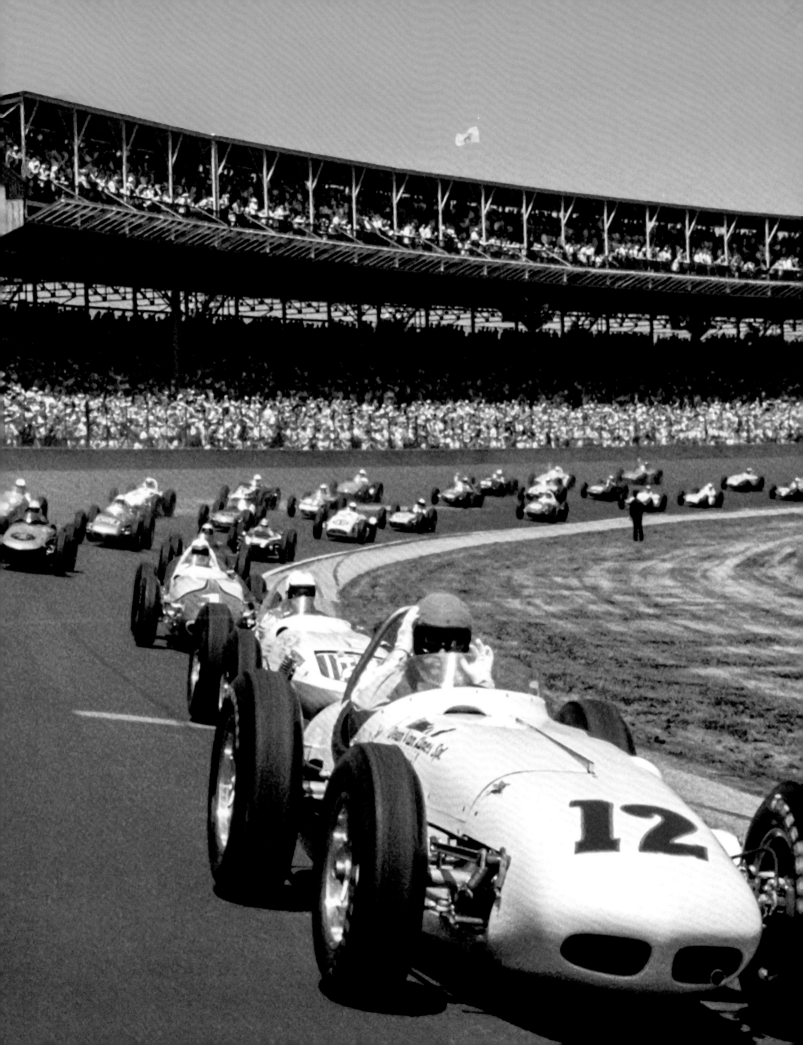

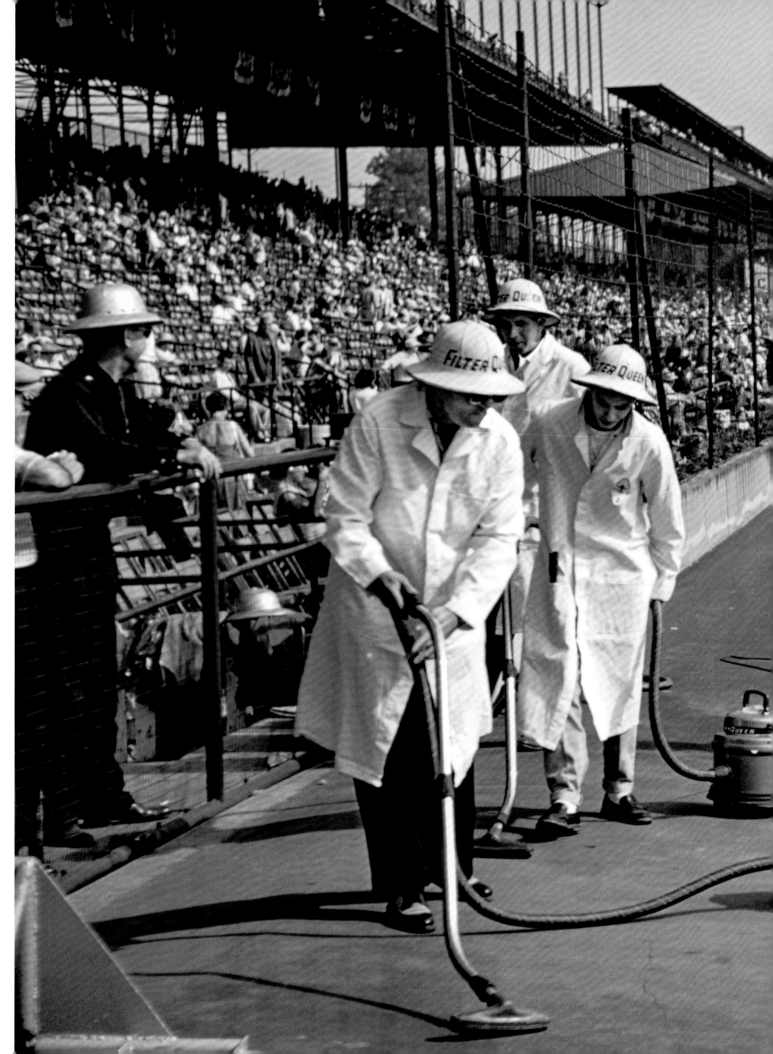

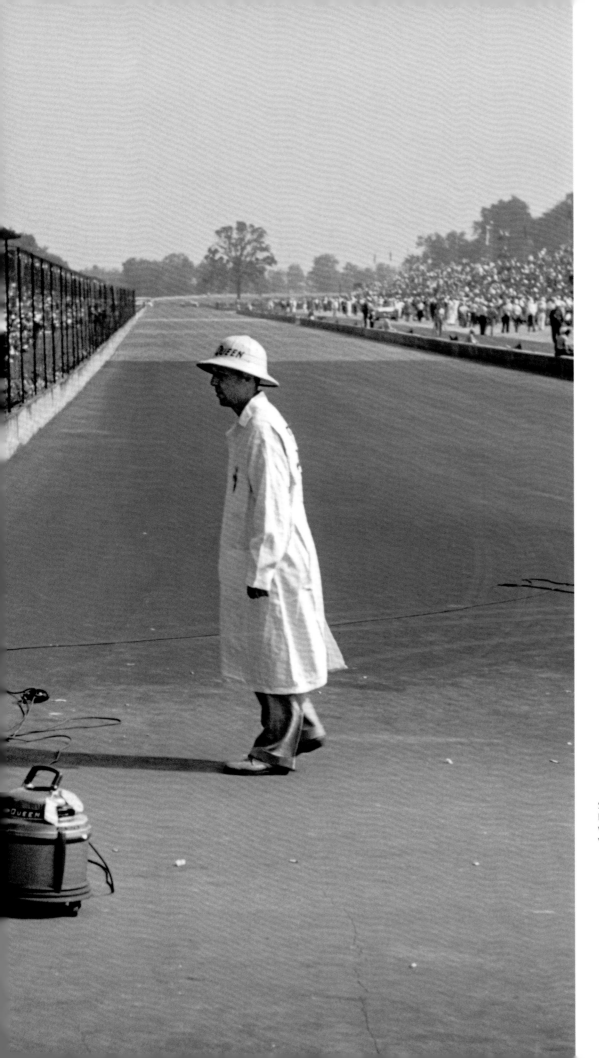

Staff keep the
Indy debris-free
with Filter Queen
vacuums.

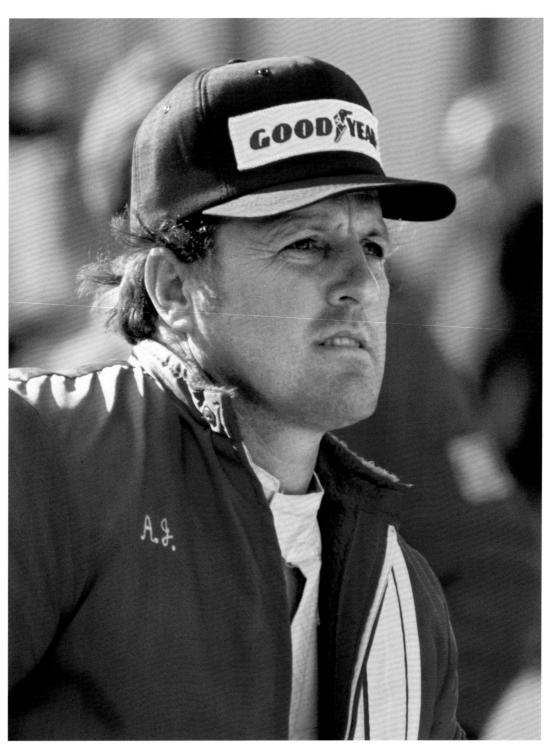

ABOVE:
A.J. Foyt surveys
the scene before
the 1974 Cali-
fornia 500 at the
Ontario Motor
Speedway.

OPPOSITE:
Mario Andretti,
the 1969 Indy 500
winner, smiles
before the 1974
start.

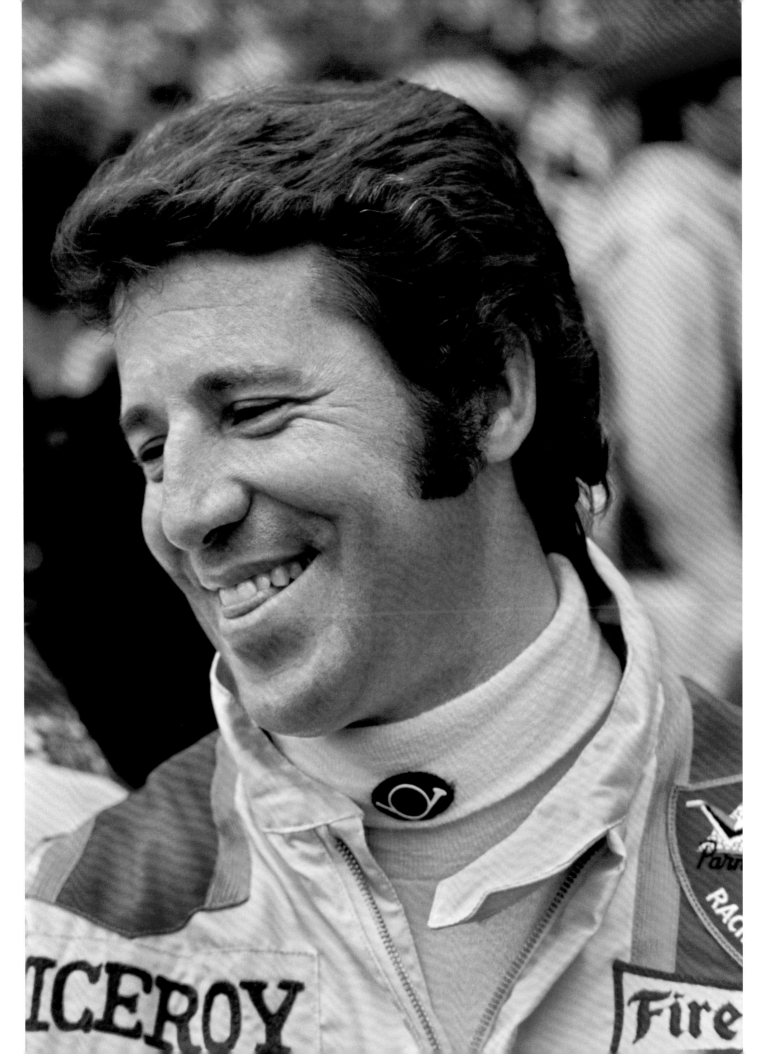

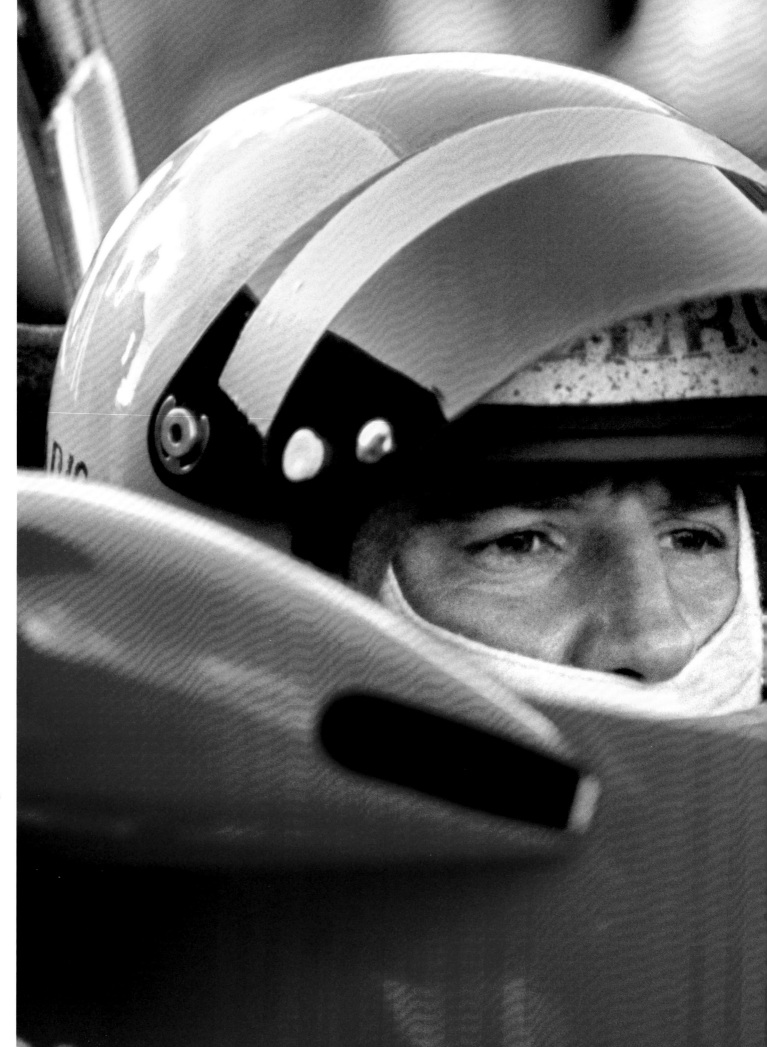

Andretti focuses
at the 1974
California 500.

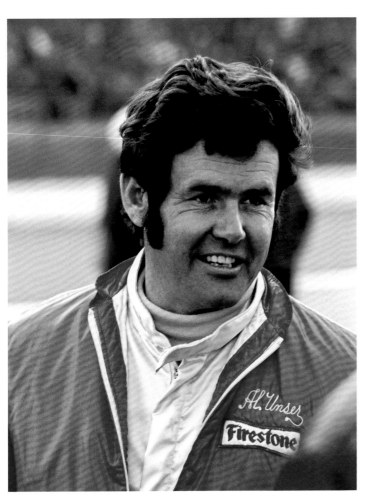

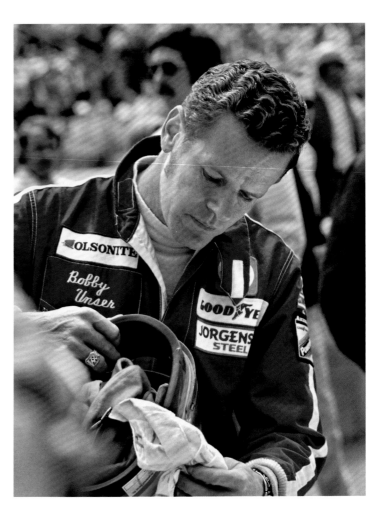

Four-time Indy
winner Al Unser
at the 1974
California 500 in
Ontario.

Bobby Unser,
during the 1974
edition, won Indy
three times in
three decades.

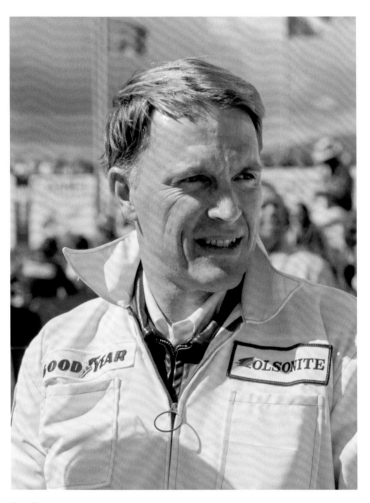

Dan Gurney, seen
here at Ontario
Motor Speedway
in 1974, won
open-wheel and
stock car races.

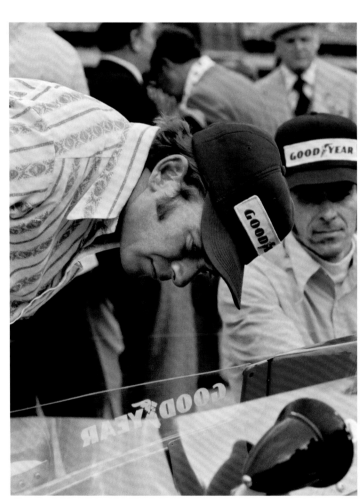

Parnelli Jones,
at the 1974 Indy,
celebrated wins
both as a driver
and an owner.

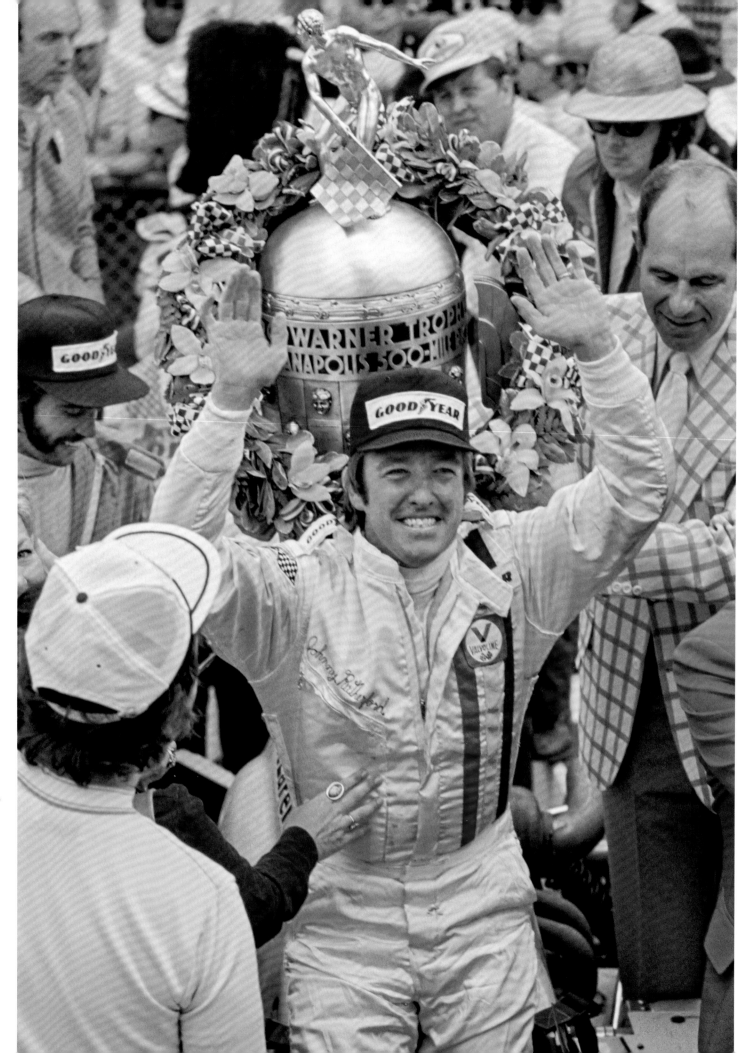

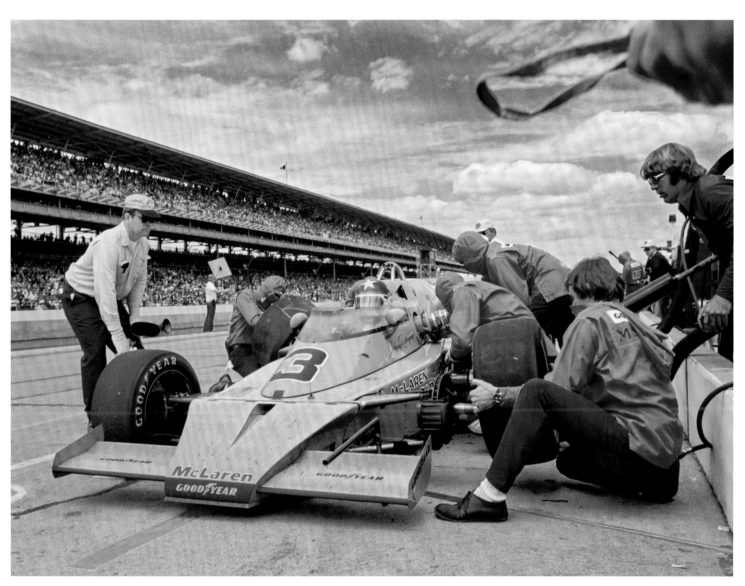

OPPOSITE:
Johnny Ruther-
ford basks in the
glow of his 1974
Indy victory and
the shine of the
Borg-Warner
Trophy.

ABOVE:
Rutherford's pit
crew fuels his
McLaren and his
resurgence from
the twenty-fifth
starting position
to victory lane in
1974.

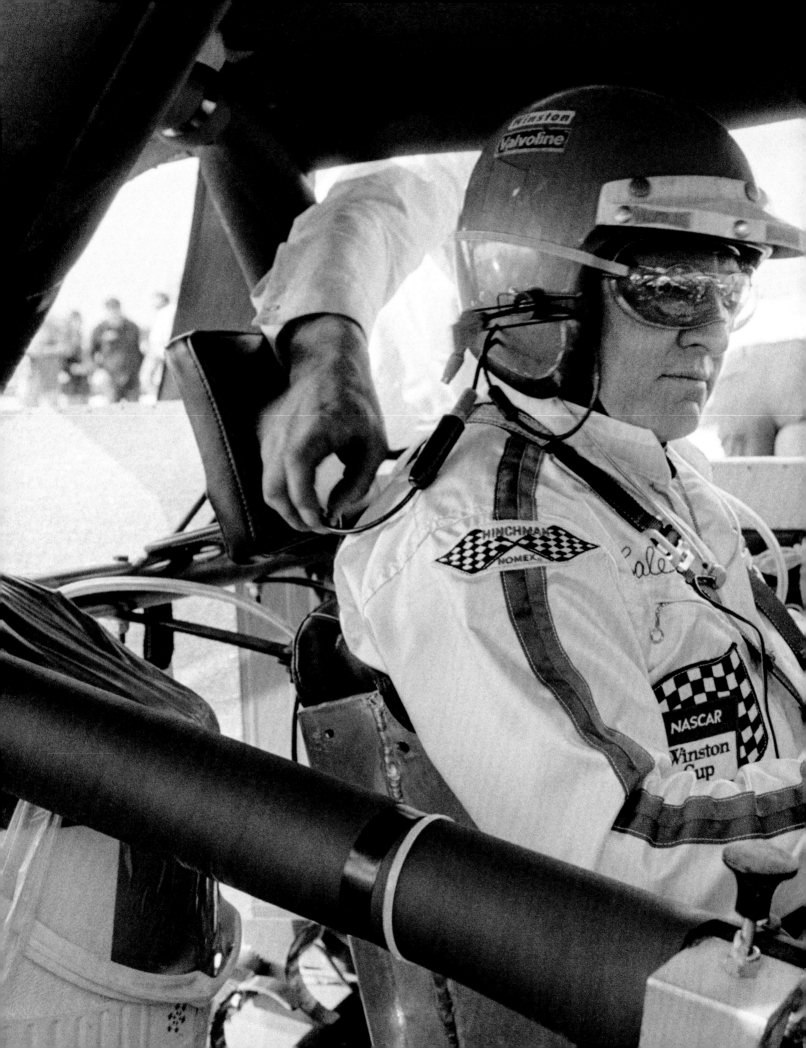

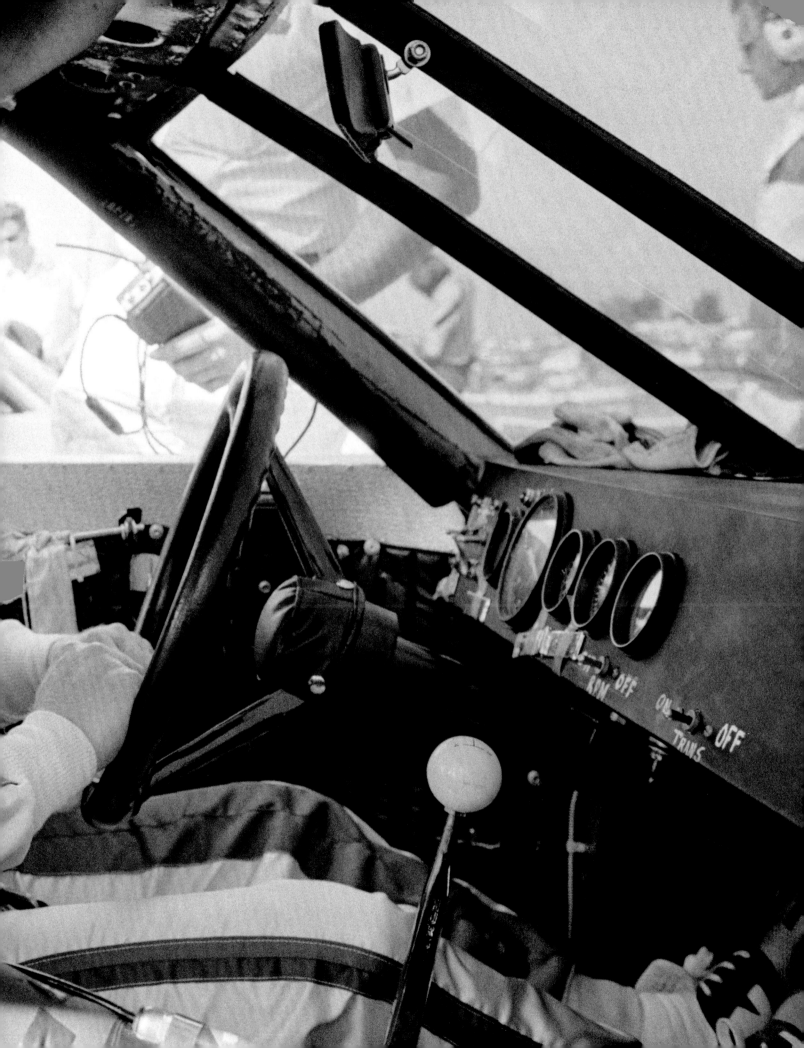

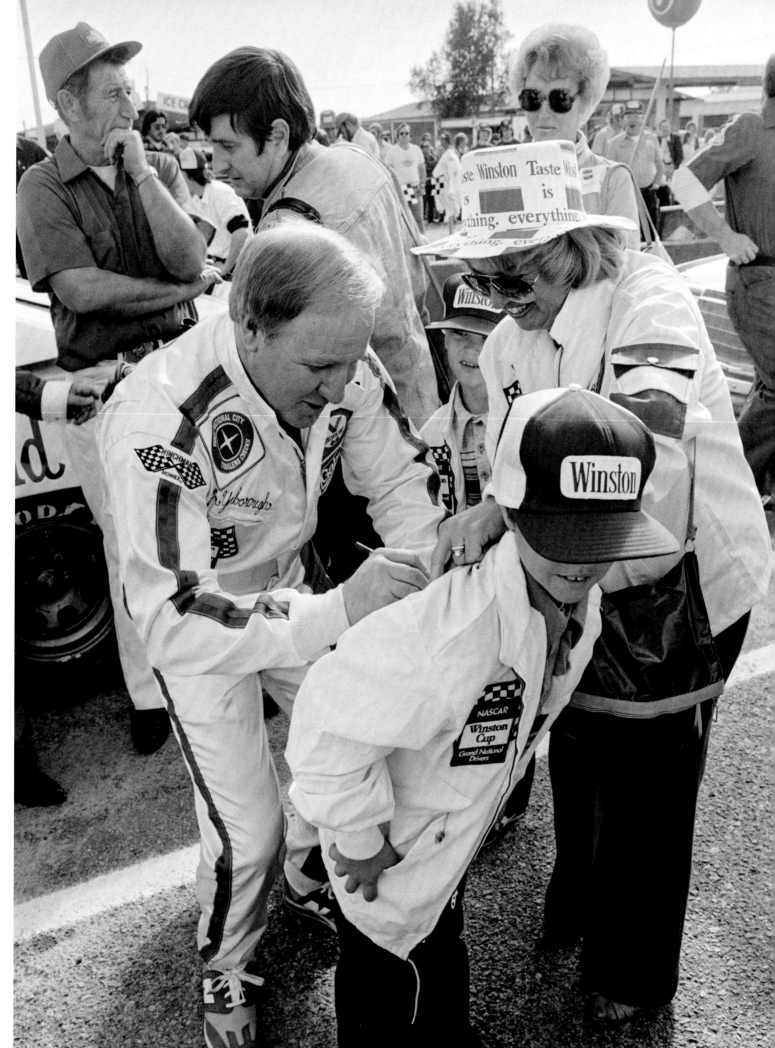

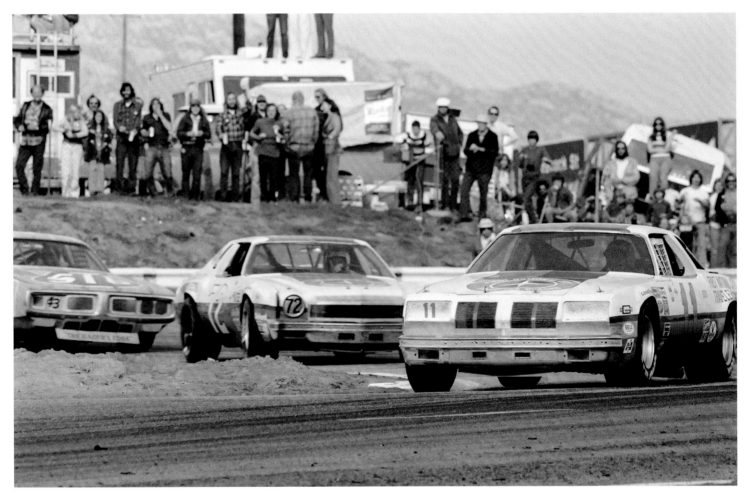

PREVIOUS:
Cale Yarborough
gets settled into
his #11 Oldsmobile
before the 1978
NASCAR Western
500.

OPPOSITE, ABOVE:
Yarborough, who
won the race and
the 1978 cham-
pionship (his third
in a row), signs
autographs and
speeds through
turns at the River-
side International
Raceway.

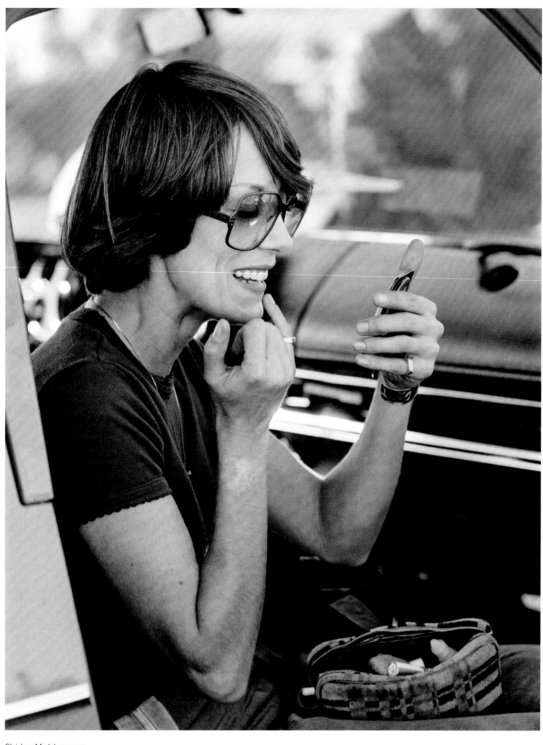

Shirley Muldowney
applies makeup
and spark plugs
at California's
Fremont Dragstrip
in 1977.

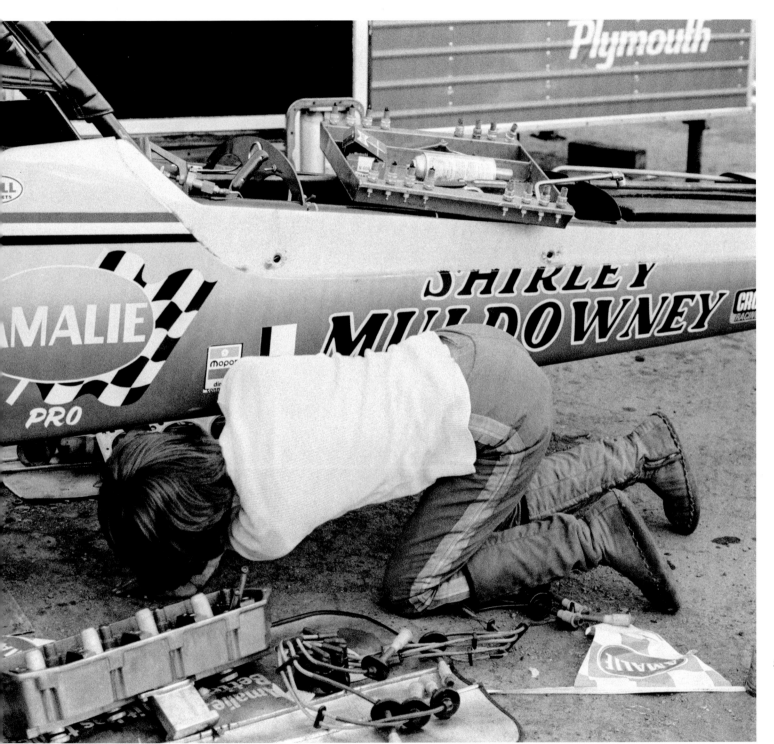

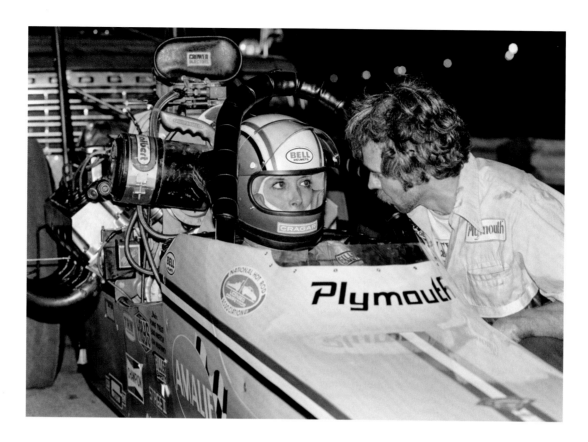

Muldowney dominated the National Hot Rod Association in 1977, winning the first of three Top Fuel dragster championships that year.

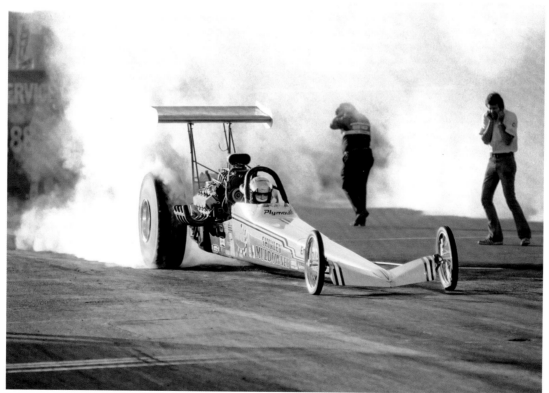

219

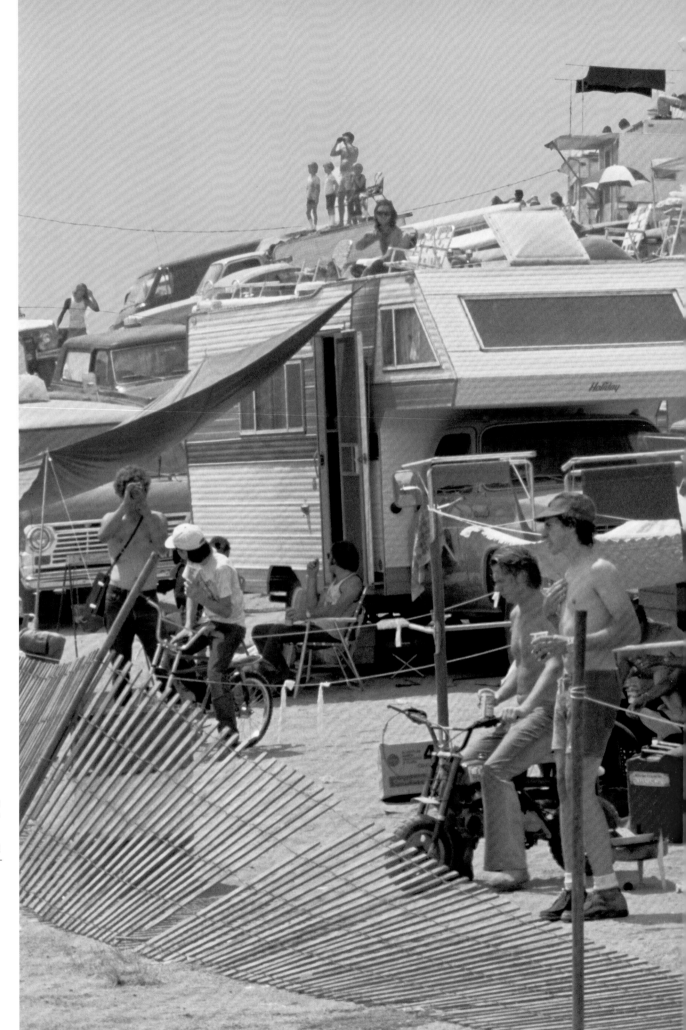

220 Off-road racing
 fans catching the
 sun and the spills
 during the 1975
 ACDelco World
 Championship at
 Riverside Interna-
 tional Raceway.

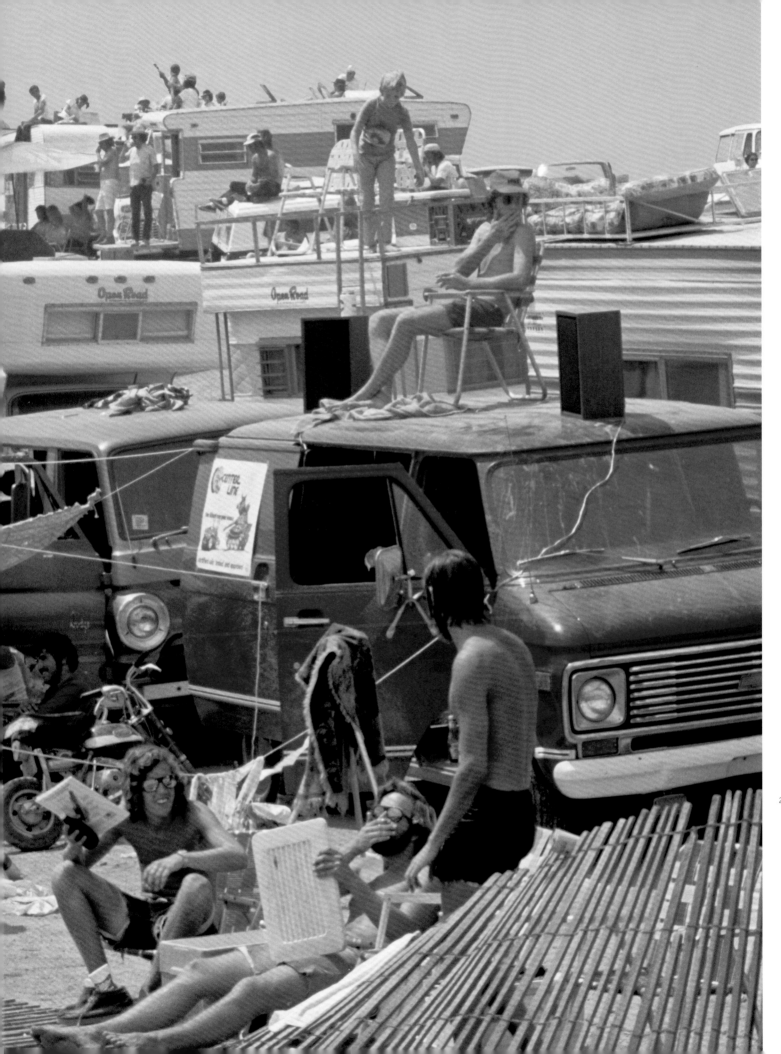

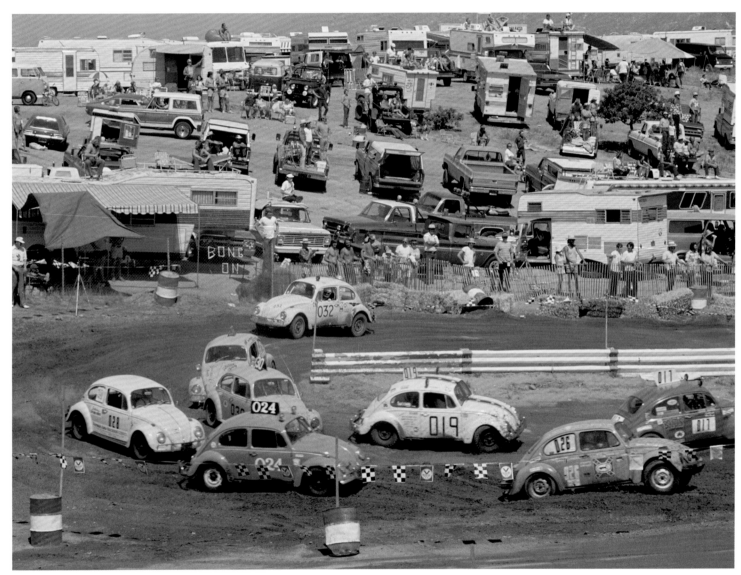

ABOVE:
Volkswagens
bounce around
a turn at Riverside
Raceway in South-
ern California.

OPPOSITE:
Gritty and
grinning, Bob
Hood poses for
Zimmerman
after his Riverside
race in 1975.

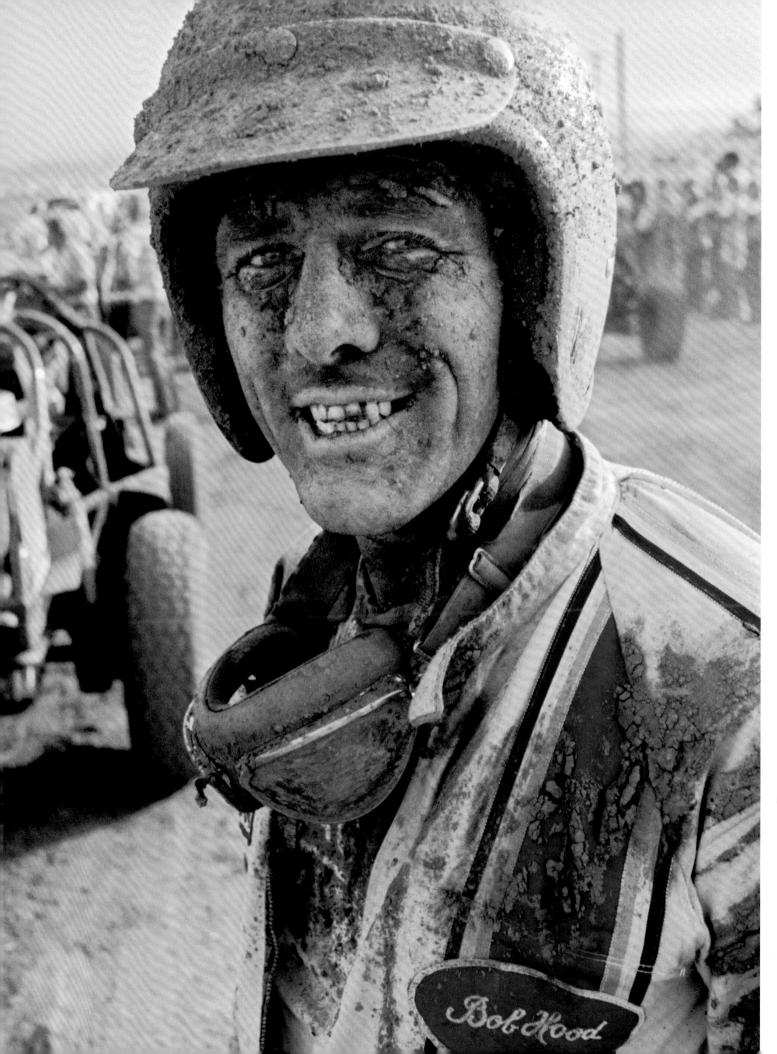

ACKNOWLEDGMENTS

THIS BOOK TOOK several years to come together, and we'd like to thank those who devoted their time and expertise in bringing it to fruition. Foremost among them is Karen Carpenter, who encouraged us to develop *Auto America* and first brought it to Rizzoli's attention.

Jacob Lehman, our editor, and Colin Hough-Trapp, our production manager, did an outstanding job as creative collaborators in realizing our vision for the book. John Klotnia and Laura Eitzen at Opto designed a gorgeous book that presents the photos with style and flair. Terry McDonell's introductory texts capture John and the era in which he worked to a tee. Joe Felice wrote captions that say just enough without saying too much, and did a prodigious amount of fact checking.

Our father's relationship with *Sports Illustrated* began in 1954; we are grateful that relationship continues today with ABG/Sports Illustrated and extend a special thank you to Michael Sherman and his team, Prem Kalliat and Will Welt, for their generous assistance with reproducing the *SI*—owned images in the book.

Alan Fitzgerald and Evan Maloney of Art Intersection, along with Richard Price, embraced the formidable task of technically retouching many of the faded, color-shifted images and created a beautiful set of match prints.

The Center for Photographic Art in Carmel, CA, and its dynamic Executive Director, Ann Jastrab, have been strong supporters of John's work and we thank them for their commitment to mounting the companion exhibition to this book.

Heidi Charleson and Lou Woodworth, and Gail and Jan Stypula provided steadfast enthusiasm and support throughout the project that has been more helpful than they know.

And lastly, Delores Zimmerman, John's wife and creative partner for 44 years, who is at the heart of all our archival endeavors—we dedicate this book to you, mom.

LINDA, GREG, AND DARRYL ZIMMERMAN

PAGE 2:
Zimmerman poses for *Sports Illustrated* photographer Tony Triolo in 1958.

ENDPAPERS:
Zimmerman adapted a teleidoscope to a camera lens to create a series of bejeweled images of GM's new cars in 1971.

First published in the United States of America in 2022 by
Rizzoli International Publications, Inc.
300 Park Avenue South, New York, NY 10010
www.rizzoliusa.com

Published on the occasion of the exhibition
Auto America, Car Culture 1950s–1970s
Photographs by John G. Zimmerman
Center for Photographic Art, Carmel, CA
August 6–September 4, 2022
www.photography.org

Copyright © 2022 John G. Zimmerman Archive
www.johngzimmerman.com

Texts © 2022 Terry McDonell

Publisher: Charles Miers
Editor: Jacob Lehman
Production Manager: Colin Hough-Trapp
Production Assistant: Olivia Russin
Managing Editor: Lynn Scrabis
Copy Editor: Cindy Trickel

Design: Opto Design

Printed in China

2022 2023 2024 2025 /
10 9 8 7 6 5 4 3 2 1

ISBN: 978-0-8478-7080-6

Library of Congress Control Number: 2022936495

Facebook.com/RizzoliNewYork
Twitter: @Rizzoli_Books
Instagram.com/RizzoliBooks
Pinterest.com/RizzoliBooks
Youtube.com/user/RizzoliNY
Issuu.com/Rizzoli

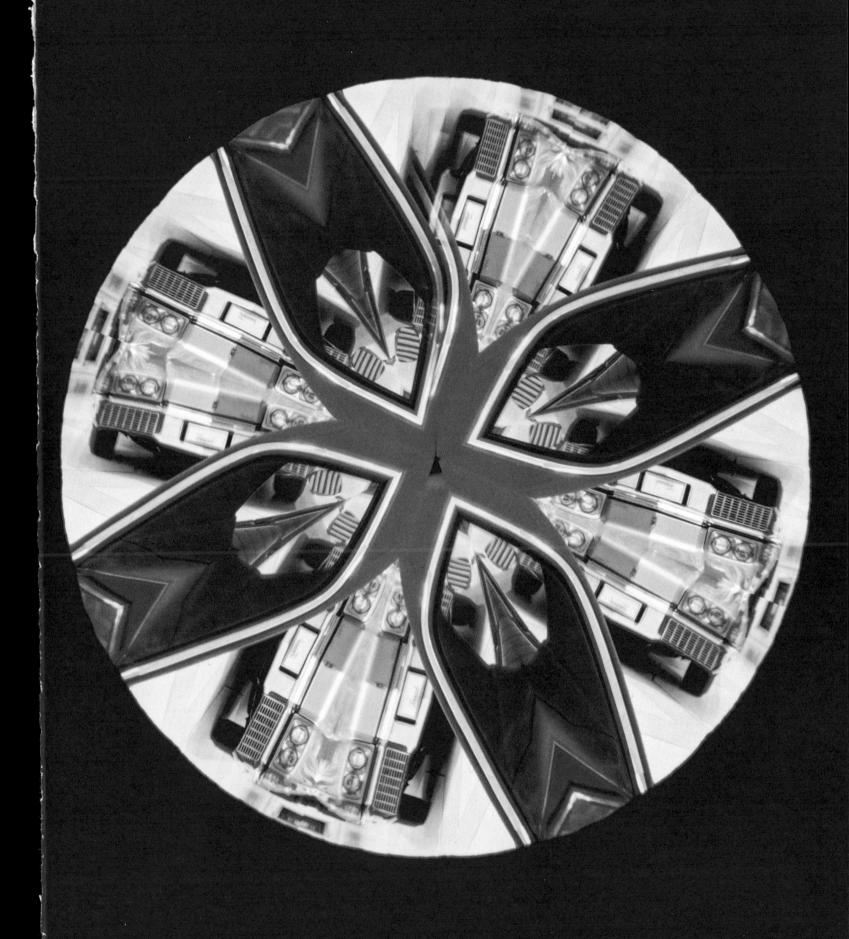

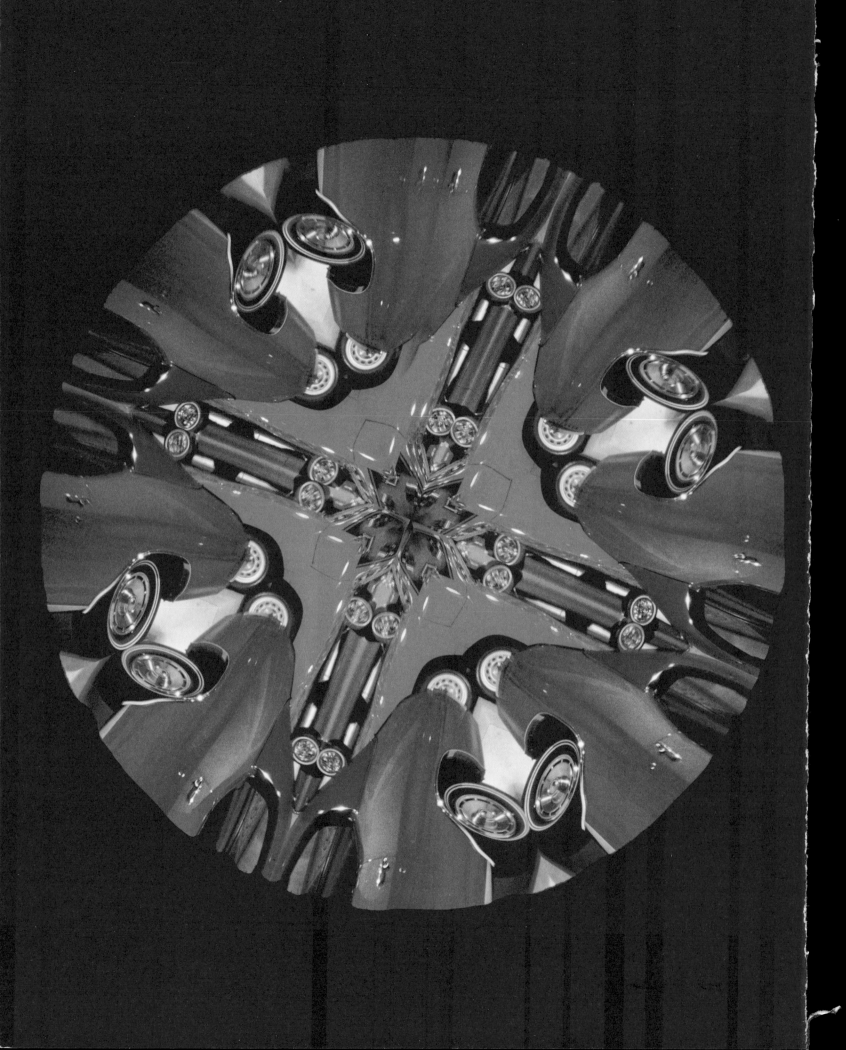